☆ ☆ ☆ ☆ ☆ 0 6 9 3

Chelsea
Hotel
Manhattan

☆ ☆ ☆ ☆ ☆

Joe Ambrose

☆ ☆ ☆ ☆ ☆

A babelogue about one hotel, its superstars,
bohemians, junkies, losers and outsiders.
With diversions concerning Harlem, Brooklyn,
negritude, the Lower East Side, punk rock,
hip hop, tales of beatnik glory, and the
loneliness of the city crowd.

A HEADPRESS BOOK
Published in November 2007

Headpress
Suite 306, The Colourworks
2a Abbot Street
London
E8 3DP
United Kingdom

tel 0845 330 1844
email office@headpress.com
web www.headpress.com

CHELSEA HOTEL MANHATTAN
* * * *

Text copyright © Joe Ambrose & respective authors
This volume copyright © 2007 Headpress
Design & layout: Hannah Bennison
Back cover photograph: Joe Ambrose by Maki Kita
World Rights Reserved

British Library Cataloguing in Publication Data
A catalogue record for this book is available from the British Library

ISBN13 **9781900486606**

headpress.com

Them that die'll be the lucky ones

Long John Silver, *Treasure Island*

As for the unbelievers, Allah can surely
do without them

The Koran

Beware the deadly underdose

Marty Matz

END OF PUNK TIME

We started as a cell in a sea-like
situation.
Now it's a little smoky and hard to breathe
and there are dead people everywhere.
In the city where once walked Gods there are no
longer even people left alive.

Joey the old punk rocker had reached the end of time. His hair dye and longhair wigs were laid aside. It was time for Joey to go — against his will — into that bad night. The glory days of three night stands in Brazilian stadiums were other people's memories now. His memories disappeared into the morphine sea that awaits us all. The stocky hospice nurse, a Nora McCarthy from Kerry, eyed Joey's drug-loving best pal, wondering if he was the wretch who'd stolen that lifetime's supply of morphine sulphate which went missing the week before things got this bad for poor Joey.

His onetime gallery-running mother and his in-bitter-awe of wealth and fame punk rock brother were gathered by his bedside. As the singer disappeared into his personal cancer coma the brother pressed Play on the shocking pink ghetto blaster. Music from the new U2 album filled the hospital room air. Tubes and machines had all been put aside. It was time to go. Hey, ho, let's go! There was no hope now, other than U2. And that was no hope at all.

Once he'd changed my life with his 7" street symphonies, and once he'd taken this sorry scheme of things entire and remoulded it closer to his heart's desire. Once he had rejected the values of his older brother and his mother to forge his own. Ira Cohen told me on the streets of Manhattan that Joey was the surviving half of a pair of Siamese twins. I heard so many stories from his friends about how he was the intelligent one, the principled one, the one with the vision, the one with the art,

that I convinced myself not just that this was true, but that I too was the intelligent, principled, one amongst my peers and the one with the art in my veins. Such is the power of repetition...and morphine sulphate.

EASY EVERYTHING AND EVERYTHING EASY

I am not on the side of my species. I move through this world like one born under a fortunate sign though there is no evidence to support this fantasy. At least I hope my luck holds out.

It is 5am. Everything is for the best in the best of all possible worlds. In a floating world I erode. I am floating desperately, watching a Sissy Spacek TV movie, when I decide to go look at the Empire State Building and to visit Easy Everything on Times Square to check my emails cheap. It is my first night in America.

The anti-ghost of Joni Mitchell arrives on time to greet me and welcome me to her universe. As I'm leaving the Chelsea Hotel, with a view to walking to Easy Everything, Joni is arriving back there in a limousine. We pass each other in the flapping glass doors. She looks like she did decades ago on the cover of Dogs Run Free, all Canadian collegiate intellect and California Blow Job Queen looseness.

Her long white fur coat rubbing up against my brown Armani effort. I'm impressed. She that has been with almost the entire lineup of CSN&Y.

Like Joni, I've lived my whole life in clouds at icy altitudes. And looking down on everything, I've crashed onto the ground. I head north, out from around the Chelsea Hotel, but I pause to stare in the window of a bad sneakers shop. I should have been here twenty years ago. Two black boys — poor and mutts — are looking at the bad sneakers, enthusing about them. I think to myself that, man, I got better sneakers at home that I'd only wear if I was laboring or working on the farm.

It takes me no time to check my emails at Easy Everything. The next monitor, a fifteen year old black kid who must weigh about 400 pounds, is slumped over a ghetto blaster tuned into a pirate ragga station just now blending *Batty Rider* by Buju Banton with *Ah Si J'Etais Riche* by Big Boss & Winsome. Which is winsome OK; a French version of *If I Were a Rich Man* with, of all things, a ragga beat.

They'll never make a go of this place. Junkies, male prostitutes, the homeless, the dirty, the hapless, the dispossessed, the strung out ones and worse, have returned to Times Square via Easy Everything. A Missy Elliot-fat dyke is chatting up young

white suburban girls in New Jersey on her cellular. She is hollering like a pig, "Yeah, sure honey. I can travel to Jersey." Then they discuss things they could do with their tongues and clits.

I get back to the Chelsea about 6.30am and I'm finally ready for sleep, jet lagged or not. The ghost of Herbert Huncke roams the corridors of the hotel. He is an old friend, come back to welcome me to the city he called home.

"What do you suggest I do tomorrow?" I ask Mr Huncke before sleep surrounds me.

"Dammit, I suggest you go see Handy Dandy, a nice man, a reasonable saxophonist, and a fine heroin dealer whom I first met in Amsterdam in 1989 when he lived over a restaurant with this charming young girl called Yaniss. I was doing a series of readings across that part of Europe organised by a female psychopath who could have gone ten rounds with Sonny Liston. It was a particularly unpleasant experience I was having but Handy Dandy fixed me up just fine. Dandy lives south of Houston with his old girlfriend, Lady High, who used to be Chet Baker's dealer in the late 50s. Then she was known as Sue Tyrer, under which name she had a couple of good supporting roles in movies starring the likes of Mitchum and Burt Lancaster. Yes indeed, Lady High was in with as good a chance as the best of them, but she let her addiction get the better of her," says America's oldest living junkie, now deceased, chuckling.

SKANK IN BED WITH A FASHION BOY

Five hundred French have invaded the Chelsea Hotel. Now I know how the Algerians must have felt. Soon they'll establish torture chambers on the third floor, install speakers in the corridors forcing us to listen to Francoise Hardy, and distribute free copies of the "thoughts" of Bernard-Henri Lévi in the lobby.

All I can hear is middle aged women in black suits saying "Ah, oui." to one another like it's going out of style. A nation of thieves, mediocrities, and psychopaths (not unlike the English — or the Irish — when you come to think about it). Not for nothing the French invented the words "bourgeois" and "provincial." I hate Paris in the springtime, every moment of the year. I never go to Paris except to make money. Ergo I rarely find myself in Paris.

I meet a young black girl called Meredith who is handing out political flyers on the street in front of the hotel, so I bring her back to my room. Like the whole of New York under the age of thirty she has never been inside the Chelsea Hotel and would love to visit. I turn on the radio and we get undressed. They're playing a tune I can't place which I can't help but notice has been used as a sample by Revolting Cocks. It goes: "This is out of the house, and out of the house music." I just love that elegant double flick of the feet with which women kick off their panties.

"So... what do you like?" I ask Meredith, a student political activist who was promoting a Zapatista movie and discussion due to take place four doors up from the Chelsea this very evening when I tempted her into my lair.

"I like to skank in bed with a young fashion boy," she says, her parent's Jamaican accents shining through her Upper East Side gloss and fancy use of the English language.

"Oh," I say, taken aback, "I'm afraid I may be a disappointment to you then."

Two sons batter their father to death with a baseball bat on the radio, where there is also a dramatization of *Peyton Place*. And when is it morally right to shoot somebody?

I feel like phoning in the answer: "When it is morally right, of course."

DOWN IN DUBLIN

I was down in death, I was down in Dublin,
I was down in the ground, I was going
someplace only dead men go, a bleak black place
only dead men know. I was down in the depths of
the deepest sea, down where there was no you or me. I
went down down down like Elvis Presley. I was down and out.
I thought you'd rescue me?

NICO CHELSEA GIRL

[Nico: "I made a mistake... I said to some interviewer that I didn't like negroes. That's all. They took it so personally... although it's a whole different race... I mean, Bob Marley doesn't resemble a negro, does he? He's an archetype of a Jamaican... but with the features like white people. I don't like the features. They're so much like animals... it's cannibals, no?"]

I have this live album by Nico released on cassette-only format during her lifetime. On it she does *Femme Fatale* and at the end of the song, when all the nostalgia vultures are applauding in quiet relief the fact that she has finally played something they recognize, she says, "That song must be a hundred years old."

What I always liked the most about Nico was the fact that, in common with some other German women I've met, old or young, pretty or ugly, she had lots of vim or get up and go about her. Though it was tough being a woman in a band back

then, though her life was difficult in general, I always saw her as brave. Her bravery is underlined by Iggy Pop's comment that, even when he came across her in the 60s, she was already a slightly older woman struggling upstream to stay in the cool zone. She stayed that icon she wanted to be up to the very end.

Once I had a pal who booked in the bands at the university I went to. I helped him writing his election literature so my kickback — when he got elected to the job — was that he'd book in Nico to do a show for me. Five times he booked her in and five times she failed to show up. Never left her squat in Manchester or her squat in Brixton or she was ill or the van broke down or there was blood on the saddle or the portents were bad. Too much junkie business.

Eventually my pal gave up; he got me Bo Diddley instead. A very fair Velvets-style replacement, since Maureen Tucker and the drang of the Velvets are entirely Bo

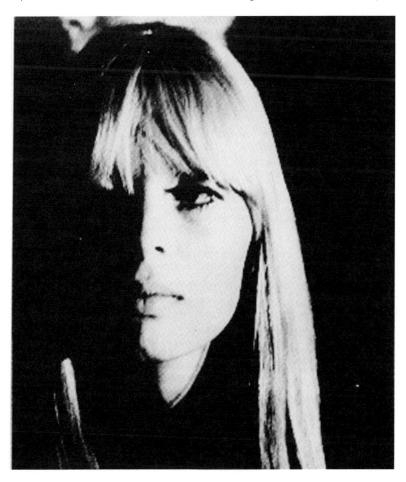

Diddley. Nico never crossed the Irish Sea but eventually she crossed the endless sea. (Bo, of course, showed up and played for ninety minutes plus an encore.)

By the time I moved to Brixton in the late 80s she'd stopped living there with John Cooper Clarke but people were still talking about her. An impoverished icon who'd come amongst her own people.

Iggy Pop: "She was probably running away from something. That's pretty possible. But she knew how to dress, and she was one cool chick… I came back to New York to do some gigs — we had progressed and we were starting to play more like we played on *Fun House*, a harder sound and a little time had gone by. I came to stay at the Chelsea. She was staying there, and she always had a cute man around — she had some new man, a French guy, and I was kind of like, 'Who is this French guy, anyway? What are you doing with some French guy? Let's have a look at him.' And I went to visit her in her room. I was really excited to see her…and she was sitting there. She had a harmonium. I'd never seen her play her harmonium, it was just a little thing, about three feet long and three and a half feet high…and she played this song *Janitor of Lunacy*, which is on one of her records, and she sang the words: 'Janitor of Lunacy, paralyze my infancy.' Just like, you know, very good poetry, just kind of like hearing her doing that right there, complete, in the Chelsea, and that was the way it was gonna go on the record. I was very impressed with that… I saw her later, and we had our differences. I got stoned with her many years later on some heroin and it was not pleasant. She did not look well and I did not react well. I wasn't much of a gent about that and so there's some regrets there."

REDONDO'S WHITE LIES TURN BLACK

All your white lies are turning grey and pus-yellow real fast right here before my eyes. Proud flesh. I don't mind Redondo telling me white lies. Indeed they protect me from insanity and like Lenny Bruce allegedly said, confessions of infidelity are often the most sophisticated form of sadism. Just that right now today Redondo's white lies are turning black as sin right here before me like the heroin bubbling cancerously on her tinfoil.

Hey Redondo! Unbelievable beauty from an Idaho farm, now living on the Chelsea Hotel's eighth floor while some rich guy pays your bills, do you want your boy to turn crazy and do you want to be the one putting the knife inside him and twisting it? Proud flesh. You're fucking with the wrong nigger.

The Vandals took the handles
by Thelma Blitz

It was weird to go back to the Chelsea Hotel after thirty-some years of not having been there and seeing the changes. For example, dingy pale yellow halls and walls were painted white and clean. The No-Smoking Zone signs told me why even the ghosts — like Jerry Ragni, co-author of the musical Hair that brought hippiedom to Broadway; Shirley Clarke, avant filmmaker of The Cool World and The Connection, which opened the world of the drug addict to the cinema; Harry Smith, experimental filmmaker, American folk music anthologist, producer of the Fugs First Album, magus and revered eccentric; as well as my friend Francis, poet, madman and beautiful loser par excellence — don't want to hang out there any more. I recall all the fierce smoking that went on in the 60s and it wasn't always tobacco.

That could be one factor that kept Leonard Cohen away from NYC; another is the possibility of terrorist attack imagined in First We Take Manhattan and The Future. It surely wasn't the prices of the rooms, which seem to have increased tenfold, keeping less financially successful artists out. Marianne Faithfull, an ex-druggie, was said not to want to stay at the Chelsea when performing in NYC because of its reputation for drugs, but stayed there anyway. The omnipresence of drugs that marked the old days seemed also gone.

Stanley Bard, manager, used to accept pieces of artwork as rent but I doubt if he still does though the amount of art in the lobby has increased exponentially as well as the rent.

Back in the 60s and 70s there were no Chelsea Hotel T-shirts, no web sites, no special rates for tourists or extra charges for

"Leonard's Room". The Chelsea was always a landmark, a special realm, but it did not exploit its uniqueness. You could go to the Quixote, have some paella and a bottle of Marques de Riscal wine even if you were on welfare. You might see movie or rock stars like Warhol's Viva, Lennon/Ono's Virginia Lust, Jane Fonda, or Patti Smith; famous artists you admired. If you weren't plagued by envy, you could talk to them. You might go to their rooms, smoke with them, and party with them. Maybe they would make connections for you, offer you their literary agent, a chance to see a famous producer with your script.

One of the most highly respected was gracious Leonard Cohen. People would whisper to each other when he was there, "Leonard is in the hotel". When he came to a gathering, like British magician Stanley Amos' exhibition, Clothing is Art, or attended a soiree in Harry Smith's room, it made the event even more special. When he would write a poem for one of the beauteous ladies of the court, she might go tearing across the lobby loudly proclaiming her immortality.

The Chelsea was like a big boho fraternity house. People used to say, "Where to go after the Chelsea? There's nowhere." or "There's no life outside the Hotel." It was like a movie set. Consciousness was heightened. Life was lived en artiste. Magic was afoot. But now an enchanted poetic world seemed prosaic and ordinary.

I wish the people who go there now could have a more meaningful Chelsea Hotel experience but perhaps it can't be courted or ordered up. "You can't go home again," said Thomas Wolfe who once occupied room 528.

THE NORWEGIAN PROBLEM

I'm invited to a dinner party on the sixth floor. My hosts are rich Texan art patrons and the guest of honour is a well known liberal Democrat Senator. We meet for drinks at 7.30.

The Senator and his wife are witty sophisticated impressive people – the Senator's mother is expected. At 8.10 she phones in to say that she's caught in traffic and that we should start without her. My hosts insist that they'll wait, that they wouldn't dream of starting without the Democratic matron who eventually shows up at 8.35. After apologies and assurances we take our places around a long mahogany table set for eight.

"I left home at 7," says the old lady, decked out in a black Dior suit. "My driver was a Norwegian."

At the mention of this Norwegian there are sympathetic clucks and expressions of dismay and solidarity from several diners.

"I had a Norwegian driver last week," says the Senator's wife. "I ended up twenty minutes late for my appointment."

There is a bemused debate about how nice Norwegians are but how fundamentally unreliable they can be. It takes me a while to work out that "Norwegian" is liberal politically correct code. They mean 'Nigger' only they don't want to use such an offensive term.

THE BUSINESS OF DIMITRIOS

Lydia Ambler — aka The Duchess — is a great lady, or so it seems to me. I find her friendly in bed, none too demanding, and she always smells sexy. I guess she must be about fifty two, based on what she says en passant and the old photographs on her wall.

"My first boyfriend when I moved in here," she tells me over toast and cheese the morning after our first night, "was the very sort of German you don't ever want to meet. Not a blue eye, a blonde hair, or a wild idea in sight. Don't ask me how Emil ended up in the Chelsea; some sort of hapless accident or maybe it was just that rooms here were cheap then and he liked cheap. He sure liked cheap. He was a geographer of all things, here in town on some sort of exchange programme. Some New Yorker was stranded over in Freiburg or some such hellhole so this asshole could be holed up in Manhattan. Emil liked pizza — that was just about the only human thing about him. He used to pronounce it like 'Pete sez.' So it'd be like, 'Hey, vhy don't vee order some pete sez?' When he crawled like a snake back to Germany I took over his room."

She was gradually brought into the drug business by Rudolf Dimitrios, bastard son of a phoney Von from Germany and a Turkish whore who reared him well and educated him well using funds provided by his absent father. Shortly after meeting The Duchess he sniffed out the lie of the land at the Chelsea and moved in, only it wasn't entirely to his taste. Either you like this type of thing or you don't.

According to The Duchess, Dimitrios doesn't have a bohemian bone in his body. "He is just a content, pudgy, little Turkish man who likes making money like some guy with a corner shop likes it or some asshole with a painting and decorating business likes it," she says. "He was just getting established here in America himself at that time so the Chelsea suited him fine as a launching pad. Later he rented this damn palace out in New Jersey where he lived in great style with a supposed wife.

"I first met Dimitrios in this cheap Polish cafe where I ate every evening in those days. I guess I was still on a sort of European circuit then. You know? When you move to a great city and you're still hanging out with people from whatever provincial shithole you originated in. For me it was Porto in Portugal which, in all honesty, is not a bad place. I hadn't a pot to piss in so I was staying with my older sister. She had a

room about the size of the toilet here on Avenue C and she worked as a PA for the CEO of some aerospace scam. This was the time of Richard Nixon. I'm not too sure of the year but Nixon was in trouble and the talk of the town. The Polish cafe, I forget the name, Marek's I think, was a great place for leftish Europeans and Jews, fairies and crims; un-nice unacceptable in polite society people. I was as crooked as they come, even then, having studied art in Porto for two years. I guess you have bent written all over your face if you're bent. And it takes one to know one. So Dimitrios saw me for what I was. By the time I'd moved in here with Emil I could navigate my way around town drug-wise and petty crime-wise. When Dimitrios heard I was living here he knew instinctively that I was where the action was."

By 1973, when the drug business was thriving, Dimitrios had his traditional gangster olive oil business going. (The Duchess gave me a bottle of "Dimitrios Extra Virgin Gourmet Organic Zeitung Speciale," now popularly known as "Zeitung Speciale" for my salads. Available in each and every high ticket fag deli in Chelsea.) No one questioned old Dimitrios stranded out there in the suburban backwoods of New Jersey, or The Duchess, principal buyer for Dimitrios Imports, who lived at the Chelsea but who commuted three days a week to her office, a small shack in the middle of a compound containing six larger shacks, somewhere in Hoboken.

Twice a year she goes on olive oil, almond, walnut, saffron, and drug purchasing trips to exotic climes where the living is easy because the money grows on trees.

The Duchess has been in the Chelsea for at least thirty years. Nobody — including The Duchess — is entirely certain about her date of arrival. "There are lost years, my dear," she chuckles junk-gently, "and there are found years." Her specialty is sizing up complete strangers with stunning accuracy. She can identify the most cunningly disguised narc by looking at him from across a crowded room. It is her business to examine each punter who wants to do business with the Dimitrios organization, to decide whether or not he or she should be supplied, and how much they should be charged. She is exceptionally valuable to Dimitrios.

Her priceless partner in crime is Bill Conduit who came to Manhattan all the way from New Orleans. Bill is known around the Chelsea — by his fans — as The Converse Kid, because of his penchant for all-black Converse All Stars trainers. Something he shares with The Ramones, me, and early Elvis.

"According to Bill," The Duchess says, "the Converse company has gone bankrupt. He says they went in for too many fancy designs the last few years. He is stockpiling Converse trainers because he says that, when they get taken over, the stitching will never be as good again. He reckons the bankruptcy is considerably more tragic than both the break-up of The Ramones and the death of Joey put together."

The Converse Kid is said to be a good fellow. I've not seen a whole lot of him myself. Since his induction into the Dimitrios organization in 76 he has looked after the small timers, the most steady and lucrative aspect of the business. "Bill Conduit's family," The Duchess says, "were a syndicate of small men who took a small idea and

made a big business out of it. The Conduit Corporation — believe it or not — makes the small pieces of those things the world thinks of when it hears an American use the phrase 'standard of living.' Like air conditioning."

She watches me with the care and calculation that a bad club comic gives to a drunk. She watches me keenly, like a sports trainer; with us but not of us.

"Within six years of us setting up the business, Dimitrios returned to Istanbul. I was twenty-five right then and he went home a few days after we had a party here at the Chelsea," the Duchess tells me while we're dining in her rooms. "He remains there to this day. Now he is an old man looked after by his two daughters; nice respectable married women in their thirties. Within a year of his going home, we had to increase our monthly supply of heroin to fifty kilos. And then Bill Conduit insisted in 1981 that we also had to get into the cocaine business. In the nineties Bill pointed us in the direction of Ecstasy. Bill was always up to speed on those latest musical trends! Me, I kind of lost the plot when Brian Jones got kicked out of the Stones, though I have vivid memories of when David Bowie showed up in town. Our white stuff came into New York Harbor via deck hands on Venezuelan freighters. Consignments of brown stuff arrived in from Istanbul, secure in sealed containers anchored at the bottom of the East River."

Her beautiful face is the only thing that betrays her age; a little skin bagging out over the architecture of her bones. She has never learned to accept praise about anything other than her good looks. She is a keen photographer in the Man Ray style; her life of crime originally organised to pay her way through a Manhattan art school.

She disappears into her bedroom for ten minutes, leaving me to listen to some classical shit, something depressing, while staring methodically at what seems to be a real Keith Haring. Harings are not uncommon in the homes of the drug or sex-connected. Herbert Huncke once had a manager, a big American woman, who used to work phone sex with Haring. She had an impressive Haring which he gave her for her birthday.

The Duchess eventually emerges with an old photograph of her younger self at an eighties dinner party with Debbie Harry, Ted Kennedy and other interesting characters. After we've shared her reminiscences surrounding that American moment in time, she resumes the much more gripping tale of the Dimitrios organization.

"Disaster struck us big time in 1982. We let an informer inside our organization — a little Moroccan shit called Abdelkrim — and the entire team got wiped out. Krim looked a little like a punque roquer, a little like a narc. Me and Bill got off the hook because nobody knew exactly what our roles were since we were never seen to put our hands on either the money or the shit. Poor Bill had to leave the country for a year, so he took the opportunity to go see Europe. Me, I sat it out here in my rooms. I had to be discreet about money; they watched me like hawks for the slightest sign of disposables. Luckily I had a few bits of art stacked against a rainy day that I could offload. I lost nothing terribly significant. A Warhol litho, a good Francis Bacon, and

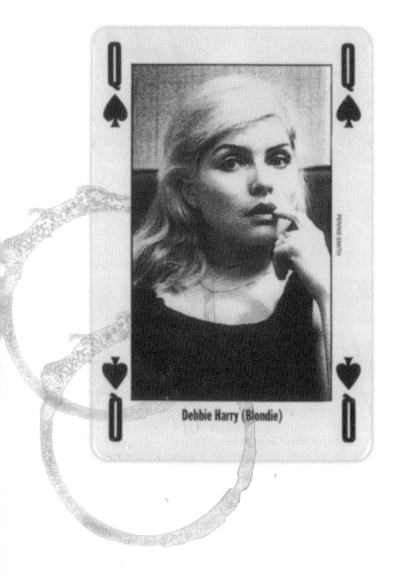

Debbie Harry (Blondie)

some pretty awful Annie Leibovitz prints this junkie gave me to cover his debts. Those Leibovitz ones, they just gave me the creeps, having them on my wall made me feel that I was being spied on. I mean, she is real creepy. Right? Annie Leibovitz? It was like having an informer in my home. Right? Our seven lieutenants — friends or real family — did serious time because of Krim. One girl was Bill Conduit's then-wife Sadie, who got off light doing two years. My sister's kid, Luis, did five. Sadie left Bill when she got out and my sister didn't talk to me again until our father was dying of cancer a year ago. Fuck that Krim! Dimitrios is still looking for the fucker from his Istanbul sickbed. Dimitrios, you see, introduced him into the organization. Dimitrios, who never made mistakes, knew Krim from way way back. I think they went to rich-kid Arab school together in Beirut in the fifties. Dimitrios thinks he has tracked Krim down to Morocco where he now styles himself some sort of religious nut. Seems he is treasurer to this mad mullah the authorities have under house arrest in a seaside resort — Morocco's answer to Coney Island. A town — according to Dimitrios who sent his daughter there with a camcorder to track down the shit — rancid with mad mullahs and secret police and cop helicopters and CIA. Dimitrios reckons Krim was always CIA, that this explains his treachery. Dimitrios is trying to engineer it so that the mad mullahs discover just what kind of individual he is. Then they'll stone him to death or bury him alive under ten thousand microwave ovens or whatever it is they do to old punque roquers. Inshallah, as they say! Hah!"

There is a silence right then for two whole minutes while she meditates on what went wrong a long time ago. I can hear Mick Jagger singing in the suite next door. It's not a record that I know...I don't know. Maybe he has some new solo stuff out. Or maybe he has done the theme song for some new flop movie. Or maybe he's making a cameo appearance on some Fugees-Related-Product. Or maybe he's right in there buck naked taking a shower while some supermodel watches, enjoying her finest hour.

I feel a little uneasy with The Duchess, just like I do when I have ceased to understand.

"Sure. We all got problems," she grunts, calmly dismissing Abdelkrim from her conversation, "and our problems obey the laws of perspective. They look big close up."

After the Abdelkrim disaster they had to stockpile heroin. "In two months we lost no less than ninety kilos of heroin, twenty of morphine, and five of cocaine. When the heat receded Dimitrios made what will probably be his last visit to New York. To all the world he's just some geriatric old olive oil importer these days. He was still handsome when I met him; now he looks like a big slab of fish. He bought three cheap houses on Long Island and by 95 we had, beneath the floorboards, a permanent backup supply of two hundred and fifty kilos of heroin, two hundred odd kilos of morphine, ninety kilos of cocaine and a small quantity of prepared Turkish opium. These three Long Island buildings are right alongside each other; a shopfront on the bottom floor

of each. One is a thrift store. I got my nephew to run a gay art gallery in the second when he got out of jail, though Luis is *not* gay. 'Gay' just makes it look harmless. They are harmless, no? Idiots but harmless. The black ones are not harmless, they're real men. The gallery allows Luis to keep an eye on the place for us. He spends two days a week there, and they actually sell the occasional piece. The third property is a music shop specializing in reggae and other black stuff. That one is a straight legit rental. There are three rooms over each shop. Important ground floor exits back and front. Doors not that easy to kick in. That sort of place. A bad neighbourhood so that nobody gives a shit whether we live or die. I remember Dimitrios once told me that it is the efficient who generally win; the gamblers who generally lose. Dimitrios now has a nice wealthy family but his secret is that he truly understands what it is to be poor. You know, my darling, that like you I was once a radical socialist…"

"Anarchist," I correct her, though I can't imagine why.

"OK, OK, you were an anarchist."

"Still *am* an anarchist." I think.

"Yes, yes, my dear, you still are an anarchist. Very romantic. Congratulations. We are the world. So, anyway, when I was a radical socialist I was such an optimist. Now, like Lou Reed says, I'm resigned to the resignation of the poor."

"Lou Reed said that?" I interject dubiously. I have every album Reed ever made though I'm not so intrigued by his collaborations with Sam from Sam and Dave or his 'Perfect Day' with Pavarotti and Dolly Parton.

"Yass. Lou said that."

I gather from her suddenly somewhat frumpy Dowager Empress tone that I've caught her out but if I keep catching her out all the time I'll lose a friend. That's the catch. Still, I've never known Lou Reed to write a bad line or to be resigned to anything. Since I'm here sitting in his city in the Chelsea Hotel I don't feel like letting it pass — but I do.

Next morning she wakes up with me alongside her in her bed. Her head gently lolls from side to side while she tries to convince herself that this is a morning in which I don't exist.

"Better," and she pauses as if in the throes of attempted recollection, "the red face than the black heart. Huh? An old Portuguese saying."

She'd interest any man who knows how to undo a button.

"Time stands still," she says smiling at me wryly, "but the mind moves fast and with remarkable efficiency. You were stupid and now you're smart. You were unhappy and now you're full of joy. What you don't like you forget. What you do like you keep on doing again and again. What you do like you experience as a joy unimaginable, a pleasure undreamed of. Three hours in paradise. And afterwards is not so bad either… Huh!"

The Duchess makes a disrespectful flopping noise with her tongue.

CONEY ISLAND BABY

It is 3am and I can't sleep so I decide to go look at Coney Island. I've seen it in so many movies but never in the real world.

It takes me a while to get there on the subway from Manhattan and it must be around 4am by the time I get off at the wrong subway station, the one prior to Coney Island. I have to walk through much industrial and urban wasteland to reach my destination. This part of town is naturally deserted; even NYC kind of sleeps at that hour. Warehousing, three storey office buildings, small factories.

I find myself on a long narrow boulevard called Neon Street. At the other end I can make out Coney Island's skyline.

Neon Street is teeming with life; lots of young Hassidic Jewish guys talking excitedly to one another and walking around fast in duos or larger clusters. A number of sidewalk cafes, seedy looking places, are open for business. The customers: Latino homies, wetback Elvises in leather and denim. Fantastic hip hop is blasting out of the dives.

I keep my eyes straight ahead and soon I'm walking along the deserted legendary boardwalk in the calm moonlight, illumination provided by the glow of the full city.

An hour later I retrace my steps back through Neon Street. Don't ask me why. The social whirl is just as lively and just as weird.

Next day, on the local TV news, I hear that a trainee Rabbi, aged twenty, was stabbed to death on Neon Street around 5am. They show the street in daytime, deserted but for the police investigators. The murder, the TV says, was a homosexual-related crime.

Paul Bowles
by Spencer Kansa

"It was in 1937 that Bowles met the Jewish lesbian writer Jane Auer at a party in Harlem. Jane recalled: "He wrote music and was mysterious and sinister. The first time I saw him I said, he's my enemy." Nevertheless, Paul and Jane and another couple travelled by bus to Mexico; Bowles went on to Guatemala. (Before the trip, Bowles had printed 15,000 stickers bearing the legend "Death to Trotsky" which he distributed throughout Mexico, where the exile was living.)

On February 21 1938, Paul and Jane were married in a Dutch Reform Church in New York, on the eve of Jane's twenty-first birthday. They honeymooned in Central America, travelling to Panama on a Japanese freighter with two steamer trunks, eighteen large valises and a gramophone – a parrot was acquired en route.

Their honeymoon continued in Costa Rica, where they stayed at a cattle ranch, before they set sail to France on a ship filled with German Nazi sympathisers. So began the years of travel for the Bowleses, sometimes together, often apart. That autumn found the couple back in New York at the Chelsea Hotel. They joined the Communist Party; later, when Paul tried to leave, the organisation informed him he could only be expelled."

Gary Pulsifer, **The Guardian** (1999)

In a quiet apartment block, behind the American consulate, deep in the peaceful shades of the suburbs, Paul Bowles finished his days in Tangier. My main reason for coming to the city, I rode the creaking elevator to the third floor to meet the lasting link between the Beats and Tangier.

After travelling to the Sahara where he wrote The Sheltering Sky he acquired a taste for Moroccan life and in 1948 he and Jane headed to Tangier where they decided to stay, spending the rest of their lives.

In a dimly lit room, warmed by the vapours of a gas heater, lay a bed-ridden Paul Bowles. Although ill with sciatica that made it too painful for him to write, he still cut a handsome figure of a man. Speaking in hushed, deliberate tones he exuded a soft natural elegance.

On my earlier visit to him that week we had briefly discussed his illness, the score he had just written for a Moroccan theatre company and how darkly funny William Burroughs' humour was, reminding Bowles of a Will Rodgers character with his drawling cowboy voice. Bowles related the time Burroughs and Brion Gysin returned from the funeral of Jay Hazelwood, who had owned the city's legendary Parade Bar. Slipping his gloves slowly off his hands Burroughs turned to Bowles and said: "Well Paul you missed a very enjoyable funeral." Surrounded by hundreds of books, tables laden down with boxes of medicine, the curtains drawn on a warm sunny day, the smell of bacon cooking in the kitchen mixed with the musky scent of incense…

Spencer Kansa: I don't know if you realise how much love people have for you in Tangier?

Paul Bowles: Nobody will murder me then.

SK: Ha ha. No I don't think there's any fear of that. We were

speaking the other day about Brion Gysin's Dreamachine, remember? When he kept complaining that you were not looking at it right.

PB: I was seeing paintings.

SK: You weren't seeing what he wanted you to see.

PB: I don't know what he wanted me to see really. He wanted everyone to hallucinate but you can't just turn that off and on at will, other people's hallucinations y'know.

SK: He really was ahead of his time wasn't he? His ideas were too different.

PB: Oh yeah, they weren't at all what anyone was expecting.

SK: I've been down to the Socco Chico. Its pretty unchanged isn't it?

PB: Mmm, it's been redone; the Cafe Central has been redone.

SK: What did you think of the cut ups that William and Gysin did?

PB: Well it was interesting. I didn't really take it very seriously. I don't believe that a word by itself has any meaning. It has to go with other words. It's interesting with the results they got but it's all, ahh, accidental. It's alright but it's hard to take it seriously. I didn't take it seriously as literature at all.

SK: I think a lot of people prefer William's more narrative work.

PB: Yes of course.

SK: Do you remember the first time you saw Burroughs in Tangier?

PB: Mmmm..It was in the Hotel Marsillia. I was sick with Paratyphoid in bed. I'd never seen him before. He came in and he had a book with him. He also had a paper contract and he said 'Would you look at this and what do you think of it?'

SK: That was for Junky?

PB: That's right, it wasn't a proper publisher's contract, it wasn't anything. I said 'Well I don't understand why you signed it' and he said 'Well I don't know'...blah blah blah [mimics Burroughs croaking drawl]

SK: So you gave him some advice about the contract?

PB: It was too late. I offered him advice on the next contract. He had signed the contract for a book which would go directly into paperback. It was connected, you turned it over and there was another novel on the back... upside down. In fact I found that book in Hong Kong of all places. Strange. And Bill said 'So you bought it in Hong Kong eh? How much did you pay for it?' I said, 'Well actually I paid the equivalent of ten cents.' And he said, 'that's too much.'

SK: It sold very well. I believe they printed a hundred thousand copies.

PB: Really? But he didn't get any royalties?

Talk turns to the subject of Malcolm X whose autobiography Bowles has been reading. I tell him a movie has just been made about him.

PB: So everyone was black in it? I've never seen a film where all the actors were black.

SK: You saw the Naked Lunch film didn't you?

PB: Yes. I didn't understand it.

SK: You didn't recognize yourself in it?

PB: Certainly not. There was nobody there that had anything to do with me.

SK: They were supposed to.

PB: Why? I mean how do you know? Who said so?

SK: Cronenberg, the director.

PB: I didn't see it, it wasn't in the film.

SK: He was very good wasn't he? The actor who played Bill.

PB: Very good, very good... Y'know I was reading a book the other day in which Oscar Levant said to George Gershwin: 'George if you had it all to do again, come back and live your life over, would you fall in love with yourself again?' Ha ha ha.

JOBS OPPORTUNITIES AND LEISURE

We've got jobs, opportunities and leisure.
You can come here whatever the weather.
I dreamed that I was drinking instant
coffee. I dreamed that I was eating instant
mashed potatoes. Two nightmares, one sweaty
night. There was cream in the coffee and cream
on the praties. I dreamed of myself in a vista
similar to a KD Lang album cover, a small slice of
Hell as far as I'm concerned.

LONGTREE GNOUA

My third morning in Manhattan I take the subway to Lennox Avenue, Harlem, to indulge my undoubted taste for negritude. I meet Mr Longtree Gnoua for the first time.

His friendship has changed my life forever. This I already know; this blade-thin man with his lean smile and phoney hungry gestures. At the start he tells me what he thinks are white lies but gradually the lies crumble, not always to his benefit.

I see two wobbling deal tables laden down by large wooden boxes full of vinyl albums of mostly black music. An old school crackhead in his early forties and his younger faithful companion stand behind those tables, maybe amazed that anybody'd want to buy this shit, their feet in worn out shoes stomping the frosty concrete like brothers from an x-rated back in the day Richard Pryor video or a Telly Savalas *Kojak* episode, steam emerging from their resigned old nostrils.

A big black guy in his fifties, stubbornly wearing seventies faux-Afrikan/hippy gear à la *Shaft* or the Panthers, is industriously working his way through the boxes on one table. He is the crackheads' only other customer. He seems diffident; mumbling aggressively to himself, knowing all there is to know about once-famous bass players or horn players, forgotten heroes of a forgotten war. He hums and haws and bullshits all the time that I am there choosing.

Each box that I approach makes him more irritated with me. He tries to elbow me aside a few times but, despite the hostility, I note that the two of us are interested in the same music: late sixties soul through to Phillysound slick shit from the disco era, with occasional driftage beyond those parameters in every direction. In another funky universe we could be pals discussing whether the first Graham Central Station

album was the finest slice of funk ever issued, or suchlike musical/political, usually male, concerns. But, in frosty Harlem reality, I'm grabbing *Aretha Live at the Fillmore* and *The Chambers Brothers Live at Newport* for $1 a piece (the older crackhead encouraging me, "You gets two free when you buys ten, son").

My competitor is counting his dimes and trying to choose between an Ornette Coleman I'm not familiar with and *The No Tell Motel* by Don Covay. One never knows, do one? Not a choice a man should have to make but, in the circumstances, I can't exactly offer him the loan of $10.

Soon he is mumbling into his kaftan, "Goddamn! Goddamn! Motherfucker!" and "Why don't you just go fuck yourself?" I think I'm not supposed to quite catch these broadsides. I'm too excited to be finding Swamp Dogg, Malcolm X, and even John Lee Hooker, from before when the Scientologists got their hands on him, to give a shit.

This is just like the day they shut down Woolworths in Ireland for good. In the basement of Dublin's Henry Street branch somebody found crates of ancient jewels which they flogged for ten pence each. That day I got the Box Tops, Nico, Joe Tex, Don Covay and Arthur Lee. I was happier in Woolworths in Dublin with my Joe Tex trophies than Barbara Hutton was in Tangier with her oozing millions. Like that long-ago Dublin day it's chilly in Harlem but dry on the north side of the city. Unlike Dublin there is loads of urban perspective because Lennox begins further north at the river's edge and keeps on going south towards Central Park.

Eventually my denigrator summons up the courage to attack in earnest. He takes off the gloves and he goes for the jugular. He is going to finish off the job begun by Bobby Seale. "Goddamn motherfucker! You have all the opportunities in the world and you come up here..." He doesn't finish his sentence but he doesn't need to. I could finish it for him. And I don't have a jugular. I'm a psychopath.

Now I'm squabbling about Roberta Flack albums with an old nigger in Harlem. This is the place that life and Air India has brought me to. That part of me which is no better than a mischievous bully is very happy.

I kind of laugh at him. This is partially a nervous laugh — in another sense I wish the ground would open up and swallow me — and partially a reflection on the fact that my life has not been so easy either. Fair enough, I've made my life difficult for myself with my wrongheaded contrariness whereas his was tough because of injustices beyond his control. He is giving me the kind of shit I expected to get from lippy Harlem street kids, whereas, in fact, they're more or less friendly, somewhat intrigued by my Paul Smith shoes.

I guess they are. I think so.

Oh gee, oh shucks. Why don't you blow me while I take a shit?

Then another customer comes along, young handsome early twenties black guy. Enter stage left one Mr Longtree Gnoua who cordially introduces himself to me. He is looking for a Miles album he saw here earlier in the day, only his girlfriend

was with him then and she rushed him away. Now she is gone to Florida for the week to visit her folks so he — Miles Davis-seeking — puts out his hand, tells me his name, and I tell him mine. He mentions the title of the Miles album. I've never heard of it but, nodding sagely, pretend that I have. Minutes pass. While we're going through the different boxes of albums he starts looking at me nastily. He moves away, not speaking now, not having found the Miles album. He leaves after paying the crackheads for three albums, one of which is by Peter Tosh. I missed that one. As he goes he fixes me with a surly aggressive stare.

Five minutes later he comes back, abashed, churlish, but talkative again. These Harlem niggers sure are contrary, substantial, individuals. I ask him if he'd seen the English TV biography of Miles. No he hasn't so I tell him that it was good even though I don't favour jazz.

In the documentary one player, not some famous guy but someone I think did session work for Miles, recalled getting an invitation over to Miles' uptown brownstone where he found the maestro subdued, alone, and preparing a first rate meal for the two of them. He was surprised by Miles' placidity and cooking skills. Longtree interjects to say that he reckons that, "cooking keeps a man balanced and quiet. Cooking is man's business." I agree with him up to a point, certainly the bit about cooking keeping us mellow, and recall that Hamri the Painter of Morocco, like Miles perceived by the world as being a bug eyed iconoclastic firebrand, was always at his most Zen-like when stoned in his kitchen, preparing food for his guests, be they human or feline. But whereas Longtree thinks cooking is men's business, Hamri regarded painting as being men's work. Women, Hamri reckoned, didn't have the cojones for painting.

Generalisations about the sexes make me twitchy.

This Longtree likes my talk and I like a guy who enjoys hearing about Hamri so I keep on yapping. He's a little shorter than me, which is short, but he fills an impressive amount of street space nonetheless. I tell him what the popular novelist Douglas Kennedy once told me a good one about Miles. It seems that Douglas's Dad was a Manhattan banker or broker so the Kennedy family lived in a rich folks' brownstone on the selfsame street where Miles did his living and cooking. According to Douglas there were all sorts of misgivings when Miles bought his place, when word spread as to just what sort of an individual this too damn nasty trumpeter was. Black, jazz, drugs, a sensualist, loose women and tight men... Miles proved himself to be one bad neighbour. The day after he moved in, living up to his reputation, he phoned the decorators and had the exterior of his home painted shocking pink.

Gnoua seems pretty much straight collegiate: good blue jeans, an old Harris Tweed jacket, and Russell Athletic sweatshirt. I look, as usual, a bit like the drummer from Slayer, right down to my ancient bootleg Sepultura t-shirt. Sometimes I have an irritable forbidding air about me. Longtree tells me that his real name is Dan

Watts though he is, "known to the world, and those who love me, as Longtree Gnoua." Which is fair enough and an hour later we're taking turns playing $1 scratched black music albums in the apartment he shares with a girl called Molly, now safely arrived (she says on the phone) in Florida where her folks, the proud owners of her, five brothers, two sisters, and eight kosher restaurants in New York and Philadelphia, live in semi-retirement.

Molly calls him on her cellular when Aretha is taking her turn on the decks after *Bumps and Bruises* by Joe Tex where Joe is doing *Ain't Gonna Bump No More No Big Fat Woman* and *Willie Was Dancing With a Sissy.*

He looks very much like a Huxtable. Very pretty. If he were a Huxtable he'd be Lisa Bonet.

"Mom and dad both work in the State Department. Mom's a doctor and dad's a lawyer. They're stationed in Caracas these days."

"So what exactly is it that these good people of yours do for the State Department?" I ask with maximum sarcasm, for I'm always on the lookout for them CIA guys.

"Oh, OK, Irish. You're not entirely out of line there. Dad handles some tricky situations for sure… sticky tricky situations are his line of business. Now… what mom does," he says throwing his jacket onto a tasty black futon, "is something of a mystery. Nothing much to do with medicine, that's for sure. I asked her once exactly what is was that she did and she just said that she collected gossip and crime statistics for the American Government abroad."

"I see." I say. I sure do.

Now he takes off his sweatshirt; under his jet-black skin muscles ripple in modest profusion, serving no purpose other than to keep him moving while adding to the poignancy of the situation.

By way of explaining the occasionally poor sound quality on my spoken word Malcolm X album, recorded in 1963 using Sony and Tandenberg gear, the diligent sleevenote writer wrote: "At times you may hear a squeak from the Sony unit but a pearl dragged from the deep by unorthodox methods is still nonetheless a pearl — a gem worthy to be cherished."

"I have never had this experience before," Longtree says like I'm suggesting a good restaurant that I've read about in the colour supplement, "but I would love to try!" He is so dead calm about it that I wonder if we've gotten our wires crossed.

I apply a drop of Clarins moisturizer. Next year, the bitch in Duty Free told me, they're introducing a "wicked" Clarins line for men. I told her I could hardly wait because some of the stuff they have at the moment — such as Beauty Flash Balm — is scented way too much for us hairy guys.

I tell Longtree a white lie, that in *The Arabian Nights* it says that a black pearl dragged from the deep by unorthodox means is nonetheless a pearl — worthy of lust and laughter. And he says, anxiously enough, "Huh!" though he is the most

emotionally eloquent man I've ever met.

"Hey, Irish, I'd just love to fuck Cate Blanchett," is the last of many things he says before nodding off by the dawn's early light; hardly Schopenhauer but then who am I to talk? *Essays and Aphorisms* my ass!

Forgotten Momentous Events
by Gary Panter

In 1974 I visited New York for the third time. Friends from college, John Harrison and Mike Schwab, were living in the Chelsea Hotel and attending SVA.

I was finishing school, trying to decide what to do with myself and was considering moving to New York or LA. Mike and John graciously allowed me to crash with them for a few days.

Mike said that they were in Janis Joplin's old room.

One night a guy yelled "Vivian," at an eighteen-storey building across the street from the hotel until the sun came up.

One day I saw a little shopkeeper armed with a two-by-four beat a naked dirt-man who was hanging out by the front door of the shop.

Moondog was on the street in those days.

Barbara Nessim and Ruth Martin were very nice to me and allowed me to hang around and waste their time.

The thing I forgot was that Mike and I went to look at a $300 apartment in the Village. It looked like a nice building. The address was a basement apartment. Mike rang the buzzer.

Two girls tattooed from head to toe answered the door. They led us into a very nice room with old ornate furniture.

"Gosh" Mike said, "This is really nice and it's only $300?"

One of the blue girls said, "No, it's not this room. It's the room in back."

We followed them back to a room that was dark. In the centre of the room was a cage. The walls and ceiling and floors were covered in shit. In the cage was a sad man-sized ape. I moved to L.A.

WE'RE JUST HERE TO GO

I'm invited to the launch of *Here To Go* by Terry Wilson and Brion Gysin. William Burroughs once said that the artist Brion Gysin was the only man he ever respected. Gysin was the inventor of the Cut Up method of writing which influenced Burroughs novels like *Nova Express* and *The Soft Machine*. He invented the Dreamachine, a kinetic work of art occasionally associated in the public imagination with the suicide of Kurt Cobain. *Here To Go* gets its title from Gysin's credo: "What are we here for? We're not here to stay. We're here to go."

Close to Anita Pallenberg, Peggy Guggenheim, Dali, and Aaron Copeland, Gysin introduced errant Rolling Stone Brian Jones to Hamri, the only Moroccan intellectual to participate in the infamous Tangier Beat Generation Scene. Hamri brought Brian Jones to Joujouka where the two of them made the totemistic *Brian Jones Presents the Pipes of Pan at Joujouka* album.

I told Frank Rynne on the phone – he flies in tomorrow – that I'm going to the launch so he told me to buy a copy of the new edition of *Here To Go* and to get Terry to sign it for him. Frank spent months helping Terry sort out his archive and his life.

Terry seems to be in a tizzy like he often is at public events so he haughtily refuses to sign the book. He angrily makes some eminently memorable and quotable remark about Frank, only I can't remember it so I can't quote it.

John Giorno: "My whole performance thing started in 1964 when William Burroughs and Brion Gysin came back to New York and introduced me to sound poetry with people like Kurt Schwitters. It had a re-birth in 1959 with Gysin treating sound as a way of making a poem. The poem was written but the sound of it, which could be very abstract, was the attraction. Brion was given the BBC Studios in London to do his mutated poem *I Am That*. When he and William came to New York in 1965 they introduced me to that notion. I did my first piece as a collaboration with Brion called *Subway Poem*. I recorded sound on the subway. It was sent to Paris and presented at the Museum of Modern Art in Paris in the Biennale of 1965, my first sound poem, I was thrilled. When you get given a little bit of acknowledgement it inspires you to go on. I went on doing it thereafter.

"William came back to New York at the end of November 1964. It was the first visit to America by both William and Brion Gysin in about ten years. It was calculated as coming to New York to conquer it so to speak. I met them at these various parties in January and February of 1965 like at Panna Grady's at the Dakota. Diane DiPrima had a theatre on East 4th Street where they did a reading. I got to know them.

"In an interesting way they were my very first spiritual teachers. Before I met them I was just this dumb American. At that time in Spring of 1965 I took my first thirty-four LSD trips with Brion Gysin at the Hotel Chelsea in Room 703. I was in my mid-twenties but it didn't matter, I was like a fourteen year old. I had come out of the 1950s. My mind was blown in the context of those LSD trips, which we took one or two times every week. The Chelsea was the only safe place for us to do that. I was living on 9th Street and Brion lived in the Chelsea in this nice big room. At those times (on LSD) you don't want to be outside. We were lovers so we fucked all the time as well. Brion was not a Buddhist or Hindu but he was doing his own sort of meditation that he never told me about, some kind of magic. On those acid trips I would also sit. The mind being a wild elephant, we'd both sit on the bed in meditation, resting our minds. They were my first experiences with real meditation in terms of trying to deal with my mind. I went to Morocco with Brion in 1965.

"I was also good friends with William. He had introduced to me, on a daily basis, to what he and Brion were working on. A thing called *The Third Mind*. Their daily work together was dealing with the nature of emptiness, the nature of phenomena arising and the nature of obstacles and suffering in this world. It was my first spiritual training — taking drugs and being with them everyday. Before the beginning of 1965 I was in the art world — Pop Art, Warhol, the dancers. Their spirituality was in their heart and only expressed through their work.

"Burroughs and Gysin left August 1 of that year after spending nine months here."

Rockets Redglare
In Love, Morphine, and Memory
by Gene Gregorits

I hung out with Rockets a half dozen or so times. He had one place in
a basement (his shrill holler would come up from under my feet on 6th
Street, "Gene, I'm down HERE!")

I saw him a few times on Sheridan Square. His dog bit the hell
out of my hand, and I offered him the vodka and he slugged the half
pint down inside of five minutes. Rockets was kind, brilliant, and
brilliantly funny. I understand he ripped a lot of people off. I'm
aware that a lot of people scoff at good memories of Rockets. Yet, a
lot more people have them. I do.

We didn't know each other that well. But it always made my day
(hell, it made my month) to see Rockets. Well, I should say, to hear
him. Rockets was in bad, bad shape the last five years of his life. As
with Johnny Thunders, the only shock about Rockets' death was that
it hadn't occurred a long time ago. And for someone so physically and
chemically stigmatized, the guy had enough life in him for a whole

fucking block party.

Rockets was a great liar. He spread rumours of his own death for a cheap kick. I thought he was pretty fucking cool. A true tough guy with brains. A dying breed. He bought me drinks. I bought him drinks.

We were supposed to go to Tower Records on Lafayette and buy ourselves each a complete set of the works of Bill Hicks. Rockets loved Bill fucking Hicks. That day never happened. A briefcase containing an address book containing Rockets' many phone numbers (you never knew where he'd be) was mysteriously stolen from an empty Bleecker Street bar. It's safe to say that the last time I spoke to him was some two weeks before that night, during god knows what month of 1999.

Soon after, I left New York. I caught a one-way, a flight to California. I gave most of my stuff away, and that was that. Rockets was in Jamaica at the time, and if he wasn't, I told myself he was because I was afraid to see anyone, even Rockets. It made it easier. New York had finally gotten to me.

A year later, an NYC zine publisher named Bob Bert told me Rockets was gone. During the course of that year, I'd often think, or say, "I've really gotta find someone who can give me Rockets' number." I knew, and would also often say, that Rockets might not live out the year. I think one of the reasons I didn't try too hard to reach him was fear of finding out he'd already died. He was in bad shape. I worried about him often. That trek to Tower would have been an entire afternoon, even if we were just a few blocks away. He could barely walk. To cross a street with him was a test of will, and friendship.

There were scars covering his arms. I never asked how he got them. It was an email that told me Rockets died. I immediately wished someone had called me instead, but it was just an email read over scrambled eggs, like nothing, "Oh, look. Rockets died." But I didn't take it that way, at all. It was the way they say it happens, like someone just kicked you in the balls. My jaw dropped, the blood left my face. I was sad as hell.

Later that morning, I returned to sleep. In my dream I was walking down 6th Street, searching for the source of this bizarre, shrill holler that kept screaming at me like the invisible man. With some degree of alarm, I noted that the sound was coming from beneath the concrete, through a thick horizontal shelf of sidewalk. Through a storm drain, I saw a familiar face. He was smiling, he was alive.

"GENE! I'M DOWN HERE!"

INTERVIEW: 1999. Ave. A and 7th street NYC

[ROCKETS:] you gonna eat anything?

[TAPE CUTS]

And...lemme tell ya...for a fact...I know that Sid did not kill Nancy. That I can completely ascertain. Not just, like, from what I know...but I'm positive. I know basically what happened. And I'll be honest with you, I can't go into too many details because I'm including it in my autobiography, and it's an area where nobody has gone yet. But basically, she was killed by a drug dealer who worked at Max's Kansas City. And the reason that Sid was...the big problem for Sid was, it took him so long to report the crime...when they...when he did report it, he had the blood all over him and everything. And people had seen him walking around with the blood all over him as if he was in, like, a daze. Well, he was in a stupor, because I was there the night that Nancy died.

[GENE:] Right before Steve X walked in...

Yeah, that's the guy. That's the guy who... (hesitant)...yeah. Basically, what happened was...that...now see, you gotta realize, what happened was, I saw Steve when I left there. I saw Steve coming up. I was there just before Steve. Then Steve came down the stairs. When I saw Steve again...the next time I saw Steve, was not that night. But I saw Steve coming down the stairs giving titbits to all these reporters about how Sid abused Nancy and the story of him beating her up with his guitar, and hanging her out the window, by her legs and all that. So that made me a little suspicious and then I realized what was going on, that he had said to me that he had all these Tuinals. He wanted to sell them to them, and he sold them a bunch. And what happened was Sid and Nancy took a bunch of them. Sid, being the type of drug hound he was, he was completely out of it. He was unconscious, fucked up. And the reason that he didn't report the murder in the morning right away was that Nancy was dead, he knew that he was gonna at least be detained, and he was on the methadone program. So he wanted to get his methadone. Plus, he was still in the half-life of barbiturates. Like the next day, you're not thinking totally clear, so that's why...that spacey look, and him stumbling, and having the blood all over him...it wasn't like some kind of blood simple stupor he was in, you know how they talk about how after someone commits murder sometimes, especially a gruesome murder, they get into this head where everything is surreal and they don't know

where they are, and you know, that whole shock thing.

Was Steve X ever called in for questioning after that?

No.

Was that because the cops didn't take him seriously, or...

No. They didn't think he was anything. He just provided background. It was more like...he provided the kind of stuff they wanted to hear. Sid was a perfect fucking scapegoat. If Nancy hadn't happened, something else would have happened. Yeah, you've gotta realize...this guy was influencing youth, and everything he was about was so negative — Heroin addiction, stupid violence — and while John Lydon sang about it, Sid was pretty much the embodiment of that kind of thing. Now, you can look at it and say how stupid it was, but at the time it was easy to get caught up in that. It was the equivalent of...well, it was like anti-glamour. And even though most of the roots are in that whole glam rock thing, it really wasn't. Anyone could be a star. All of a sudden, regular people were giving themselves rock star names. It was street culture, criminal culture and street culture taken to...you know, I guess the closest thing we have now is hip hop, and the violent aspect of that. The whole violent aspect, the whole street thing you know, guys who are making two million dollars on an album going around cutting each other with box cutters, shooting each other with guns in alleys.

And cops had something against anything having to do with punk...

Oh, absolutely! I think it was even deeper than just the cops. I do, I do believe that...you know, listen...the government does not let somebody who has that kind of a forum just spew endless shit. C'mon, look at what happened with Jean Seberg. She got involved with the Black Panthers, and all that, and basically the FBI hounded her to death. Jeanne Seberg played Joan of Arc, she was a very good actress. She was a French film star. She also was in *Breathless*. A waif-like blonde French woman who actually was Swedish or something. The point is, she got involved with the Black Panthers, and that whole thing in the sixties...

The New York Panthers or California Panthers?

The California Panthers. So the government started following her and she's just one. There was the Hollywood Ten and that whole blackballing thing. You don't even have to be a celebrity. It's just having access to the printed word. And how many people now...I'm sure they're having a ball with this Internet stuff. I'm sure they have

whole buildings full of people that do nothing but hit websites to see what's going on with websites.

Do you think that the establishment really took punk and the Pistols that seriously?

Yeah. I think to an extent they realized that it was...let me put it this way. I think they realized the potential was there. All they really needed was...I mean, take a Malcolm McLaren, who was interested more in power than in money. Someone who was that Machiavellian...if someone like that had stepped in and used Sid and people of that ilk...and even worse, some of the other ones that come down the pike later...we could've seen a whole different mindset among youth. It was definitely diffused with that Sid thing. Look at just the personal switch. How the hell was he...you know, there he was, his first love, his first girlfriend, he's a rock star, he's a junkie, he's the most libertine character that's been around for quite a while, that has had that much attention...and then all of a sudden, he goes to the complete fuckin' other end of the spectrum. He's fuckin' in jail, with a murder charge probably he's not gonna have his freedom, he's gonna have nothing. He's locked in an American prison, which for a guy like him, who was known as Sid Vicious, who was like 6'4, 6'3, weak, he's skinny and can't fight worth shit, but who has a big mouth. He'd have been killed within the first six months. He never woulda went to trial. He woulda got killed in Rikers. It was tough.

In the period that he did spend in Rikers. did he ever get raped or beaten up?

No. He got beat up a couple times. He wasn't the kind of person who jail guys would have seen...who even, you know, bull faggots in jail wouldn't have seen as attractive. He was too funky. You know, I mean he was dirty, he smelled bad. I loved him, I thought he was a great guy. Because he was an innocent, in his own sad way, he was an innocent.

Aside from the drug connection, did you have a pretty strong friendship with them?

Well, I couldn't stand Nancy. The only other thing I'll tell you is that there is a connection with the Satanic Church, and there is...uh... (long pause). I know, whenever I mention this (laughs), or come up with this, it's like (feigns shocked reaction) oh god, "fringe lunatic!", but...Maury Terry wrote a whole book about it, *The Ultimate Evil*, and there are reasons...well, there are definitely reasons that I have to believe that it was videotaped....that Nancy's murder was videotaped. (pause) But it's the same kind of thing...they videotaped the Son Of Sam murders, and there is enough evidence there that Maury Terry is not the only one to believe that, and

a lot of other people do believe that. Snuff films are not that exciting for the really jaded characters when they consider that it's some whacked out welfare mother who's gonna take five grand for her kids, and probably has AIDS anyhow and is gonna die in a year.

So the celebrity status of Nancy would have made the snuff film that much more popular.

Yeah, especially her status at the time. And the whole thing of having Sid sitting there on the couch, completely out of it...which was the tableau that I left them in... you know, Nancy screaming and bitching...and freaking out and being obstinate like she always was...and Sid just completely zonked, practically in a coma.

Was that the usual pattern for them in their relationship?

Usually they would either...they were either crying, screaming, or nodding, pretty much. Fighting or arguing or busting on other people. Nancy constantly was egging Sid on to like, "Hit that wank off, Sid!" or things of that nature. "Oh, that skank is looking at you! Go over and smack her." Stuff like that.

Of course, she knew Sid wasn't any good at fighting.

Yeah, well... she's more interested in the drama.

So in twenty years, what do you think has kept that videotape from being discovered?

It was never easy to see, you know. You probably had to put up quite a bit of bread to see it, to have a screening. Listen, the place where Lucky Chang's is, the basement over there? Thirty years ago, they had live, just like how they did it in 'Nam, they called it "telephone". Matter of fact, telephone shows came over from 'Nam.

[A derelict stumbles to the cafe gate and leans over towards Rockets]

What do you want, a cigarette? Yes, they came over from 'Nam.

What were telephone shows?

Like...you know, a girl would sit on a chair and be abused by a guy...suck his cock, get smacked around, and then...sometimes they would say "telephone for you!"...then take a gun out, put it to the girl's ear and pull the trigger. Shit like that.

34

There's some of them, where the girls were... usually one of the things that makes a snuff film... they don't want complacency. One of the things that makes a snuff film enjoyable is the idea th-...well, 'enjoyable' (RR gestures the use of quotation marks with his fingers)...is that the idea that they don't know it's comin', that they're making a hard S/M flick, tape, or show, and when they realize that it's not just gonna be like a couple of whip lashes, and maybe a couple of razor cuts and cigarette burns, and that once they're tied up it might go all the way; most of them are in denial right up until the last second. I know one person who's very wealthy, and a real sick individual, almost like a connoisseur of very decadent sexual books and paraphernalia. He dived into the Vatican library, you know. (laughs) And I know this all sounds like all that trite shit you hear, but...it's true.

There was a German film that was made by these artists who had obviously [as pointed out by a friend who had seen it, made a recreation] of the Sid and Nancy tape. And......they used kids.

So it was almost like a joke. It was supposed to be kiddie porn, but a kiddie snuff film. And it had a little kid about five years old, on the couch, sitting playing with a knife and all this. Him and his girlfriend, another four year old, made up to look like Nancy...they get into an argument and the kid stabs Nancy. Now that was the one that was the most popular, but they also made a version where there's the Sid character, kid, laying on the couch nodding, and the door opens and this other guy comes in with another little kid, with a video camera, videotaping the third boy... stabbing Nancy. This was done by a German artist who had seen the tape and tried to recreate it as a... almost like a goof, like an inside-inside-inside joke.

Did Sid Vicious know that he was being taped?

No, he was out of it. That's why I say, Sid couldn't have killed Nancy. There's no way someone who was as stoned as Sid was, when they estimated Nancy's time of death...and I have to be honest with you; after all these years I really don't remember how late it was, because in those days, your clock was like, on 24-hour time. I was using a lot of drugs and everyone was. I mean, everyone would open their door at 3, 4, and 5 in the morning if you brought drugs over...or if they had been waiting for their drugs anyhow.

Well, either Sid or Nancy had contacted you earlier that evening about Dilaudid.

Yeah, I was supposed to get them more Dilaudid...

And Tuinal...

Yeah, they wanted more Tuinal and they wanted dope. They actually wanted

dope. But I said to them, "I don't want to get you the dope because the dope out there is shit. I'll get you Dilaudid," which is pharmaceutical and just as good, especially for their purposes. So… they had had that before. I had gotten them some before and they were happy to get that. But the point was that Nancy had showed me like $1,400 and she said "get Dilaudid. I got the money." Because once or twice before, Nancy had said to me, "get me this or that", and I showed up with whatever I had gotten for them. Then she said, "Oh, I don't have the money. It's not here right now. Can you wait about an hour?" So the first time I said yeah, because they had always come through with the money before. This one particular time, that was the last time I let them get away with that. That time, of course, they said, "The money will be here in about in hour." I said, okay, so for an hour they shot up drugs and the money never showed, of course.

But the Tuinal they did was what Steve brought over before you talked to them.

Yeah. The Dilaudid was what I was gonna get them. My point being that Nancy showed me all this money and the next day, Sid had like nine dollars and change on him. And that was all the money that was in the apartment. They didn't give me the money upfront, because the thing was I was gonna get it and bring it back to them.

[Rockets peers over at my notes]

(smiling) Oh, I see Neon Leon. When I came back to the hotel the following morning, I left. I couldn't get it at that time. And I saw that something was up.

But you didn't actually go into the room.

You couldn't get into the room!

The last time you were there was 4:30 am.

Yeah, I had been there early, and I must have came back like 11ish because Sid had already been taken away, or was being interrogated in the room.

Do you know what Sid did when he woke up?

Yeah, he went to the methadone program. We talked about it afterwards, when he got out. Now the first time Sid got out, he started hanging out and trying to behave, not get in trouble. But he was hanging out in clubs and stuff, and basically doing dope here and there, but not really being outrageous, because he knew he could

get put back in like that, you know. You're on bail, you know, you gotta be careful. Which is why...what happened was...that's when he really said to me, he said, "You really gotta stay with me, make sure...because you know the city a lot better than me." Because he really was lost in New York. He said "You know the city a lot better, you know what is gonna bring trouble on and what won't, better than I do." So I said..."All right."

But then he got into that whole Hurrah's thing.

Yeah, that's what I was gonna...so what happened was one night, Sid wanted to see...well, actually, we didn't really have any plans. We were hanging out at Max's, and this guy Peter Kodiak...he's a photographer. He did The Only Ones back cover, for *Another Girl, Another Planet*.

He shot the sleeve cover of So Alone, too right?

Yeah.

He's back to his real name now, Peter...something else...

I think he's doing fashion work now. All right, so he showed up with a limo, invitations to Hurrah's and a stack of drink tickets, and this guy Dave; he was his assistant. Now he didn't come in the limo with us, he was already there, stationed already.

So you guys went in a limo?

Yeah, and I think this was a set up. So we get there and Sid gets a handful of drink tickets...I mean, a ridiculous handful of drink tickets: fifty drinks. So we're drinkin', we're drinkin', and SkaFish was on, and Patti Smith's brother and his girlfriend were in front of us...and Sid was dancing around, playin', playing around, and (long pause)...he fucked up. I think he did something to Patti Smith's brother's girlfriend, something...and they got into words. Sid hit him with a beer mug. Todd Smith fucked him up pretty good. I was surprised that...because usually Sid....well, I guess Patti Smith's brother was a bigger punk than Sid was. (laughs)

He actually broke the mug on his face...

Yeah. It broke on impact, which is pretty...that's what I'm surprised at. Usually, you do more damage with those things and they don't break. I'm surprised it broke. Smith was very bloody.

Anyhow, all the bouncers came running over and it's funny because (name

deleted) was one of the bouncers there. He's a producer now, and he's a friend of mine...but he was one of the bouncers, and there was a bunch of other bouncers and they all came rushing over. Now Arthur Weinstein of course is a real good friend of mine — he owned Hurrah's at the time — but all these bouncers came rushing over, and I was dragging my girlfriend Joann and basically carried Sid out, all 6'4" of him; got us outta there. I managed to get us out, but I had a couple of scuffles with two of the bouncers. I was a whomper when I was a young guy.

Well, didn't you used to be a bouncer?

Yeah. I used to run the UK club which was an after hours club. I used to throw Hell's Angels and mafia guys out of the after hours club.

And there was a bar called The Red Bar...

Yeah, I used to work the door. Like, I decided who came in, who didn't. But also...that place, there was never a fight at that bar, ever, except for the ones I had outside, you know. But...anyway, so...I got Sid out and I took him to The Nursery, an after hours club, and his hand was cut open, so I...this is a real Rambo story...I took him into the ladies room, and I got a needle and thread from this girl, and just kind of closed it up enough so that it wasn't dripping and shit...wrapped it up.

How the hell did you manage to do that!?! You were really drunk at that point!

Oh yeah. Yeah, well...(laughs). Plus, it was like, that whole Sid Vicious thing. What, he's gonna say, "No, don't do that"? Of course he was gonna let me do it. (long, hard laugh) He just saw it as more of his myth being invented. Anyway, strangely enough, it was like four days later before he got arrested.

I guess Todd Smith went right to the cops after the incident.

I really don't know. I'm sure the cops were called, so maybe...he passed away, didn't he? I think he did, yeah.

What about Neon Leon?

I don't know. Supposedly he had Sid's jacket. He was staying at the Chelsea at the same time. Now, at that time I had moved out of the Chelsea. I used to live there on and off for years. Matter of fact, right up until about four years ago, the Chelsea was my second option.

What about the story of Sid going to Neon Leon and telling him that he was depressed and that everything was over, stuff about dying...

Well, that's Leon's story but I can't see Sid feeling that way. When he came out of Riker's, he definitely was not ready to give up, and Sid was not the type to give his shit away. Sid was more the type to get something from somebody. I don't want to knock the guy, but I think that was more fantasy on Leon's part. Somehow, he did wind up with Sid's jacket, but who knows? Sid could have left it there, you know. There was a lot of shit going on at the time, it was like...people were saying things like I didn't even know Sid. I mean, how did I not know Sid when on page four of the *New York Daily News* there's me carrying Sid out of Hurrah's, the pictures that guy Dave took.

[TAPE CUTS]

What do you know about the Marcia Resnick — Johnny Thunders — John Belushi rumoured heroin dealing?

John Belushi used to live right above the UK Club; him and Judy. And I enticed him, when he first got here, to go to the UK Club. This was a twenty-four hour club, open all the time, seven days a week. It was like four in the morning, and he really started to like the whole after hours thing. So I took him on the rounds; to The Nursery, to a bunch of the other places. (laughs) In a way, I feel a little guilty, but that's how he actually met Marsha and stuff, because Marsha used to hang out a lot at CB's, then the after hours places. Matter of fact, I met Marsha soooo many years ago when I was first hanging out. In the very beginning of the whole punk thing, she was doing her book *Bad Boys*, and she took a picture of me on the steps of the Sunshine Hotel, right next to CBGBs. A flophouse. Even though he was John Belushi, he was such an obvious embarrassment to everybody. There's a guy that embodied the spirit of a Sid Vicious. Definitely. He'd get drunk and that whole thing, and when you combine that with the thing of comedy, and the physical comedy...you'd have a couple at Odeon paying, in late seventies dollars, about $200 for dinner...and John would come over and take the guy's fork, put a roll on it, and bang it so the roll would pop up in the air. (laughs) Like, give the guy a break...

Did he have a whole entourage?

Yeah. Him and (Dan) Ackroyd really were like skin tight though. You'd see Ackroyd at the bar, smoking a cigar and drinking a brandy or something, and John would like, be drinking ten vodkas and running around, you know, grabbing women. I think one night he grabbed Ellen Barkin's ass when she was still a waitress there.

So at one point rumour had it, Marsha Resnick was dealing heroin out of the backdoor of the SoHo Weekly News...and there were also connections to the Yippies and what was going on at Studio Ten.

Yeah, I heard all that...Studio Ten.

Were you born in New York?

Yeah, Chinatown and Little Italy. I was born on Baxter Street; born in Bellevue hospital, 1949, Mother's Day.

So you just had a birthday!

Yeah, last Saturday. I'm fifty years old. No one would have thought it.

How old were you when you first got involved with a scene?

My mother was a heroin addict, my father was a Mafia guy, so basically...there was always a scene. I was running around with the gangs from Little Italy and even the kids in Chinatown. There used to be a thing of...the kids from Chinatown...you wouldn't think so...but kids from Little Italy and the kids from Chinatown didn't really fight each other because they were right up each other's asses. It was much more about keeping the bridge and tunnel at bay. That's who everyone hated. All this stuff about, like Abel Ferrara...I liked a lot of his work, but he missed the mark with *China Girl*, because it really wasn't...because there may have been incidents like that, I'm sure there were. Although later on it got (bad). Years and years ago, there were a lot of kids that would flirt with that whole trip but just keep doing whatever they were doing, and assimilate themselves into society. There was huge exodus. In those days the thing to do was move to Long Island from Manhattan. Which is why Massapequa and so many of these towns in the north shore made a phone book what you would expect to see in a phone book from Little Italy. But basically, it wasn't about the Italians vs. the Chinese. It was about Jersey guys, and Brooklyn guys...everyone hated Brooklyn people...because there was like these weekenders who would come in and fuckin hit on our girls, and get drunk and throw beer bottles in our parks.

Did you get in a lot of trouble as a kid?

Yeah. I wasn't like real juvie material, but a lot of fights, a lot of scuffles, a lot of being warned...in those days cops used to smack you around and send you home. Unless you really...and in those days, you didn't kill somebody. You kicked their ass.

I mean, the guys that would take a razor to somebody or something like that, those guys did that once or twice and wound up in Spokeford or wherever the fuck they belonged.

When was the first time you were aware of some kind of underground scene, a drug culture...

Like I said, always. I always had illegal activity in my home. I was five years old. My uncle Eddie tied me up with his raincoat when the FBI kicked down my parents' door for robbing the Minneola post office. He carried me down the fire escape and drove me to Long Island. Shot an FBI agent right in front of me. Drove me to Long Island, gave me to my aunt and said...you know...Fay, Michael's going with you for the next six months; otherwise they're gonna try to take him away from Dominic and Agnes.

What name were you born with?

Morra. Michael Morra.

So when did you come up with Rockets Redglare?

Around...well, I had a band...very much a failed band, but a band at the end of glam, beginning of punk. The name of the band was Rockets Redglare and The Bombs. People started calling me that, which was actually kind of my plan anyhow because I always knew I was gonna go into show business one way or another...and I figured, there's that thing, "if you go into show biz, Americanize your name". And I said, "well, how American can ya get?" (pause) Rockets Redglare.

[TAPE CUTS]

I'm really fucked up chronologically, I guess, because I've always been so...so immature. (laughs) But it wasn't about garage bands in New York.

[TAPE CUTS]

Well, we picked a good day for this, anyhow.

[TAPE CUTS]

I didn't write the music, but we were ripping off anything that we liked; just kind of rearranging it.

What did you like?

Bowie. We were a beefed up, Incredible String Band. We got some gigs here and there; a lot of loft parties. We were hanging around SoHo a lot, the West Village, East Village…

Who were some of the first people that you remember meeting, who were of some social stature in the area?

Actually, Todd Rundgren. I used to always hang out with Nils Lofgren when he was in New York. Then later…I was hanging out with John Cale and his guitar player Sturges, porno stars, Sharon Mitchell…very naughty. I played the judge in a (porno) film that Sharon Mitchell directed, which was funny. They sprayed my hair silver — and this is when my hair was black and stuff.

At the time, it was rather predictable to be in a room, in a party full of people from the drug dealing circuit, and the porno industry, and the punk scene all together.

Yeah. Like Ming Toy, people that like…well…almost all the musicians had girlfriends that worked as strippers or porno actresses. A lot of the girls did that to pursue their careers. (laughs) There were times when I would just come back, I'd see my friends... You gotta remember, with a guy like me and my drug use, — which was powerful enough — that there were periods of time that I really didn't have time to do anything but getting high. There was this guy, at the beginning of my film career, Lance, that had a loft on 30th Street and 6th Avenue. His loft was like the playground for adults. He had mounds of heroin…he was a heroin dealer and a coke dealer. He has fashion models over there and celebrities. I'm not really gonna get into who was there, but there were a lot of people there. He took this incredible liking to me…and he really almost kind of like seduced me into hanging out there, because he liked to pick my brain. It was great for me…he had almost every film I could imagine on laserdisc, Beta, or VHS. He had all this great pussy around all the time. And I mean…pretty much the deal was pretty pathetic. He used to hold kangaroo court and shave a model's head after he had chained her to a radiator for a day or so. There's a girl that's gotta be in London in two days…and he shaved her head. There was one that he did it to and she went to the job anyhow…and it was a big deal, it went over really big. And she only originally went because she needed the money and figured they'd put a wig on her or something. Gia was there all the time.

So when did you get into the drug thing, in terms of being hooked yourself?

I grew up with drugs. I helped my mother and my stepfather kick when I was twelve. I

was already strung out when I was in high school. They tried, my family tried, all kinds of stuff to keep me from getting high. They'd send me to Brooklyn with one relative, send me to Long Island with another one. So there was a whole period of time where I was bouncing around.

Did you make it through high school?

Yeah.

Was it hard kicking your habit as a kid?

Not really. In those days you could buy two-dollar bags. Matter of fact, I got through three years of college...but a lot of dealing too though. I realized that was the only way you can keep your head up.

In your early to mid twenties, you really weren't a part of anything, but you were dabbling in a lot of stuff.

Yeah. I was like twenty one, twenty two, when I got out of rehab. I got sent away when I was twenty, for a sale of heroin. But I got probation.

So you were already hip to what went on with the cops if you got busted and all that.

Oh yeah. Like I say, I was sniffing glue when I was eleven and twelve...Carbona... cleaning fluid, you know. I was doing diet pills. I knew how to get TussinEx, which is a really strong synthetic, almost as strong as morphine, by just complaining of chronic coughs. You could get Robitussin pretty easy, but TussinEx...if you knew exactly the right kind of cough to complain of and how to cough, you could get it from a doctor. And if he didn't come up with it you had to almost recommend it: "Oh, my doctor in Connecticut used to give me the stuff, the cough stuff..."

Did you ever get caught doing that?

As long as the doctor writes legitimately there's nothing you can get caught for. I mean, you can get...there was a time when you could get really strong narcotics. You could complain of a pain in your bladder, then take a urine test and prick your finger with a pin, put a drop or two of blood in the urine...automatic.

Do you have any good stories about the porno era, about hanging out with the people, seeing what kind of lives that they led, that kind of stuff?

43

There was a lot of dysfunction and weirdness. Just imagine the frustration of some guy that has access to ten, fifteen...actually good-looking girls that would just rim their asshole at the drop of a hat. And because of all the coke, and just being so fuckin jaded, they just cannot get it up. These guys are in such a fucking weird head...(long laugh)...if you were there, believe me, you woulda had tears in your eyes. I laughed so hard. This guy Jerry... his father's this mafia guy from Vegas. And the father has sent Jerry to New York to oversee his porno empire. Jerry has gotten so caught up in these chicks and in all the bullshit that he's totally coked out, all the time, and he's got these twins that go with him everywhere. And a couple of times I had been with Jerry and the twins hanging out, doing blow and smoking cocaine. The twins would be eating' each other out for like two hours, and Jerry'd be kind of like languishing around. But I figured, "Ah...he can have it anytime he wants." He's probably just more interested in getting high or something. I've seen a lot of that. That as one of the things that bothered me that...there was this girl that totally fitted one of my all time fantasies. She looked like a little librarian. She had glasses and milky white skin, and used to wear these cotton sundresses. One night, we're watching this movie and she starts crawling around on the floor on all fours. She pulls off her panties and just starts backing up to where I'm just laying on the bed watching this movie. And I had the coke pipe there, and I realized, holy shit, I'd rather watch the movie and suck on the pipe, and give this girl Lisa the boot. So...that was one of things that made me realize, that made me get my priorities straight. (laughs)

Anyway, so Jerry...couple times we were hanging out and I'd see similar things like that go down. I just figured...Jerry can do this at any time. But sex is one of those things I guess...I know...you can only do so much. But there are all these drugs you can do until you drop dead. So I was seeing this girl Gloria who was a dominatrix, who I met through Sharon Mitchell... And I'll tell ya a story about her too because for a dominatrix, this girl was the most passive and submissive woman I ever met. Which seems to be the trend...all dominatrixes seem to be suckers in the long run. Anyway, I'm there with Gloria. Now Gloria is no babe in the woods. She's been around the block a bunch of times. Jerry comes over with the twins...and a third girl...who was a knockout: blonde, Swedish type...which I got another good story there. So, Jerry goes to Gloria's apartment, a beautiful place on 53rd Street, right above Trescalina restaurant, by 2nd Avenue. Jerry comes in with these three girls, bunch of coke and shit. He starts cooking the coke and says to Gloria, "Do you mind if I get comfortable?" Gloria says, "No. no problem. Get comfortable." Well...I guess in Jerry's twisted concept of what comfortable meant, it was his cue to completely take his clothes off, lay down on Gloria's bed, and start whippin' this flaccid fuckin dick of his —

[GLEN & ROCKETS:] Hahahahahahahaha!

44

All over the place. But I mean, really, it was embarrassing and pathetic. This thing is so dead.. it's like he may as well have taken a piece of wet rope and been throwing that around. And I happened to look over at the twins and the blonde girl...it was so funny, because he's running all over and it's three girls, all simultaneously rolling their eyes in their heads. But when Gloria walked in the room (laughs) the look on her face was just priceless. He asked her, "Do you mind if I get comfortable?" Hahahaha! And he did that for about four hours. Nothing happened. But that's how burned out some of them can get. But I'll tell ya one thing...a lot of those guys wind up with greased up, big black dildos under their bed because their dick just stops working. They're in so much need for some kind of stimulation that I guess they decide to get on a real positive frame of reference with their prostate.

I'll tell you the story of the Danish girl. Actually, I started going out with her after Gloria. I didn't know (she was a porno actress) when I first met her. I thought she was just a thrill-crazed émigré. She never talked about any of that. I'm showing her one night...we're over at my apartment and I show her some scenes from my movies. She goes, "You know, I've been in movies, too." I said, "Really?" And she says, "Yes. You must see some of the films that I acted in sometime. I will make you dinner tomorrow night, come over." Now, this is really funny, because this girl...I could not picture her being anything but one of the sweetest little girls in the world. Every day, she'd buy a little gift for me, whether it was just some stupid little toy or something...sometimes, we'd be walking down the block and she'd actually start to walk backwards, while facing me. I'd say, "Why do you do that?" And you know, she's giggling and prancing and stuff. So finally I just pressed the issue one night, and she said, "Well, I just like to see you coming towards me. It makes me happy." I'm thinking, "Gee, what a sweet thing to say." Anyway, she makes me this dinner, which was really fuckin atrocious. I don't know if you've ever had any kind of Swedish food? It's like this weird, terrible spice...bad, just a lot of fish, like fluga, falugal...flu — I don't know what the fuck it was...cod, with some kind of...I don't know, herring sauce! (laughs) I don't know, but it was about the fishiest thing that I had ever tasted. It tasted like you were biting into some kind of fish's bladder. Like fish piss, melting in your mouth. Anyway, she goes, "After dinner, we'll see some of my films." I go, "All right." Well, the first one was a Danish film. She puts on the videotape and it's this...it's in Danish, but it opens up and it's beautiful! It's this young girl, and she's running through the park with her dog, and you see her playing with the dog, and jumping and stuff...and she gets to the barn of her farm. She's got her horse there. So now, she takes the horse and starts grooming the horse. But it's really cute and it was her dressed as a little girl, dressed in a pinafore, a little short pinafore...I'm saying, "That's a little weird", you know. So she takes the little dog, gets on the horse, as the dog runs with her, and she's riding the horse. She rides the horse all the way out from the barn, out by the north forty or something, gets off the fucking horse, starts rolling around on the grass with the dog, (laughs) starts to blow the dog! I'm looking at her...(laughs)...and she's going like

this: (winks and makes nudging motion with crooked elbow) as if to say "What do you think? Pretty good, huh?"

And get this. After a while she gets up, leaves the dog there like this (imitates dog with dumb grim and eyes rolling back) and she walks over to the horse and starts playing with the horse's cock. Then she starts blowing the horse. (laughs) Then it shows her, and there's a screen title, and I guess it was twenty years later (laughs), or ten years later, and it shows her driving a Saab to the farm...she gets out, and the dog comes running out, and she scruffles the dog's head...gets on the horse again...now she's dressed as a business woman, right? She gets on the horse, hikes her skirt up, you know...rides the horse out by the north forty, and does the same thing as a grown woman, right? Then, of course, the guy across the way sees her, the young buck farmhand...

[Glen & Rockets laughing]

He sees her doing this...and then they get started. After that it just degenerated into a typical porno flick. But I was just so flabbergasted...and here I am, an inch away from saying to myself, "Ah, the mother of my children!" So...we had a good couple of weeks, and we had had some great sex, but...after that, I realized that this was a go anyplace, do-anything kind of girl. Up in one club one night...at the Mudd Club, we were hanging out, I was drinking a Vodka and cranberry which was my constant drink, and she slipped down, like...the Mudd Club had a wraparound bar. The bar was packed...and me and her just happened to have a spot at the front. So she slipped down, opened my fly and starts giving me a blowjob. I guess she didn't realize, or didn't care...I didn't realize it, that that was the spot where the bar separated...it was continuous on the top, but it was separated...

For the bartenders and the waitresses —

— to slip under, so they can come in and out when they had to. I'm noticing while she's sucking my dick that people on the other side of the bar are looking over (laughs loudly) and laughing, and you know...speaking to their friends...(laughs) and I'm going like this, looking for snot on my jacket, or arm, you know. And I looked down, and I see the light (laughs) shining on us. There are a lot of weird stories. In the UK Club I saw some really weird shit, like mafia type guys so fucked up on coke and shit they'd take this transvestite into the bathroom and lay, I guess, all this coke on her, on him...now I had always assumed that if anything happened, the transvestite would be sucking the mob guy's cock, and that, you know...you're not gonna say anything to a guy like that, like, "Hey, that's a little freaky, ain't it?"

[Glen & Rockets laughing loudly]

46

You know, "What are you, a homo?"(laugh) You know, you're not gonna say that. So, one time, he gets me....the mob guy says, "Come on in and do a line with me", and I say, "No Frank, it's okay". He goes, "No, come on, come on." So we go in there and I guess he trusted me, and liked me, or else he was just really fucked up, because we're in there about two minutes and...(Rockets knocks loudly on cafe table) "Who is it?" It's the transvestite, knocking on the door. I guess either like, pissed because...(Rockets points out girl standing on the sidewalk) I want to tell you something interesting. See this girl here? Right there? Fifteen years ago that girl was sooo...I mean, she still has a decent face, but she was so beautiful. She had such a fucking amazing body. Now she looks like a housewife. She looks like a fucking suburban housewife. Poor women man, time fucking kicks their asses. These fucking girls, they think they're gonna be pretty forever, and young forever.

[TAPE CUTS]

Me and Spacely (John Spacely, star of notorious heroin-verite film *Gringo*, aka *Story Of A Junkie*, 1984) got along; we were friendly, you know. The unfortunate thing, and it's not to knock Lech (Kowalski), but you know...Lech kind of did Spacely a fuckin' big dis-service by doing that movie...because Spacely started to think that any day the fucking hand of destiny was gonna pull him out of his shit and he could be as big a fuckup as he wanted to be.

He got a lot worse after Gringo?

Yeah. I mean...he didn't realize he was being used...not that Lech was really using him, but he was being used by a lot of people. To him, he was fucking good buddies with Keith Richards and shit, in his mind. You know, so fuckin Keith threw him a hundred here or a hundred there, you know, when they were in town, and they did that shit at the St. Mark's Bar, and Waiting On A Friend on 7th Street. There's a picture of John Spacely and Keith Richards...or there was, for a long time, up at the Holiday Bar.

Did the Rolling Stones see that film, do you think?

Probably not...but you know, I'm sure that Spacely made Keith aware of it. (laughs) I can remember when I was doing *Desperately Seeking Susan* and *Talk Radio* and all that shit...a couple of times I'd run into Spacely in a nightclub or something. Here I was now, in films...and I'm not trying to say I was like better than him or anything (sighs) but I did the stand up comedy... When I really started to work, I worked. I did stand up comedy, I fucking wrote the cabaret show every week... I had Buscemi, Mark Boone Jr., all those guys involved...John Lurie. I fucking had what was then the *Saturday Night Live* of the Lower East Side. When you think about it, quite a few

of the people that had performed in my cabaret shows have done very well for themselves. Then I fucking pursued my work, and I fucking showed up on time, sober, fucking straight, and ready to go. Didn't let my fucking addiction and my problems get in the way of the job.

[TAPE CUTS]

With Lech Kowalski...after Johnny Thunders died, I did a comedy thing and Lech videotaped it. And I was talking about John, it was a memorial thing for John, and I did some comedy there, and he taped. Me and Lech always got along.

[New York Times: Rockets Redglare, a comedian, actor and longtime fixture on the Lower East Side of Manhattan who played characters not unlike himself in many movies, died on May 28 in Manhattan. He was fifty two. The cause was complications of kidney failure, liver failure, cirrhosis and hepatitis C, said his cousin, Madeline Schuster. Rockets Redglare's rugged good looks and rollicking nature made him a recognized figure on the Lower East Side, where he hung out and often lived. In the early 1980s he began performing as a comedian in neighborhood clubs like the Pyramid and Club 57, where for a few years he staged a string of performances called the Taxi Cabaret. In the mid eighties he began acting in films, appearing in nearly two dozen over a 15-year period. He played a sushi-hating cabby in Desperately Seeking Susan and a poker player in Jim Jarmusch's Stranger Than Paradise and appeared as himself in Basquiat. Although his parts were often small, his colorful presence impressed viewers. "When Rockets was on screen, you couldn't take your eyes off him," said the actor Steve Buscemi, who met him on the downtown comedy club circuit in the eighties, appeared in 1992 with him in In the Soup, then directed him in 1996 in Trees Lounge and last year in Animal Factory. Born Michael Morra, Rockets Redglare grew up in Sheepshead Bay, Brooklyn, and in Lindenhurst, on Long Island, sometimes living with Ms. Schuster's family. No immediate family members survive him. While growing up on Long Island, he worked as a roadie for a band called the Hassles, which included Billy Joel. It was his first brush with the life of show business. In the late seventies he worked for a time as a bodyguard for the Sex Pistols and later for Sid Vicious, that group's bass player, who split with the band.]

WHERE DYLAN WROTE BLOOD ON THE TRACKS

I should organize guided tours of the Chelsea Hotel for the dispossessed of the South Bronx. This is the room where Bob Dylan wrote *Sad Eyed Lady of the Lowlands* for

you. Or was it *Blood On The Tracks*? Or where he fucked Edie Sedgwick? Or did he live here with Sara when he was secretly married to her and the whole world know nothing about it? Who gives a fuck about this repulsive *Rolling Stone/Q* magazine trainspotting anorak shit? The important thing is...

HILL ST. BLUES/NYPD BLUE/LAW AND ORDER

In all the series I'm watching on the TV I keep thinking that I see Hamri or Brion Gysin paintings on the walls in the background. Particularly on the old LA stuff like *Colombo* and *The Rockford Files*. It's not impossible; Hamri might have sold some paintings to those California acting and directing faggots. After all he lived there and worked there as a professional painter during his years of exile from Joujouka. I know he sold a lot of paintings in California.

But he can't have sold the amount of paintings that I imagine I'm seeing – and Brion Gysin couldn't sell a thing while he was alive.

TEN GREAT BOOKS TO READ DURING A SEASON OF TAKING HEROIN

Holmes Dupont occupies a modest, slightly shabby, suite on the seventh floor. Only shabby because he is content to leave it that way. Not for him the seasonal shocking pink or lime green makeovers which seem to be the main things on the minds of the rich kid female art school types who more and more make up the Chelsea's population. (Along with hairdressers and 'poets' and useless people and choreographers and drama coaches and rich filth and advertising agency scum and gay singer-songwriters and authors of detective fiction and bands recently signed to TimeWarner and...)

Holmes is that growing phenomenon, a trust fund old guy. ("When my father came to pick me up at the yacht club New Year's Eve bash in 1965, the doorman said, 'Sorry sir, this club is strictly for rich kids.' to which Dad replied, wittily enough by his standards, 'I'm the father of a fucking rich kid!'")

Dad Dupont took a small family brewing enterprise in Florida and turned it into a sprawling conglomerate that owns a number of radio stations, nightclubs, and shares in about twelve other businesses. Holmes' older brother Tab now controls the empire

though Holmes is still on the board of directors and in for a slice of the action. His general air of caution is the only thing that marks him down as being rich. He favours pastel jumpers and grey slacks, soft leather slippers and gold rimmed spectacles.

Holmes controls his heroin situation by keeping his addiction to the weekends and the third world. He goes on occasional junk benders in Thailand and other hot poor spots. Weekends in Manhattan he allows himself to go all blotto. Weekdays he keeps himself sort of steady on his feet through a mixture of hashish, the occasional glass of beer, and lots of vintage B&W movies on the TV.

He doesn't need to work but divides his office hours between progressive philanthropies (fundraising for the Zapatistas, helping build AIDS hospices in Ghana, or finding decent homes for old junkies) and producing underground movies. ("I'm not exactly Dino de Laurentis. I'll get the ball rolling by throwing in the first $100,000. That pays for the notepaper. Then I'll ring up my pals and contacts, see what they can do. See can we get James Garner or Alice Cooper or someone to do a cameo.")

Holmes' relationship with heroin is a particularly virile one. When he heard that I was making notes towards a book he wrote me out a list of the top five books that he reckons are suitable for reading "during the heroin season." There were, in fact, six books mentioned. This list, scrawled out on the title page of a paperback detective novel, is interesting enough but it is also just a list wherein nothing is explained. I mean, does he intend me to turn around and read all this stuff? Six books? And must I read them while doing junk? Life is short and books are long.

I call to see him one midnight armed with a bottle of Wild Turkey and my portable minidisc recorder so that we can elaborate on the list. He has certainly read the books from cover to cover.

HOLMES DUPONT: Number One. *Pride and Prejudice* by Miss Jane Austen. This is just a diamond. You feel you can get right on that horse and go out looking for a suitable husband for your favourite daughter yourself. I don't know what your Mom was like but the mother in *Pride and Prejudice* strikes me as being every mother. My own mother devoted her entire life to marriage; first her own, then my sister's. On junk the book confuses me, which I like since Austen is so organized and linear. A little confusion adds spice to the mix.

Number Two. *Naked Lunch* by Bill Burroughs. Well, this book is what the critics incorrectly claim *Ulysses* is, a major kaleidoscopic book about a great city during a moment in time. One thing you can say for sure about Bill Burroughs, unlike a lot of those deadbeats (forgive the pun), is that he could write. He was a reporter from the front lines of the drug and sex wars. Linguistically, the book has that satisfactory wholesome all-roundness that I associate with chicken soup. I don't think you have to know Tangier to like it but, as it happens, I *do* know Tangier and the city of the novel is not of this world, or *that* world either. That ridiculous movie. I mean, I think Dublin is not much of a place — forgive me for saying so. I was there once for a

weekend — but Tangier is pretty labyrinthine. Poor James Joyce! He had his work cut out trying to turn that dump into experimental writing.

JOE AMBROSE: I think Dublin was something a little bit more special way back then.

No, of course. You're correct. I'm sure it was. I'm not all that well educated a guy though I'm pretty well read at this stage. I once asked Bill Burroughs, "What is the secret of your success?" "The secret of my success is," he told me, "that I never smile for photographs."

Three?

Three is *Go Now* by Richard Hell. This is both a good book about junk and a good one to read while under the spell of junk. Do you know Roberta Bayley? I just love Roberta. That whole book is about her and Richard Hell. Do you know Richard Hell? Richard is a very nice person but I've not seen him since about 1985. I've just read his book. I love that book, I read it three times one weekend. Richard was in a very strange condition when he lived here. I think he was having conversations with Edgar Allan Poe in his room. That was the time that Patti Smith and Mapplethorpe hung out here. Number four has got to be *Bouvard and Pechuet* by Flaubert. If you're going to read just one book in your whole life about two men, that's the book to read.

And five?

Five is *Horse Under Water* by Len Deighton. Deighton is one of your great writers about towns, cities, districts and food. His accounts of Gibraltar and Portugal in *Horse Under Water* are like Impressionist art. The horse in the title is of course heroin. This is one of the finest books about heroin smuggling: the way he paints this dubious member of the Portuguese aristocracy — can't recall the name of the character now...ten years ago I read this one — gives us one of the most finely drawn minor characters in modern English fiction. I gotta have a sixth because during the season of junk the chances of a man losing his paperback or slim volume are immeasurable. And I can't think of anything interesting to say about Flaubert because it's twenty years since I read it under the influence of opium. My little list is not in any order of preference or gravity, just the order in which I wrote them down on paper for you. So there is no disrespect intended to *The Koran*, a vital book, just because it comes last here. It ties in with *Naked Lunch*. I lived in Tangier from 71 through 72. I shacked up with a beautiful girl from the mountains by the name of Ferdous. She had a marvellous hardback English translation of *The Koran* some European had given her before I came on the scene, so every night before bed we'd share our gifts. I'd teach her a little English using her

Koran and I'd learn about a little slice of Islam from her in return. That *Bible* of ours is really just so White Trash but *The Koran* is strong…dark…handsome…aristocratic. Me and Ferdous were sticking to a strict junk regime and she insisted that there was absolutely nothing in the book against taking heroin, that therefore Allah didn't frown on it. I still had enough adolescent arrogance left in me to imagine that I might write the second great novel about doing junk in Tangier. It was going to be called *Junk Berber*.

Bad title.

Very bad title.

THE SUBWAY TALIBAN

Once upon a time, many niggers ago, I didn't have a beard or carry a laptop. Now each day I enter into this life totally armed and dangerous. Subway voices surround me like experimental atonal music which I have a yen for though I'm no avant gardeist. Avant garde is such a dated self-serving concept.

Faces, hair, eyes, legs, voices out of mouths moving, arms, jeans, songs, ads, moans, snores, laughs, tears, shoes holding feet walking, the smell of shit, the smell of sweat, the look of poverty, black leather belts, thrift store gay novels, the loneliness of the beautiful, the camaraderie of the mediocre and the ugly, mingling with the black leather jackets, the muddy worker boots, the pervasive smell of after shave, unwashed pussy, a teenage white boy in a heavy Camp Cromwell sweatshirt that makes him sweat, mental danger, the jewels and binoculars, last Converse All Stars ever seen on this Earth, Walkmans emitting old U2 albums. This life of the commuter is a scandalous life. The life of the commuter is dangerous.

The Taliban youth looks like he comes from a good family, a normal home. He looks like a brown eyed saint in his white Islamic warrior robes and his white Taliban turban. I circle around him at midnight on the 42nd Street Subway station platform. I've just come out of Easy Everything and I'm heading back to the hotel, too tired for the short walk.

"You lived here long?" I ask after we've exchanged nods.

He misunderstands me, thinks I'm asking him if he lives alone.

"No," he says in a rich kid Moroccan accent, emphatically but gently for he is no tough-guy moron, "I live with my parents."

"I was just asking if you'd *lived here long*, "I emphasise. "I was just wondering how you find it here."

"I find it great," he cheers up, relieved I'm just being friendly, not some too-friendly homo zombie. He seems not even remotely spiritual so maybe he's just another vain pretty boy dressed up in exotic gear.

But he has this glow about him. He is like a Shaolin apostle from the *Kung Fu* TV series and a pure brown-eyed slice of the new American pie.

ALBERTO GARCIA ALIX

I remember Alberto Garcia Alix taking a photograph of me in Madrid when Islamic Diggers were doing a poetics festival there with Richard Hell, John Giorno, Tav Falco, Joujouka, John Cale, Hamri and Lydia Lunch. Alberto likes taking photographs of himself and of girls who look like prostitutes, though who am I to judge? Maybe I just don't know enough about girls.

I guess on calm reflection that if they looked like prostitutes, they looked like the fittest ones I've ever seen. He uses romantic towns like Moscow and old fashioned locations like tango parlours in Madrid. Now his first New York show is happening with Barry Neuman whose Modern Culture Gallery operates out of the Gershwin Hotel, where the corridors are decorated with Warhol lithographs and where there are some minor Pop Art trophies in the lobby. Marty Matz says that The Gershwin is trying to be the new Chelsea Hotel but that they try too hard. On the other hand, Marty says, they've done some readings and that, at least, they do try. "It's something," he reckons. Somebody else told me that the owner allowed Leee Black Childers to crash there at one stage when he was resting between homes.

Frank Rynne — who arrived in town this morning — says that Alberto didn't like us that time in Madrid but I have no recollection of that phenomenon. All I can remember is Hamri being prepared for his photograph and how much he liked having his picture taken. I do recall that the better known the sitter, the more excited and committed the photographer was to his job. I also remember thinking that he was queer because there was a crotch-orientated biker aspect to his ethos. In this regard, if the impressively fit, pussy-rich portfolio Barry is patiently showing me and Frank is anything to go by, I was wrong.

Memorial for a Troubadour
by George Wallace

[A Memorial Service For Martin Matz]
New york city November 18, 2001 — here we are "moving up the mourning bench," Janine Pommy Vega says, and she has a somber tone in her voice. She is peering out over the crowd. It is the memorial service

for Martin Matz, Sunday, November 18, 2001, 2:30-4:30 P.M. Ira Cohen
has already stepped up to the podium of NYU's Cantor Film Center
theater on East 8th street to kick things off.

"I am the perpetual wanderer/the insatiable traveler," wrote
Martin Matz once and, appropriately, that is what's printed on the
commemorative program made up for the day. Someone said Marty Matz
weighed 300 pounds if he weighed an ounce and that's probably not far
off, but it doesn't come close to describing the largeness of a man
carrying his entire life in a suitcase through the world, a man who
wouldn't walk a quarter of a block but could sprint when he needed to;
— for example, if the liquor store was about to get locked down for
the night — a man who could handle six flights of stairs to someone's
walkup if they agreed to take him in as a guest, and frequently enough
they did. He could make you open up your door and let him in, and
he would stay with you awhile and then move on; and afterwards you
wouldn't even ask yourself why you had gone and done that, you knew
quite well why... Because Martin Matz was a troubadour and a hustler
and a charmer. Take that epigraph. It continues for another couple
of lines, like this: "the mystic nomad/forever moving/toward some
strange horizon/of twisted dimensions/and chaotic dreams" — apt words
from a wordsmith of considerable skill, printed above the names of
the sixteen or so officially named speakers, Ira and Laki Vazakas and
Andy Clausen and Steve Dalachinsky and Penny Arcade. And Janine is
like the rest of us: she has seen too many of these memorials, now
it is Marty's turn. So many of the Beats are passing on, who is there
to replace them? Herbert, Bill, Allen, Gregory, Ray Bremser, Jack
Micheline, Bob Kaufman, Neal and Jack...long gone; and now Martin Matz.

Ira Cohen is a blackrobed master of a ceremonies. Ira would as soon
not have to host these, all the hip Bohemian lost traveling angels
fall in the midst of their wanderings, all things fall and rise,
becoming angels...in fact, "we are here to remember" the next last
outlaw poet, Martin Matz, 300 pounds if he was an ounce, who railed
and cursed wondering why no one put him in the book of outlaw poets;
"because the book was bogus" says Ira. Yet they come to the podium one
by one, take the microphone and speak, Janine, Ira, Steve, Andy, and
the ones who filmed him or cared for him or loved him, the ones who
loved being taken in by him; Martin Matz who did not even know when
not to bother trying to hustle a person, he just enjoyed the hustle
too much not to. In Laki's video we see Martin hustling Herbert — it
is at the Chelsea Hotel. Charming Huncke, Huncke who has nothing to
hustle away is all street hustler charm himself, is astonished with

the persistent charm and energy of the big guy; Huncke beguiled.
And this afternoon, there's a Rabbi and a Swami and a playright
and a lawyer, and oh yes, drug takers and thieves. They have all
at one point or another committed some theft of the heart they all
understand; they are all beguiled.

In the midst of it all Eileen Kaufman calls me from San Francisco
to tell me she loves Marty's poetry, so like Bob, she says, "of course
he went through women like wine, Marty was there on the boat when they
spread Bob's ashes in San Francisco bay, tell everyone i said hello"
and so I do. And now we are here praising Marty and everyone is trying
to out-tell Martin Matz tales he told them himself, waving their arms,
telling Marty stories. We are moving up the mourning bench.

Who can tell stories like Marty Matz could? A travelling salesman
maybe but person by person they step up to the microphone and try.
"Someone said Marty never had tattoos because he thought it was Jewish
law: you can't be buried in a Jewish cemetery if you have a tattoo,"
says Ira.

Marty would think nothing of spending fifty bucks for the stuff
he needed to make spaghetti sauce: "he was Rabelaisian," says Roger
Richards.

The Indians of South America called him "a man of wretched excess"
and he was proud of it, says Ira.

"He smuggled cocaine into the country by reducing and spreading
like gloss over photographs," says Laki.

"He tried to sell me an unsigned Huncke painting for fifty bucks,"
says Dalachinsky. "What could i say. I said no."

"The Latinos called him tio Martin," says Bob Yarra, a West coast
immigration lawyer friend from fresno. "He spoke such wonderful
Spanish." One time Bob gave marty $300, and the next thing he knew
when he turned around "Marty was buying drinks for everyone at the
bar."

"Martin told me it is the job of the artist to wander around for a
long time, doing nothing," says Rabbi David Wise. Wise put Matz up for
months; a huge physical presence but somehow when the man would lie
down "he seemed so tiny!"

Wise is candid about Marty's arrogance, his manipulativeness, "but
yes, the honesty of Martin Matz...he stayed at my house three months.
I told him no drugs and he kept to his word," says the Rabbi. "But he
made it up with vodka; the Russian Chasidim encourage it."

If he had written nothing else but the poem I Know Where Rainbows
Go to Die, Marty Matz would have done enough to be remembered as a

great poet. As it is, he deserves to be a famous one, having written many others: poems like Pipe Dream 8, which starts out, "less spiders and more porcupines would make a better world," and just keeps getting better from there; the poem characteristic of Marty's grin-full innocence and ingratiating manner. It wasn't just cocaine — there were moments when Martin Matz could reduce poetry down to essences, too.

Here at the memorial some people say he was a great poet, some say he was a big baby. Whatever he was to people, everyone who ran into him loved Martin Matz and they were exasperated by him; victims of his latest suicide gesture, beneficiaries of his keen desire to reciprocate, all of them falling for his charm. "Beware the deadly underdose" said Marty and he lived that maxim to the hilt, overindulging in everything he possibly could get his hands on "but with heartfelt appreciation for the experience," says Jamie Rasin — he was one of Marty's greatest friends in manhattan and knew the score when it came to Martin Matz, all 300-pounds-if-he-was-an-ounce of him.

What is the score? Marty grew up in Brooklyn. His father took him to the Symphony but then he died. Marty was 10 or 12 and his mother remarried and took him to Nebraska. He emerged from the Midwest a street poet and wanderer in the true Beat tradition. In his youth Martin Matz was a handsome man and an excessive one; mystic Rabelaisian nomad and a messenger to chaotic dreams; a perennial figure in the ever-blossoming garden of American Beat culture. Martin Matz was like most, scarcely known to the outside world, someone had to beg Allen Ginsberg to give him a shot on stage.

Unlike most, at his best Martin Matz was a master storyteller who could keep his audience spellbound, whether in a Sardinian bar, at the Royal Albert Hall or at a Kosher dinner table in Williamsburg, New York. Bob Kaufman would leap on coffeehouse tables or throw himself on passing cars in North Beach to recite his incendiary poetry. Martin Matz, a little less nimble than that, had a hustler's knack for collaring all and sundry into his orbit, where they were treated to a poem, a deftly woven tale. Was it a hustle? Was it supplication? Was it the generosity of irrepressible wit? Or payment of a troubadour's debt to the wider world which supports and sustains him?

Whatever the economics of it, here at the memorial, several of the Beat videographers have caught this magic of Marty's on tape. "A heroin addict walks into the barber chair and flops down in the chair, he just sits there, rolling his head around, mumbling," says Marty in a Laki Vazakas video. The barber says what'll it be. "A shave," says the mumbling druggie, nodding out. "If you want me to shave you,

you'll have to lift up your head," says the barber. The addict's head
sagging still further, he says "oh all right, then make it a haircut."

In footage shot by Penny Arcade, Marty is telling his Oklahoma
whale story, which goes something like this... There is this law which
dates to 1912, it says bringing a whale into Oklahoma is a hanging
offense. Here's why: in 1910 this fella from the East coast gets his
hands on this dead whale, and he has this great idea; he's going to
put it on a railcar and tour it around the country, showing the dead
whale off, for a nickel a head to every American who will pay for the
privilege of viewing it. Well, by the time he gets to Tulsa you can
smell that man and his whale coming from forty miles away, and when he
pulls up at the train station the authorities are there waiting and
they tell him to get the damn thing out of town.

"This is my livelihood," says the guy, "i get a nickel a head!" So
they offer him $500 and he takes it

Only then instead of taking off with the whale he just pushes the
reeking carcass off the edge of the rail car, and he leaves town.
So now the town of Tulsa is stuck with a dead whale at their train
station, and it stinks, and they don't know what to do. So, finally,
someone gets the bright idea to blow the dead whale up.

And they try that. They actually put a couple of sticks of dynamite
in it, but of course it doesn't work: the thing explodes all right
and everything but all they get is thousands of little pieces of dead
rotten whale carcass blown all over town.

"And that's why bringing a whale into Oklahoma is a hanging
offense," says Martin Matz or words to that effect. "That just
goes to show what an effective deterrent capital punishment is. To
my knowledge that's the last time anyone has brought a whale to
Oklahoma."

A whale of a story from a whale of a guy.

Here's the skinny on big Martin Matz. For so big a man, he could
worm his way into a person's heart with tales like that, and did,
across decades and continents, the hearts of hundreds of people, some
of whom show up at the Cantor Film Center Theater on November 18.

Perhaps one heart couldn't have been big enough to hold a man so
big as Martin Matz. Perhaps this is why, from Chiang Mai to Fresno
to the Chelsea Hotel in New York city, Marty travelled from heart
to heart, the perpetual wanderer; a latter day beat troubadour who,
now that he is gone, has everyone who knew him telling a Martin Matz
story.

Like today, November 18 2001. Before the afternoon is over day has

bled into evening and evening into night. People are telling Martin
Matz stories, this life spilling out on the sidewalk, and i travel
along with the crowd, up East 8th to the university, five blocks to
the Cedar Tavern. The memorial service has turned into a celebration,
an all nighter of epic proportions, half of the Cedar is occupied by
friends of the latest "last of the outlaw poets" to have passed out of
this world, Martin Matz. And the party doesn't stop there; from the
Cedar Tavern it travels on to someone's apartment on East 13th. The
party goes on and on.

 For all i know it is going on still, Manhattan Bohemian society
celebrating Martin Matz, one of its own, a giant man and epic
wanderer, lost but reborn in their own lives, the renewal of the Beat,
a troubadour forever moving toward some strange unexpected horizon of
his own—and our—devising.

REQUIEM FOR A BEATNIK

When I get back to the hotel I find, under my door, a handwritten note from Holmes
Dupont:

 "It was most entertaining talking with you yesterday about junk reading. I think I
mentioned to you that my dear friend Phil Fletcher, whose place is three doors down
from mine, was poorly and not expected to make it. We just heard this morning that
he passed away late last night. His ex-wife Ruby and his partner Henry are having a
little Irish Wake for him tonight in his suite. I thought you might be interested."

 Around 1am I head in the general direction of Holmes Dupont's place, knowing
that the wake will be very much in evidence. As I get out of the lift I smell the high
grade skunk weed and can hear some sort of jazz shit that could be Mingus or Miles
or any of those gone dudes. The door from which the music comes, three doors up
from Dupont's place, is ajar so I let myself in.

 About twenty people are spread around in a beautifully smart and organised
lounge: walls painted white, heavy Victorian mahogany furniture, some Beat
paintings on the walls, the first collection of vinyl LPs I've seen in the Chelsea.

 The older mourners sit on the available chairs or couches. Those who are younger
and livelier are making the running, standing on their own two feet or sitting cross
legged on the floor, fiddling with the drinks table or fussing in the kitchen or trying to
decide what CD goes on next.

 I don't have a fucking clue who this Phil Fletcher was. I recall Holmes saying
something about him but Holmes talked about so many different things at such
length last night that I have only the vaguest memory. Two of the characters who
normally sit behind the hotel's desk are in evidence, commenting vaguely on the

heroic nature of Fletcher's contribution. Contribution to what? Politics? Literature? Music? The amount of heroin being consumed in New York City? What I do gather is that he was sixty-three, played a part in three or four important underground presses in the sixties, was part of Dylan's retinue during the *Rolling Thunder* tours, and turned to writing when he got that bit older.

His ex-wife Ruby, a fine looking woman in her fifties whom I've seen about the hotel, is clearly very upset at the loss of her old pal. She holds court in one corner of the room, surrounded by colourful looking people aged between forty-five and seventy-five. Most of these folks are fat or physically fucked up one way or another from lives of excess. Nothing remains for them now but a similar end, a similar wake at some yet to be decided date.

His "partner" Henry is a little slip of a lad, no more than eighteen, who sits at the opposite end of the room from Ruby. He too is holding court with mourners though his pals are younger, roughly sixteen through thirty. Holmes Dupont tells me that Henry is terribly upset, that he and Fletcher had been together for a year. But Henry is laughing with his friends like a teenager is supposed to laugh.

"Phil made a will three months ago when he knew he was going," I hear Henry loudly confide to a girl about his own age who turns out to be his first cousin, "and he left all his legal crap to Ruby but he left me all his money. Such as it is. Thank God for that! I mean, the rent here..."

Henry has a tough city voice. Though he looks like a little boy he has the voice of a man. He is what people call "pretty" when they use that term with reference to a male. Ruby stares at him coldly but, I think, without resentment. Holmes tells me that it was just as well I didn't get here earlier, that there were some grim scenes. Apparently some of the old-timers started recalling Fletcher's contribution to the counterculture, how generous he had always been with his time, his money, and his intelligence. It was pointed out that at one stage Fletcher had been Burroughs' protégé. This went on for an hour or so, pleasant enough nostalgia shared by kind people.

Then some of the kids, to whom Fletcher had presented himself as a somewhat elderly punk or Dada guru, began to question or challenge Fletcher's 60s achievements and, by implication, the entire value system of his older pals in the room. Ruby took this badly so she disappeared into Fletcher's bedroom to be alone. Ten minutes later Henry followed her into the room and everyone could hear him accusing her of going through his and Phil's stuff. Meanwhile in the main room the booze and the drugs began to take hold and some of the testimonials were less than complimentary. One boy said Fletcher had come on to him somewhat aggressively, gripping him by the shoulder while trying to undo his fly. The oldsters started going, "Oh, no! No!"

It was at that stage that the room divided into the two camps which I discovered on arrival.

This is fun, with all the high drama of a real Irish wake. An hour into my visit

somebody suggests that since I'm a DJ why don't I choose the next music. I find a CD of an album I own on vinyl, *Music in the World of Islam, Vol. 2: Lutes*. This goes down well with most people. I'm happy so long as the CD lasts. Most of these 1975 tracks come from Iraq, Afghanistan, and Iran.

I take my leave when some nerd who is trying to look like Beck puts on the early *Sin É* live album by Jeff Buckley. If I'd been around when Jeff Buckley was drowning, I'd have grabbed him by the feet to ensure that he stayed under water until he expired. I don't think the mourning for Phil Fletcher is going to grind to a halt anytime soon. Holmes tells me that they're burying him in the morning. Also, earlier, I got a message from Ira Cohen that this painter who did the glamorous but perhaps sexist cover for *Bitch's Brew* by Miles Davis has just died.

NIGHT WITH A DRIP

"I passed my first night in the Chelsea Hotel with a drip," says Isabella Arrogant professionally, doing it one more time for the cameras and $2,000.

I was put in touch with her this morning by one high powered heavy metal publicity bitch who's organizing an interview with Slipknot for me. Every day she sends me helpful emails, and each email has a different philosophical or neo-intellectual quote attached to it, down the bottom where she gives her office address and her cellular number. The quotes tend to come from Dead Wise Ones or Nobel Prized Wise Ones or Che Guevara or Neitzsche or the accordion player from Soulfly or some white guy I've never heard of or who the fuck.

Today her email to me is ,"Since you're staying in the Chelsea you should go and talk to my pal Isabella Arrogant. Isabella came here in 1965, has always lived and worked in the Chelsea. Her real name is Isabella Unpronounceable so she changed it to Arrogant. She came from Turkey a long time ago. She is like the Anita Pallenberg of punk… three or four of the best punk songs were written about her."

Calls between Chelsea Hotel guests are free. The Slipknot bitch gave me Isabella's room number. I phone. She answers right away in a voice that sounds like she's being frigged or she's washing her teeth but in fact she is being filmed, being filmed as we speak, so, giving a fair impression of being an Anita Pallenberg of punk, she invites me over. "I can only talk a little, OK? But come over for a coffee and we can arrange dinner for later in the week. Don't sign a release form unless they offer you a fee."

Her son Aladdin answers the door. "Oh, you must be Mom's Irish friend!" he says; excitable boy. "Mom is just gonna take a break in ten."

I bet he takes it up the ass better than his mother.

Aladdin is kind of lopsided like a thirties cartoon character, his clothes are very strongly hip hop, right down to being slightly frayed around the edges. He is about sixteen, thick sensual brown lips betraying his mother's obscure Turkish background.

As if from nowhere he shoves a mug of excellent coffee into my hand.

"Sugar?" he asks in a whisper.

"No sugar. In life or in coffee," I whisper back. That's what I always say. It usually makes them laugh but it makes Aladdin worry.

His cellular rings. He snaps it open and, with more aggression than I'd have expected, asks, "Who is fuckin' this?"

A lad insane?

"I passed my first night in the Chelsea Hotel with a drip," Isabella Arrogant says professionally, doing it one more time for the cameras and the $2,000. These days, according to her biog. (which I'm reading on a clipboard while she is anecdoting), she divides her time between "California and Nirvana." We know where California is. I can only surmise that this apartment in the Chelsea is Nirvana to her. It is nice if not so big. She manages four Hollywood punque roquers who've just been signed and signed good.

Later, she has arranged with the director of the show, she will discuss "the obvious fakeness of Jacque Levy's vulgar lines about staying up all night in the Chelsea Hotel writing *Sad Eyed Lady of The Lowlands* for you," and also recall those first nights alone in the Chelsea Hotel, the "voluptuous safety and intractability of being unknown in Manhattan." She will confess for the cameras, as she has for an oral history of Max's Kansas City, an oral history of girls in U.S. hardcore punk, an oral biography of Iggy Pop, and an oral history of oral sex, that, "My life is nothing but a long, dirty story."

She and me and Aladdin have a good twenty minutes together. I criticize all the lyrics on *Desire*, their theatrical nature, the neo-Republicanism of Levy's main rock'n'roll buddy, Roger McGuinn. I tell her how much I like the way Johnny Thunders handled and rewrote *Joey* to make it seem like less of a hagiography to the dead Mafia don. Some of this talk impresses her, and some of it goes over the head of her son. She is at the Chelsea five more days then she goes on the road with her band who are middle of the bill on a transcontinental skate dudefest. So I'm invited to dinner two nights later.

"I'll invite The Duchess," she says dryly, like the name should ring a bell with me, "and if you need any drugs, Aladdin can help you out in that department."

"And Bill Conduit," chimes in Aladdin, like she's forgotten to invite Madonna or Debbie Harry. "If ya gonna invite The Duchess, invite Bill Conduit too."

"Who exactly is Bill Conduit?" is a big question I'm asking myself all the time these days. Conduit stays shrouded in mystery like he's a character from one of the dodgy aforementioned songs on *Desire*. I only met Conduit with The Duchess the once but I'm always bumping into him in the lift and one time we talked backstage at the Bowery Ballroom when Trail of Dead were playing two sold out shows there. Conduit was holding court with some fit Japanese women. I ask Aladdin about Conduit but it is Isabella who replies.

"I guess Bill must be getting on for fifty now," she says unexpectedly fondly. "When I first met him he was in thick with the best punque roque crowd. Bill was a goodtime guy, beautiful fatal olive face. He used to live in Brooklyn with Noo Sturges. She was this, this controversial singer. People fucking hated her and Bill loved her. There was this one review which speculated as to whether she was the poor man's Debbie Harry or the thinking man's Patti Smith. She was the victim of that kind of slick cosmopolitan sexism. She died back then of cancer. Smoking. Bill got bored with punque roque right around then and when she died he moved into the Chelsea, got married, got divorced... Bill...of course...has done very well for himself: ended up in Rykers onetime which can't have been a picnic. Bill being kind of diminutive and, certainly then, fine looking."

"What'd he do to get to Rikers?" I ask. I was once a journalist. A hack, even a long retired one, is never afraid to ask an impolite question.

"He was, uh, partial to rubber cheques in a time when rubber cheques still stood for something. He even supplied me with a few. They're no collector's items, Bill's bounced cheques."

She sighs, a sigh which protests against the fact that men sometimes wear better than women, though Isabella wears it well.

Later, about 3am, Aladdin is around in my place and we're listening to *Batty Rider* by Buju Banton. I'm telling him about the *Boom Boom Batty Boy* controversy which he is too young to remember, and about the time I saw Buju live at the Brixton Academy.

Claude and Mary (from In the Sixties)

by Barry Miles

Also living at the Chelsea were Claude Pelieu and Mary Beach. I wanted to meet them because I sold Bulletin From Nothing, their cutup magazine, at Indica. Allen told me a wonderful story about Claude to give me an idea of what to expect. Several years before, at a party given by Panna Grady at her apartment in the Dakota, Norman Mailer and Claude had been standing, waiting, outside the door to the bathroom, both getting more and more desperate. Mailer knocked urgently on the door, but to no avail. Claude was drunk and could wait no longer, so he pulled out his penis and pissed in Mailer's pocket. Mailer was initially unaware of what Claude was doing, then jumped back in horror.

Enraged, he grabbed the door handle and virtually tore the bathroom
door from its hinges. Out fell a heap of mops and brushes. They had
been waiting outside the broom cupboard. "Now," said Allen, gleefully,
"every time Norman sees Claude, he puts his hands in his pockets!"

I called Claude and Mary and went to visit. They had a one-bedroom
suite overlooking 23rd Street with double French windows opening out
onto a balcony. The walls were gleaming white, recently painted, and
books were piled high on the marble mantelpiece. At the right-hand
end of the mantelpiece were piles of blank paper and an old office
typewriter where Claude wrote, standing up. The walls to the left of
the door and the right of the window were covered by huge collages of
cut-outs taken from underground newspapers and magazines, particularly
from Evergreen, Robert Crumb cartoons from EVO and Zap, and sex
pictures from Pleasure, Screw, New York Review of Sex, Kiss, et cetera.
Words were collaged all across it, as well as political jokes, with
Nixon peeping between the spread legs of a naked girl. A Sony portable
television to the right of the door was always on, and static coursed
across the newsreader's face. Claude and Mary had very European manners
and immediately offered ice-cold beer, coffee or spirits. They seemed
in every way a respectable middle-class couple. Claude wore his hair in
a neat Beatle cut, which was restrained by the standards of the time,
and Mary dressed as the middle-aged Yankee heiress that she was.

Two bookcases were filled with modern literature; new copies of
paperbacks often sealed in cellophane to protect them. Claude and Mary
conversed together in French and all my visits had this background
of the French language, as Mary translated items of conversation
that Claude misunderstood, or when she asked him to bring more beer
or to roll more joints. They did a tremendous amount of work here,
translating Burroughs, Ginsberg, Leary, Ferlinghetti and others into
French. They did not often go out; a trip to Greenwich Village to buy
all the new sex papers and paperbacks was quite an event for them.

To an outsider their relationship seemed at first to be antagonistic,
with Mary constantly criticising Claude in rapid staccato French,
accompanied by a grimace, and Claude continuing at great length to
describe, in as derogatory a manner as possible, the defects and
qualities of Mary's clitoris and cunt. This use of shock language was
characteristic of Claude and he lovingly bestowed it on everyone.
Mary's great friend Peggy Biderman would have been surprised if Claude
didn't refer to her at least once as a 'Jewish cunt' during her daily
visit. They were all very open and friendly and showed me all their
files and books on Burroughs and Ginsberg. They made me as welcome as

possible and I was very grateful for it.

A few days later, in the El Quixote, I saw Claude and Mary eating at one of the centre tables. Claude looked up as the waiter approached. He had on full Egyptian eye make-up. The waiter started back in shock. 'You want to fuck me, eh, motherfucker'' Claude asked the waiter. 'You think I'm a goddamn fag?' The waiter knew Claude and on this occasion actually smiled. The manager, Gil, frowned in magnificent Spanish disapproval from behind the bar.

Another time I was with a large crowd of Chelsea residents, sitting at the huge table at the back of the bar, next to the door which led through to the Chelsea lobby. Leonard Cohen, Harry Smith, Peggy, Claude and Mary and a few others were all there drinking. A Polaroid photograph was passed around of Claude lying flat on the bed, his feet on the floor, his erect cock stuck through the middle of a dollar bill. Everyone laughed because Claude and Mary looked so respectable otherwise.

Conversation with Claude and Mary was about Abbie Hoffman, Jerry Rubin, Ed Sanders, Allen Ginsberg, William Burroughs, the Black Panthers, Jean Jacques Lebel, the underground press, counter-culture and dope. We drank Miller Highlife and smoked pot. They were not well informed about music except the Fugs and the MC5, which had reached them through literature. Once, sitting in our favourite large booth just inside the El Quixote, Claude and Mary were trying to find a name for a new literary magazine they intended to put out. They had a list of Ed Sanders-type names like Moist, but none of them was really suitable. I passed Mary the menu, closed my eyes and pointed at random to one of the items, in the best Dadaist tradition. They called the magazine Fruit Cup, and dedicated it to me.

I once ran into Claude in the lobby looking rather pale. He had just come down in the elevator. Normally one or other of the elevators was out of service and neither of them exactly inspired confidence. Claude had entered the elevator and had been joined by the maid who cleaned their room, a very large black lady from Haiti. Claude was more than six feet tall and well built. As the doors slowly closed, she grabbed him in a bear hug and began jumping up and down with him, shouting at the top of her voice, "I − don't − like − small − men!" Although flattered by her attention, he none the less felt a certain consternation because each time they landed, the elevator cable seemed to stretch and the car shuddered and groaned. Claude was sure he was about to die and said he planned to cushion his fall by throwing himself on top of her if the cable broke.

JULIAN SCHNABEL

Julian Schnabel is sitting in the lobby, flanked by a flunky, talking to some obnoxious looking satiated stoat in his early twenties who might be interviewing him for some lesser print organ or who might be willing to suck his cock. Same difference. Schnabel looks impressive and manly, and he is laying out a few reasonable enough aphorisms. "When somebody says 'reputable art dealer' think 'reputable drug dealer'" is a good one that gets a cracken awakes-like caw or laugh from the asshole who's been granted the painterly audience.

Then the conversation drifts off into other painterly directions so I'm drifting towards the gig ads in the *Village Voice*. Just then another ambitious young man in his early twenties, this one thin and reasonably well presented, approaches the satiated stoat to say hello and how're ya doin', genuinely unaware that his fat pal is in the company of greatness. But the stoat won't let anybody step on his blue suede shoes.

"Hey Jim, long time no see," says the walking thin one.

"Oh hi, George," says Jim the stoat dismissively, doing his best imitation of a Bret Easton Ellis-style asshole, turning away from his old chum in the direction of Schnabel, who must see something of his younger self in George because he is beaming with a painterly, fatherly, smile.

"I just got my first work in three months. I think it's a good part. Things have been really slow," says George laconically, about to move on.

"Look! What do you want?" asks the irritated stoat, blowing his gig. Schnabel almost bursts into a giggle. Thin George heads towards the lift, a Chelsea permanent resident.

THIRTY TODAY

A homeless guy sitting on the pavement outside the 23rd Street Subway entrance is saying is a calm voice, "Thirty today. Thirty today."

He doesn't sound distressed to be in his situation at thirty and he's not using the event as an excuse for panhandling. He sounds like he just got out of bed in his suburban home and the wife and kids are throwing a surprise party for him later on tonight, like he'll be going for a drink after work with the guys from the job. He's just plain pleased that it's his birthday, especially pleased that it's an important one like his thirtieth.

Many people are like this — they celebrate their birthdays, other folk's birthdays, Christmas, Thanksgiving, the end of Ramadan, wedding anniversaries. I don't.

But I feel like going over and saying to him, "Happy Birthday!" But I don't.

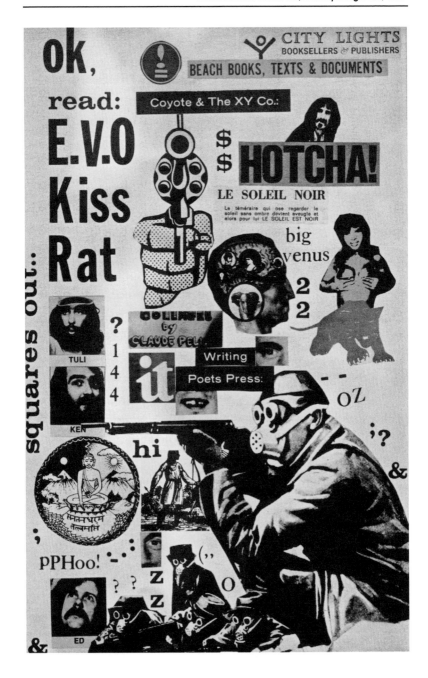

JOHNNY THUNDER'S APARTMENT /
BATTLE FOR BEIRUT

This story goes back a few years. A boxed set. A track from the vaults. Previously unreleased material. Six newly discovered tracks plus a whole CD of live material. Three thin but strong brown lines chopped out on the box's cover.

I was once in the apartment of Johnny Thunders in the company of that other great needlepoint maestro Phil Lynnot. It was the time of that great atrocity, the Battle for Beirut. I was always seeing on my colour TV fresh news of the bombed out basements and the torn apart habitations of the onetime Beirut bourgeoisie.

I'd bumped into Lynnot earlier that afternoon in a small soul food place on Chicken Street that I used to frequent in those days, called Chicken Little. I was arguing with my girlfriend so Lynnot couldn't help but pick up on my Irish accent. Turned out we had mutual pals like members of Irish rock bands, midget junkie music biz publicists, and seven or eight of the more enterprising drug dealers in Dublin. He had to go, that very day, to hang out with Thunders who was, temporarily, billeted at the Chelsea in the apartment of a former girlfriend who'd split for Europe for a year, leaving Johnny to protect her home!! And did I wanna meet Johnny Thunders? Yes. So see you in front of the Chelsea at 2.30.

Lynnot was very much a stylish customer and considerably further up the food chain, with all Thin Lizzy's European hit albums and sold out stadiums under his belt, than poor old Thunders who was more or less at the end of his "career." Lynnot, despite the bangles and beads of his Top of the Pops triumphs, was a good person and a notable songwriter, not to mention being a worthwhile noisesmith with his bass. He assured me that Thunders was an interesting dude and pleasant too.

We met in the Chelsea lobby, took the elevator to Johnny's floor, fobbed off two Chinese junkies who were panhandling on Johnny's corridor. The place was really run down then, as dangerous as Alphabet City. A lot of people were paying very low rent and some of them were paying no rent at all. We shared the lift going up with a transvestite who, it subsequently turned out, made home deliveries of heroin to some of the more infamous residents.

Philip was anxious to get indoors because he had a fat baggie of smack on him that he'd just scored and needed to party with. Despite frantic Dublin knocking and shouting, there was no response from Thunders' room. We were knocking on Johnny's door for a good ten minutes, getting nowhere. Lynnot was all set to go downstairs and flash his platinum card to get us a suite of rooms of our own, right there right then, when these sorta spider-like scratchings emanated from around the area of Mr Thunders' door lock.

(I had a novel extract published in a German anthology of prose by writers who

are also in bands or musicians who are proper writers. My fellow contributors included Nicky Sudden, one of those who once grabbed, in the confusion of life, for the mantle handed down by Keith Richards and Johnny Thunders. In the German book, Sudden writes about Thunders. He mentions being backstage at a Prince Charles charity gig in Hyde Park, the very epicentre of reactionary rock values, infested with Sting, Elton John, and suchlike vermin and poisonous snakes. At this legitimate target of an event Mr Nicky Sudden bumped into the moronic Jeff Beck.

Sudden says to Jeff Beck that he'd once handed Thunders a copy of his *Live at Max's Kansas* album to have it autographed. Thunders' comment was that he hated the sound on that album; the only good thing about it was the photograph of himself on the back cover because, in it, he looked like Jeff Beck during the epoch of The Jeff Beck Group. The real Jeff Beck, decades later, turned to the real Nicky Sudden and said, "Johnny Who?"

" 'How the fuck did a lowlife like Nicky Sudden get backstage at a Princes' Trust gig?' is the first thing that comes to mind with me when I hear that story," said Frank Digger correctly, when I recounted the whole incident to him. My own thoughts exactly. Three months later I repeated the story and the comment to Nina Antonia, the biographer of both Thunders and the New York Dolls. "Well, I can answer that question for you," said Nina while we were hunting for cheap sneakers together, "Nikki Sudden was going out with seventies superstar BBC DJ Annie Nightingale at that time." So Sudden had access to every Old Guy backstage pass known to man, Rolling Stones U.S. tours, you name it, and must have been in hog heaven.)

The spider-like scratchings emanating from around the area of Mr Thunders' door lock came to an end, and were replaced by seven or eight twangy human sounds such as *Huh?*, *Cun?*, and *Wha?* From behind a black door with the number 216 painted on it, we could hear a chain lock being put into place, Lynnot all the time shouting "Johnny! Johnny! It's Philip. Phil Lynnot. Let us in for fuck's sake, man. I bought a birthday cake for you. Got some cake right here right now man." Which caused an extraordinarily efficient mustering of energy and resources inside number 216. Very soon keys were turning, throats were being cleared, and lights were being turned on. The day had just begun. Next thing I knew us two Irish lads were inside and the door was being locked behind us.

Thunders looked good. You could have cut bread with his chirpy cartoon accent. He looked like Keef just like he was supposed to do and like Jeff Beck from the epoch of the Jeff Beck Group. He got that much right. The apartment looked like the Battle of Beirut, all hope had been abandoned. The smell from his kitchen mixed over ripe water melon, three day old rubbish, some prawn shells fit to get up and start walking of their own accord, sour red wine, and the 16 year old chick who was responsible for the fine-smelling lasagne baking in the oven.

Lynnot was twelve months dead when, years later, the punk band I managed, the Baby Snakes, were doing a gig in London. One of the other bands on the bill,

not a very convincing outfit, were mainly junkies, and pretty young junkies at that. Their guitarist Zack was a charming, mean, and well read youth aged seventeen. Of course he was old beyond his years like some junkies can be but also with proper lips and hips. Zack came from an Up There Notting Hill family and he told me how his folks booked him into this upmarket rehab clinic to detox one time. He was going out for a walk around the grounds at midnight when the next thing he sees is this big slick car pulling up into the driveway. Two big tough roadie types hauled Phil Lynnot, who looked green and like he was dead already, into the foyer.

"Man, I just loved Thin Lizzy so you can imagine my amazement at seeing Lynnot," Zack told me still bug eyed with the recollection, " and the state he was in, how ill he was... they were bringing him to this place, little more than a drying out farm. He stayed there about three days, just got worse and worse. He was just in a room like a hotel bedroom with a family doctor coming in every day to take his temperature. You could smell the death off of him, coming out of the room. I called in to see him twice but he was way too sick to talk. He just smiled nice at me, seeing my long hair and tattoos, seeing that I looked like a musician I suppose. Eventually they moved him off to a sort of old people's home where they had to do emergency surgery. When they opened him up to have a look at his liver, they found his organs were rotting already though he was still alive. They just sowed him back up. Within the week he was gone."

LOVER AND LEVIS

This is how it feels to be lonely. This is how it feels to be small. This is how it feels when your world means nothing at all. I hate doing this to her, it makes me feel squalid. I don't hate doing this because I hate doing this to her. I hate doing this because I hate doing it to myself now that at long last I have found a warm funny womb to crawl into.
"You meet me?" said in a voice of childish concern.

"You meet me?" like it's the last thing on earth.

"Now you are the happy nigger, Irish," says Longtree. We are sitting in my rooms listening to one of the five-for-a-dollar rap CDs I bought earlier. It's a great Jah Screw one. Not rap of course but a compilation of reggae ragga dancehall shit produced by Jah, whose name is so cool that I once borrowed it and used it for the name of a character in a novel. The man in question, the man upon whom the Jah Screw

character was based, took some obscure offence but then we Irish like to take obscure offence. We're like the Spanish in that regard.

Us Catholics. When we die our celestial chambers will be decked with gold and we will ascend to Heaven on cumulus clouds wrapped in sky blue garments similar to djellabas.

"I want to stay here in this world until the end," says Longtree out of the blue when the CD ends and there is nothing new going on.

He pulls this CD out of his pocket that his best pal in Harlem has just done with some DJ. It's weirdly interesting. I don't know. One song goes

To lose your lover and your Levis?

Your t-shirts and your paintings?

Please say "Help" and come.

PERSONALITY CRISIS

I must be going crazy because I keep thinking I'm running into Sylvain Sylvain from the New York Dolls in the Chelsea lift. It must be the drugs, though I know he is pencilled in to do a CBGB benefit gig in the Bowery Ballroom that I'm going to on Saturday. He is in the lift with me, asking his lady friend if she has any cash for a taxi, somewhat embarrassed that I'm overhearing their domestic conversation.

SUCKING THE IRISH

Nathan was on tour with U2, filming their East Coast shows for the making of a hi tek documentary for VH1. What a shame that a farouche boy like him who started off so well in a penniless way documenting the psychobilly and garage bands of Dublin on Super 8, when Dublin was just the world's biggest unemployment exchange, should have ended up being sucked into that vulgar Protestant money machine but, on the other hand, thanks to God that Nathan can make a living.

There was a tour break of three days in New York and Nathan got himself invited to a dinner party at the Chelsea. There were members of U2 present, plus all sorts of worthies from the worlds of rawk and Irish America: some retired punque roquers, various younger Kennedy women who like being fucked by young Provos, members of Talking Heads that nobody gives a shit about or can even remember their names.

Nathan was lucky enough to sit around the dinner table next to Debbie Harry who took a shine to him.

"Can you speak Irish?" she asked Nathan, who is a shy kid, for all his prettiness.

"Just a little. I learned it at school, but I forget the most of it," he replied.

"Did you have an Irish teacher at school?" inquired Miss Blondie.

"Yeah. Our Irish teacher was Miss Murphy," said Nathan.

"Well, why don't you pretend that I'm Miss Murphy? I'll stick my tongue down your throat and see if I can suck some of that Irish out of you."

HAUNTED HOUSE MUSEUM

Two Latino brothers, who pretend not to know one another though they're identical twins, are making deliveries from two different restaurants, an organic Japanese and a plebby burger joint, to two separate rooms. One of them — the Japanese organic kid — gets off the same floor as me and heads in the same direction as me. It is obviously his first visit to the hotel because he looks around in complete amazement. The interior of this place is quite something in terms of gothic Victorian dank atmosphere. He quickly gets on his cellular and calls his girlfriend to tell her, "It's like a cross between a haunted house and a museum. You seen that video, *The Shining*? With, like, Jack Nicholson? It's like *The fucking Shining.*"

AVENUE C

Suicide King and One Eyed Jack, who lived in reduced circumstances in small rooms alongside one another on the Chelsea's tenth floor, were the best of friends. Every Friday night they tried their hands at the poker game that Hannah Reed ran on the third floor. So when Suicide needed money one day, One Eyed Jack pulled out a roll of tens.

Later they fought because Suicide King refused to pay back the loan, though his circumstances had greatly improved.

"Un hombre duro!" Suicide King said sarcastically about his old pal, when Jack got annoyed and threatened to do something about it.

"Despotico!" One Eyed Jack replied, sad to have lost his friend over so very little money.

BOWERY BALLROOM

Garland Jeffries is onstage. First I heard of him he was getting a namecheck on John Cale's first solo album after he quit the Velvets. Friend to Lou Reed, obviously, given his appearance at this Reed-sanctioned benefit gig for some old black guy who used to be a go go dancer or a bitch-fucker in the Max's Kansas City back room. Jayne County, who used to have a yen for Frank in London in the eighties, is the DJ. Somebody, I think

Danny Fields, announces to the three hundred or so folks gathered (rich looking guys in colour supplement threads), that this whole event would have been impossible without the support of Lou Reed. This causes a few begrudged claps and grunts from the audience. It's still very much *Fuckin' Lou Reed!* in New York. Then the MC goes into a soliloquy in praise of Reed's entire career, how Reed has made a remarkable array of solo records. The crowd don't seem all that much more convinced so it's almost embarrassing when it becomes obvious that the next thing up is Lou Reed, who takes to the stage to some applause, singed and wincing at his poor reception.

He does a sharp version of *Waiting For My Man* about standing on the corner with lots of suitcases in his hands. Then he takes a background role while Garland Jeffries does some ancient doo wop shit. Reed seems pleased to be drifting into the background on those tunes. I hate doo wop. Sentimental attachment to this music is a bad thing. That *was* Sylvain Sylvain I was running into in the Chelsea lift.

Three days later I'm back in the Bowery Ballroom with Frank to see Ash, who've had loads of hit singles in Europe but who're still working on America. Frank has known Tim Wheeler for a while now so after the show I get introduced. Tim arranges to come see me at the Chelsea two days hence. He has changed his clothes after coming off stage and is sporting a Lou Reed *Transformer* t-shirt. I tell him about the Max's Kansas City Benefit.

Later we take the subway north to make an after midnight visit to Ira Cohen.

WARHOL FOUNDATION/ The Anita Pallenberg story

Sometimes I stare at myself in the mirror and forget who I'm becoming. When the old men do all the fighting and the young men just look on.

The assignation at The Andy Warhol Foundation was organised about two months ago. Peter Playdon from Coventry School of Art is working on this project concerning the movie *Performance*. Somewhere on the internet or through academic connections, I don't know which, he has arranged for us to go see this film called *The Anita Pallenberg Story* at The Andy Warhol Foundation. Seems one of the women involved in making it works there and she has graciously agreed to organize this screening just for us.

I've arranged to meet Tim Wheeler from Ash back at the Chelsea so my time is kind of tight. I have a 2pm appointment to meet Tim in the lobby and the movie screening is scheduled for 10.30am so this should be okay. I'm as interested in this thing about the Stones and androgyny as a man could be without being perverse.

It's a freezing morning as I walk from the Chelsea to the Warhol Foundation on Bleeker Street. Arriving early and hungry, I head into a diner across the street.

None of the people Peter has arranged, by round robin email, to meet outside the Foundation's ground floor entrance have shown up yet. In the diner I order a roll and a tea and sit on a stool looking out onto the street. I can observe the entrance from there. This is a real Simon and Garfunkle vibe, steamed-up windows, the smell of coffee, the smell of toast, the lonely people. All I need is an acoustic guitar, a duffel coat and maybe some snow falling. I am a rock, I am an island.

I see a black girl loitering outside the Foundation and, since the group who're going to view the movie consists of me, Peter, a musician called Frederick, and a woman called Kandia Crazy Horse, I hazard a guess that this may be her. I finish my roll but take my steaming hot tea with me. By the time I get across the street the freezing wind has rendered the tea drinkable.

I've just started talking with Kandia when Peter and Frederick show up and we head in.

The walls are as extravagantly covered in Warhol works as the walls of an adolescent boy's bedroom might be covered with Slipknot or Britney or Tupac posters. There is an attractive enough looking oriental fag behind the reception desk but that's about the only vaguely Warholian thing about the joint, interior decorated like one of those hip boutique hotels. A serene silence, similar to that once found in a smalltown Catholic church in Ireland during a midweek afternoon in 1973, dominates the atmosphere. All we're lacking is a leftover smell of incense. This is different though; this is the adult silence achieved by the presence of serious money, Yoko Ono-style money.

Back in the hotel Tim and his girlfriend are waiting for me. She is a beautiful looking woman whom I subsequently learn is a model. We go rambling the Chelsea corridors. Tim says he was backstage at Ryan Adam's gig last night and that Adams offered them his room in the hotel since he was heading out on tour. I show them the bicoastal bisexual movie star's place. (Carter tells me that he intends to use it more as an office in future. Coulda fooled me.)

Sylvain Sylvain and his girlfriend are putting their suitcases into the back of a smart family car when I walk Tim to the front door. Sylvain looks like he has a normal life, whatever the fuck that means. God bless him. He fought out his war. Now it's Tim's turn.

Suitcases? Me, I feel you must have the whole thing, go the whole way. You got to have rock'n'roll luggage like you got to have rock'n'roll clothes, records, and attitude.

STATEN ISLAND FERRY/ The art of war

By the time I reach the terminal it's 1am and dank; Dickensian, murky, disreputable, like in *The Alienist*, that crap Caleb Carr serial killer novel set in nineteenth century Manhattan. My outward bound fellow travellers are low rent revellers, stunted looking shift workers, and a multiracial selection of lumpen drunks'n'drones. I even discern two native Irish in the drunk contingent. Not too many independent ladies in evidence though there is the usual array of craven late night female consorts stripped of their autonomy.

In an ironic way, women don't play that big a role in American society. Stepford wives-ism remains a powerful force. It's like the great intellectual achievements of American feminism have passed a lot of women by. Women still get treated like they're real ladies whom one should avoid cursing in front of and whom one should open doors for. Cunnilingus should be undertaken silently and not discussed at dinner parties while there are ladies present.

Conversely, and this has always been the problem with so-called gallantry, American men indulge in a pig-like ongoing meditation on the size of women's tits and their sexual availability.

The ferryboat moves forcefully through choppy waters which are half protected river delta, half open sea. It's a bit like when you go out into the lagoon in Venice. The sea could suddenly turn rough and tip you into the abyss, it seems to a nervous traveller like me, though the calm boredom of the people around me is reassuring.

We pass the Statue of Liberty on a bright cloudless night and all I can make out is a cloudy blur because I'm too vain to wear glasses. I see enough to know that the famous icon is right there in front of me, and I have a fair idea of what size it is.

We pull into the Staten Island terminal where the crowd disappears with shocking immediacy. In what seems like seconds they're gone to waiting cars and trains so that I'm left more or less alone. I leave the terminal building briefly but all I see in front of me are motorways going in every spaghetti direction. Just beyond this sea of highway there are a few uninteresting looking grey civic buildings. Discombobulated figures, wretched post-apocalyptic beings reminiscent of monsters in a *Heavy Metal* cartoon I once saw based on Burroughs' *Wild Boys*, emerge out of various darknesses: the darknesses of doorways, ruined buildings, wrecked cars, tunnels, unlit footpaths.

The usual array of urban wolverines have spotted me for a stranger. I retreat into the terminal building where an antiquated but beguiling information board using strips of red neon says that the next ferry back to Manhattan leaves in twenty-five minutes.

In the waiting pen there are all manner of humans. A gang of black junkies in their forties, lost to this world, shabbily dressed; malevolent despite being more or less incapacitated. This time there are some interesting looking women travelling alone; what the tunesmiths call sad old broads all glamoured up with nowhere to go, waiting for the next Neil Sedaka or Neil Diamond show coming through town. The wiped away take-away food stains on their plastic suits are not quite wiped away. The Queens of 1974.

Three well dressed young guys sit down near me and we start talking. All three are studying the Modern American Novel at Columbia. Swellegant. It's passably interesting to be bullshitting them about Borges (whom I once saw reading) while they're bullshitting about William Burroughs (whom they've never read anything by). Of course they would die for Bob Dylan and the death of Joey Ramone is a total tragedy. Totally! All this fucking ancestor-worshipping crap that students indulge themselves in makes me want to puke. Why don't they go out and buy thirty-five albums by Dylan if they think he's all that cool?

I ask them what they were doing on Staten Island after midnight. Seems all three come from there. Their dads are, respectively, the principle of a large Catholic school (the hunky blonde one who looks like Johnny Depp), the owner of a chain of electrical goods stores (a rather porcine, likable, and smart enough one), and a TV news guy I've seen on one of the local channels (the black handsome moron who will go far in this life). They were out home at a party to celebrate the newsreader being in the TV game for twenty years. All their dads were there. All their sisters were there. Sounds riveting. They're on their way back to different Manhattan apartments.

I'm briefly distracted by a gaggle of guys from a rock band with their girlfriends, all involved, weighed down by guitars and other detritus from the life of the small time gigging musician.

Lots of old black ladies arrive on their way to start working. There is a separate class of somehow more respectable and less drunk old drunks, what used to be called "characters" in the fiction of Chandler or Runyon. Good looking muscular black adolescents in Genetesque profusion pose in the most extravagant hip hop gear. Pity they don't like the music too.

While I'm passing my time with the American novel students (we've moved on inevitably to the Chelsea Hotel which of fucking course they'd just love to come and visit me in since it's totally awesome) this weird couple start looking at me sort of strange. They're kind of short and Goth with dyed long black hair, purple eyeliner, all manner of horrible expensive black leather gear; the type of people that make my flesh crawl. Once upon a time their educated junkie chic must have cut quite a swathe through demi monde society. I reckon these two look like real Golden Horde or Johnny Thunders types. Maybe they're the sick fiends behind the Golden Horde's website.

Eventually, as we make our way on board and I lose the Columbia jerks, the

woman half of the leather couple summons up enough courage to approach me, whereupon all is revealed. "Excuse me," she says politely, "are you Handsome Dick Manitoba?" I assure her that I am not but insist that I am delighted to be mistaken for the leader of The Dictators. She thinks I'm lying for a moment, and then she catches the Irish accent, says she and her boyfriend were sure that I must be Handsome Dick Manitoba. I look exactly like him, she says. This explains the odd way people behaved when me and Frank Digger went to Manitoba's bar to meet Jack Rabid.

People just like us get off the Staten Island Ferry from Manhattan, and we that've been waiting on Staten Island get on.

SISTERS/SIRENS

"You meet me?" said in a voice of childish concern.
"You meet me?" like its the last thing on earth.
Oh sister, do you still think that I purr like a throaty cat?
Oh, brother, I'm smart and sharp as I ever was but I'm no longer young.
I want the shovel and six feet of dirt. Want to rock *and* to roll. I'm lonely and cold.
I get what I deserve. I grow old, shall wear the bottom of my trousers rolled. I am
humble and I can also be nice. I am moving. In and out and up and down.

Moving around Manhattan in a car I have that helpless lost feeling which gets
accentuated when the car is a cab. Both feet on the solid ground anywhere in the
city I feel fine like I'm at home.

A black limousine passes by the Chelsea. A thick ribbon of video tape, perhaps
Betamax, trails behind the limo for about two hundred yards. The source of the
tape is the rear passenger door of the limo.

Four rich lesbians in some kind of high grade Audi coupé grind to a halt right
there in front of me. Their windows are down so the Michael Jackson *Black and
White* album is humping out of the speakers. He — the only man on the planet to
whom I've ever comfortably attributed the term "my contemporary" — still sounded
great then. Being my contemporary, he could tell the difference between a good
guitarist and a bad one. More importantly, being my contemporary, he could work
out the purpose of a good guitar solo.

The lesbian gals are real suit and tie jobs. The boss — about fifty tough fucking
years for everybody who ever came in contact with her from her folks right down
to her contemporary underlings — is the one behind the wheel, as if to the manor
born. She looks like the Senior Vice President in Charge of Canteens at Chrysler
from 1951 or something like that. Her girlfriend — a well preserved forty called Manu
— sitting in the passenger seat is less of a freak show, sort of beautiful so long as you
know your black and white movies and can place her. No pre-Raphaelite, she is a
slightly stout Elizabeth Taylor from *Butterfield 8*, or Shelly Winters before she started
expanding. Manu has haggard kind eyes and a foolish mouth.

The two in the back, another lezzy couple, are more of your generic dyke outfit,
all designer mountaineering gear and sensible overalls such as never felt the
swipe of mud or the rancid spread of sweat. Back in the day in Brixton we used to
call these types of lesbians, who usually went around with a big dog in tow, Dog
Dykes. All four of them, anyway, are having the motherfucking argument to end
all arguments about choosing which CD to play next. This is why they've pulled in.
They're not going to the Chelsea and they're not going to Abasement and they're
not attending the Zapatista consciousness raising video and discussion that I'm
thinking of attending myself; those being great events for girls with long wild hair,

ethnic clothes, and not too many notches on their knives.

The boss dyke stamps her considerable foot and says they should play an old Buju Banton thing, the box of which she flourishes like she's Olivier in a Shakespeare movie. The boss is my kind of guy. I've seen Buju's show and he gets my vote. The boss's girlfriend Manu is alright too, and she is up for Gangstarr or KRS One. Or, inevitably, Buju or Madonna, who is fine to listen to if only she'd shut the fuck up in between albums, one of which every five years would be just great. So we know where this is leading. The two in the back are entirely dismissable — the ugly one wants Peggy Lee or Nina Simone and the still uglier one wants The Spice Girls. Give us a break bitches.

I get back to my suite with minutes to spare. A message from Bill Morphine from the Bill Laswell organisation returning my call. A message from Longtree, can I phone him when I get in. I can. I do. Before I dial his number I start a pot of coffee and put on one CD from the new Isley Brothers boxed set.

"So how are ya?" I ask him full of false Irish heart, like the Clancy Brothers are still stuffing Carnegie Hall, JFK is still buggering away in the oval orifice, and the Pope is relaxing with an altar boy at Castel Gandolfo.

"Me?" Longtree chirps like Mick Jagger reading the Shelley poem for Brian Jones at Hyde Park, which is a nice way of saying he sounds like a total homo, and a nigger total homo at that. He also sounds like Sly Stone around 1968. "Me is in a state similar in important respects to boredom."

Longtree says to me, "There are only three things you can't play games with — the police, the sea, and the fire."

I say, "Right."

"I am the sucker that I seem," I say to him at the end of the conversation. He has just persuaded me to take heroin again tonight. This — it will be the ninth successive night — is becoming something of a habit. I feel rather sulky about the whole affair, like I'm being lead by the nose to the trough.

This is real junkie thinking.

Then I nod off again,

Thanks to Longtree I'm now leading the life of slimy greatness.

Then love links you up with a locally famous face.

FUCKING A MOVIE STAR

In dreams my memories ramble out where my heart cannot go.
Hoyt Axton

I get with the bicoastal bisexual movie star. I spent the night with him in The Holocaust Cafe. Then later back to his place not mine — he has a permanent apartment in

the Chelsea with all kinds of stuff there like magazines, opium, unreleased movies by the big guys on DVD, photographs of his beautiful wife and their child (she perhaps the last real sex symbol in movies), coke and the fresh McDonald's straws still in their wrappers to go with it, a load of clothes, (much of it expensive material and not a whole lot of it too tasteful), cool CDs and then, alas, ones that he thinks are cool, loads of men's stuff. His wife rarely visits these days, stays in Europe and California. This was his home before they got married. Still is home, best as I can see.

He is not an uninteresting sex partner. Good looking though not as good as he looks in movies. He really is a big movie star. This is for real. I'm fucking a movie star. I'm up — on top — of a movie star. This must always be excellent but best of all I think is the fact that he's married to one of the few women in the public eye whom I regard, deep down, as being sexy.

He — Carter — has made one good movie, another in which he is good, and several others in which he looks good. Not bad by today's standards. The good movie, in which he is great and looks great, is a science fiction one. I don't normally go for science fiction or comedy but the bicoastal bisexual film star's one good movie also stars my favourite character actor and a singer I respect a lot; the character actor now grown real old, too old for chasing bad guys in motor boats like he used to do back in the day.

While we slept I dreamed that I was going blind. I stood at the mirror in a piss-smelling toilet in some private apartment staring at this fifties mirror over a manky sink which was coldwater. First I saw this tiny white spot, like a leak, in the corner of the iris. This worried me so I went away for a second to think about it. When I dashed back to the mirror later that eye — the left one — was entirely white (pus-white) — and the right one was flooding quick. Then there was one second full of the blackness of the abyss and then I woke with a jolt, sat up in the bed, turned to the right, placed my feet upon the tiled floor in the movie star's bedroom. He was sitting by his desk.

"Black cat crossed my path today," said Carter as the heroin bubbled black on the tinfoil and he dragged it deep inside him, "Hmmm...he had his baggage in his hand."

"It's finger lickin' good ya'll," he smirks.

"Sorry but I'm vegetarian," sez I.

"Darling please cool me," he pleads like a fag. I got no time for that shit in real time but I know that he is acting. He is no sissy and was no sissy in the bed. He put up a magnificent struggle.

"Once with boys I used to E," he says out of the blue.

"Me? I used to too," I reply, a lie. "Now I can't and won't."

"Ah, one time she was peeing," he says about his wife Jackie, of whom he is genuinely fond, "and she was saying to me *I'm peeing my fucking neck out*, we were both laughing, it was a warm day, a morning, we'd been to some soiree the night before but we'd gotten home early and watched some shit, some Bette Davis

shit, I was showering the time, man, watching her 'cause it'd come to a little trickle, she just made me so fucking... you know, you gotta know... that sweet... lickey... it got like hard... a rock until it was fucking... painful, man, you know the way you get when you're 14, 15?"

Yeah, I know. "The bus gives you a hard-on with books on your lap," said bozo Jimbo back in the day. The mere thought of his shower scene made Carter rock hard right there right then. Solid as the Rock of Gibraltar. How much would the two or them earn if they recreated their bathroom scene on the screen? It would have to be in some commercial shit, not like Cruise and Kidman in Kubrick's last movie. Also, Carter is somebody but he is not Tom Cruise.

But he is not a charlatan either. He is not a nice person. He is not profoundly well hung. He is not interested in acting. He has a little bit of strange about him for sure. A lot of the time when we're not drugging or sexing, (i.e. 99% of the time) we talk about writing. The Holocaust Cafe was three hours about Brion Gysin (my entry card into his life) and Burroughs, the rest about music. No shit? That I'd known about Shane McGowan since before the Pogues. Dylan was totally deep. He'd been backstage in Albuquerque with "Bob" who was doing the song for the wife's next movie. He kinda trumped my Shane McGowan there I guess. Music he likes a lot but doesn't know a whole lot about. He wants to make a movie about moshing. Naturally.

I met Johnny Cash so suck on that, faggot.

Fair enough he brings a little sex and mystery to the situation. I'll give him that. He really is a movie star and he really does take it up the ass with no more than the regulation sharp guttural sissy-boy blues intake of breath; the horse and his pale rider; the pale rider and his horse. The rock'n'roll nurse went through my head. I forced him to sing that for me. No fee involved. I think he wanted me to sign a confidentiality clause but I told him I wasn't the butler.

BORSTAL BOY

Arthur Miller: "Behan seemed a rather patched together personality of several colours by this time, I thought, what with his desperate heedless lunging backwards towards a passing fame that required the image of the happy-go-lucky, late-rising, debonair Irishman, all on a sick stomach. Balancing himself like a bully boy on feet spaced apart and rapping out slang like a worker-chap, he was in actuality a son of middle-class Irish people. When I sat with him at breakfast that morning, he turned to me and said, apropos nothing in particular, 'You're a real playwright, but I'm not. I just scribbled some dialogue a couple of times...' and broke off with a surge of anguish which he deflected with: 'But we're all born and dead, in a day, aren't we?' When I said I had been moved by his Borstal Boy and The Hostage he brightened gratefully but waved it all away nonetheless. In his morning sobriety he seemed to cease concealing

something crushed in his gut, the joking was gone, silence reigned within him and it seemed terrible that people were in effect encouraging him to drink and perform his cute Irish act with his salivating brogue which Americans adore."

ISN'T IT GRAND BOYS?

It is a cold March New York afternoon. I step through the Chelsea's glass doors. Six anxious looking Japanese girls stare at me excitedly. I'm not entirely sure who it is that they think I am. Staying in the Chelsea, you grow used to being part of a tourist attraction. People walk around the lobby, where there is actually very little to see, virtually swaying in awe of being in the presence of such iconography. I think they kind of expect Bob Dylan to walk around the corner any second now, guitar strapped on, writing the follow-up to Love and Theft right there in front of them.

In addition to looking like the drummer in Slayer, I've been told that I'm the double of the star of a popular Moroccan soap opera. I don't know who the Japs think I am but they seem happy enough with the deal.

A black woman in her forties, who looks kind of old fashioned, passes by holding the hand of a pretty little girl about six years old, who is grasping a piece of thick video tape, seemingly the selfsame tape I saw trailing from the limousine a few days ago. The kid has a lengthy enough piece, about ten feet long.

I waste a long time uptown looking for this famous Gotham bookshop but eventually I find it after an entertaining enough ramble through the Jewish diamond district. Much, much, too cold for rambling today. There is a notice in the Gotham window saying that the premises has been sold and that, after being in this spot since the stone age, they're on the move. The staff are all these pretentious bookshop staff types busy talking their intelligent stuff in loud voices so that I can hear them. The whole performance seems to be for my benefit because I guess I look like some arty or boheme type. Or maybe I look European.

They're talking about regional pronunciation in the Southern states; a bull dyke type, a string-of-misery hippie, a faggy black boy, and a faggy white boy.

They say in the guide books that this was Jackie Kennedy's favourite bookshop. I somehow doubt this.

I wander out of Gotham. I'm cold down to the bone in a way that no woolly jumper can prevent. I'm feeling the misery, being sorry for myself, when for some reason I notice a family group ahead of me. What is it that catches my attention? The family of four is walking along like a mother duck and her ducklings. Dad is out front foraging and sussing out the land ahead. His wife is almost alongside him but not quite so. Behind straggle a twentyish son and a lovely teenage daughter. No bullshitting around in the clothes department – this crowd, used to the cold, are trussed up expensively in sensible, if uncool, cold weather gear. Best that money

can buy. And why wouldn't they be dressed right? It turns out they come from the coldest wettest most godforsaken place on the planet, about thirty miles from where I come from in Ireland.

The dad is Liam Clancy from the Clancy Brothers and Tommy Makem, who conquered America in the early sixties, an integral part of the soundtrack to the Kennedy years. Dylan said that Liam Clancy was the best ballad singer he ever heard. The Clancys, like me, came from Tipperary. First time I ever saw Liam Clancy was around 1966 when there was a General Election in Ireland and he campaigned outside the polling station in my home town for the Labour Party.

My Granny Ambrose used to say that the Clancy Brothers were a credit to Ireland and to Tipperary, that they were beautifully spoken, polite, and immaculately dressed.

Liam Clancy came to New York in the fifties as an actor and soon became involved in the folk/radical drama scene.

CBS News: "When Irish music came into its own in the United States in the 1950s, there were no brighter stars in the Irish sky than the Clancy Brothers and Tommy Makem. After appearing on The Ed Sullivan Show they were soon singing for President Kennedy himself. They recorded more than fifty best-selling albums. Singing songs of Irish rebellion and songs from Irish pubs, brothers Liam, Paddy, and Tom Clancy, along with their friend Tommy Makem, filled concert halls across the country for decades."

Bob Dylan on the Clancy Brothers: "They just reached a lot of people with their exuberance and their attitude — mostly it was attitude….they're all great singers. There was a bar called the White Horse Bar… you could always go there any time, and they'd be singing, you know, the Irish folk songs. I learnt quite a few there myself. But Liam was…for me, I never heard a singer as good as Liam ever. He was just the best ballad singer I'd ever heard in my life. Still is, probably. I don't think I can think of a better ballad singer that Liam…Liam always sang those ballads which would always get to me." After the band broke up he moved back to Ireland where, in the seventies, he enjoyed huge commercial success. He is older now. My brother Robbie says that he has a recording studio and pub in Co. Waterford. If he's not to be found in the pub, he's in the studio. And if he's not in the studio…

He's in neither today. He's walking alongside me in New York. I'm kind of intrigued. Though he is walking in front of his family, he is not actually leading them. He seems lost in a dreamy world of his own, perhaps recalling the time when he was the toast of this town. The son and daughter are two fine looking pieces of Clancy. Mrs Clancy looks a good deal younger than Liam.

As my Aunt Josie once said to me, every dog has his day and every cat his night.

I follow this family voyeuristically for a minute but I want to go into an electronics shop. If I keep after them any longer, they'll think I'm some sort of Folk Revival stalker, maybe a demented Clancy Brothers and Tommy Makem fan. They've already

noticed me.

It's a long long way from Clare to here. It's a long way to Tipperary.

THE CLANCY BROTHER

Eventually I got to meet him in Ireland.

Liam Clancy: "Greenwich Village was an island for people escaped from repressed backgrounds, who had swallowed the directive to be inferior, to know your place, to kowtow to royalty, to hierarchy, and all the other nonsense."

He lives on the south coast of Ireland in a village called Ring, not far from his home town, in a house fit for a superstar. One could easily imagine Charlton Heston or David Lee Roth living in this house. Ring is part of a Gaeltacht, as places where the near-extinct Irish language is still spoken are known.

Liam Clancy: "It became impossible to work with the Clancy Brothers because the creative spark was gone. They were much older than me, Paddy was fifteen years older. As time went by the drudgery set in and I was being slapped down like the younger brother. I decided to leave the group. About that time we had an accountant who assured us that everything was alright but it turned out that, for years, when we were making the most money, he had never filed Income Tax returns. He just threw everything into a box and forgot about it. We got hit for $250,000, huge money in those days. By the time we'd paid off the Eternal Infernal Revenue I was broke."

Bob Dylan: "All the legendary people the Clancys used to sing about — Brennan on The Moor and Roddy Mc Corley — I wasn't aware of them, when they existed, but it was as if they'd just existed yesterday. I would think of Brennan on the Moor the same way I would think of Jesse James...I wrote some of my own songs to some of the melodies that I heard them do."

Brennan On The Moor grew up to be Dylan's Ramblin' Gamblin' Willie. The Parting Glass, which remains one of Liam Clancy's outstanding party pieces, got turned into Endless Farewell. And Dominic Behan's The Patriot Game – amid much whingeing from the lesser Behan – became With God on Our Side.

Liam Clancy: "The Fifth Peg became famous as Gerde's Folk City. Monday night was Hootenanny Night where I first saw Cisco Huston and Judy Collins who came in once with a broken leg. Bob Dylan, going "Hey, man! Hey, man!" became a regular who started writing songs to our tunes. He'd be there every night he could, absorbing stuff like blotting paper. As far as we were concerned we were freely given these old songs by old timers, maybe some old tin whistle player up on the side of a mountain in Ireland who sang Brennan on The Moor for us first. It was originally a big long thing, about forty verses which took half the night to sing. I think we got The Parting Glass from the poet and playwright Patrick Galvin when I

was living with my brother Paddy in Greenwich Village. Galvin had put out a book of songs from which we took the words, and we got the tune somewhere else. In our travels around, at folk clubs, we might pick up six songs in a night. They didn't belong to anyone; they were just being revived. You swopped them around, changed them around. If somebody wanted to write new words or if you wanted to write new words, it was great! Dominic Behan was basically very greedy. I said to Bob Dylan when he was playing in Dublin, "Did you ever pay him?" He said, "Naah!" I asked him what happened with his manager, Grossman. Dylan said, "He got very weird. He broke up with every act he was ever involved with and sued everybody for $37,000." I said to Bob, "Not $35,000 or $40,000?" Bob said, "No. $37,000." I said, "Did you ever pay *him*?" He said, "He died of a heart attack on a plane."

THE LAST RELIGION

When script and religion went hand and
hand the last religion rose up to kill.
Propaganda by deed.
Those prostitute girls just make me sad and
Prostitute boys don't make me bad,
Prostitute girls don't make me hot and
Prostitute boys don't make me hard.
Take some spliff
Don't get sick,
Don't touch the bitch.
I hope she don't get shot
For trying. Crying. Buying.

LONGTREE

Beware of whores who say they don't want money. **William Burroughs**
Play it strange. **Johnny Cash**

His smile a standing apology for the iniquity of his existence.
Catholic Radio is pointing a telescope at the sun.
Hole in the sky where God used to be.
The Queen of Henna
Hard like a nigger in jail.
The eye of the pyramid is open and awake.

CAMP CADAVER

The Duchess slept badly last night. She had one of her black mantilla Portuguese Catholic dreams. William Burroughs once said of her that she was a beautiful tall imitation Russian Countess of the vampire type. When you see her after one of her bad nights you kind of know what he meant.

THE FILM STAR WINS AN OSCAR AND PHONES HOME

Frank Rynne goes back to Dublin via Paris and I'm all alone again in Manhattan. Things going slightly wrong with Longtree though this is not his fault. He has bitch problems. Like he says, we couldn't expect her to stay in Florida forever. Now she is back in Harlem and has five thousand intelligent fair-enough questions for Longtree. Where did he get that Anais Nin book with the English travelcard as a bookmark? Where is the Isley Brothers boxed set? Whose hair is that? Where is her satchel? How long is it since he did the washing up? Where was he when she called at three in the morning? At least, as he points out laughing sadly, she thinks it's a woman.

Frank is hardly out of town when I turn on the TV and see that the Oscars are happening on the other side of America. I didn't even know that Carter was nominated. I see my man and his bitch on the entertainment news. It transpires that he has just won Best Supporting Oscar for the worst movie in the world which makes him look like he has a big ass when in fact he has a reasonably boyish ass for a twenty nine year old with some German blood in him. The following day the phone rings and it's him.

"Oh hi," I say all nonchalant, this being the first time I've ever been phoned by an Oscar winner the day after he got his Oscar, "I was just thinking that you didn't win that fucking Oscar for the way they made your ass look in that movie."

"Ah, shit," he laughs, more stoutly goodhearted than I ever remember him being (and I warn myself that he is an actor and a good one at that). "I knew you'd hate the movie but I had to do something. I was... aaah... I was..."

"You were going nowhere."

"God! You sure are a kind friend! Yes, OK, I was going nowhere so I had to make a movie..."

"A fucking movie which makes your ass look fat when in fact you got a real nice ass."

"Ass?" Carter is getting mystified. People – and Scientologists – have been congratulating him for the last twenty four hours and offering to suck his cock.

"Yeah man, your ass wins you the prize, man," I laugh.

"Anyway…" I can hear the tired thing in his voice. He is weary, perhaps genuinely mellow and happy.

I've ranted him into submission enough.

"Anyway, congratulations, really, I'm impressed," I say because I mean it. Of course I'm impressed. The boy did good. "You did good. You did good to win the Prize. You know I don't like the movie but you're… I guess I think you're a serious person and that you'll now use your clout well."

"Thanks. I will. I promise." Now he is all pleased and pleasured and submissive.

"You don't have to promise me anything. Where the fuck are you anyway? Are you here? In the hotel?"

"Nah. I won't be back for three days. I'm doing five thousand interviews and then I get home and do the same again. So let's go to dinner Friday night."

"Yeah?" I'm a little suspicious that he has so much time for me now he's so busy.

"Yeah. My mom is having a party for me late Friday so maybe just you and me go to dinner in my old neighbourhood, place my uncle owns, then we go on to the party?"

"Suppose the *National Inquirer* sneaks up on us and wants to know who your asshole buddy is, why you're not out celebrating with your beautiful wife the mother of your child?"

"That's the other thing I want to talk to you about. I want to talk to you about the two of us working a script together. I just bought the rights to this Hubert Selby story. You know Hubert Selby?"

"Not personally, no. Yeah, I know him, course. Lydia Lunch knows him. I even saw the movie with the Dire Straits soundtrack."

"Yeah, well, I didn't mean personally, asshole! Though I've heard he's pretty cool. So maybe this is something you and me could do together. You'd like the money, right?"

"Love the money."

"Well, whether we work it out of not, that's our excuse for dinner on Friday. You're the brilliant young Irish writer I'm working with on my Hubert Selby project. Jackie is already gone to Mexico to do a cocaine movie."

"Cocaine movies always bomb."

"I know that. She knows that. She don't give a fuck. She's just acting in it, not producing it."

"Your mother'll like me?"

"Like I told you, my mom's Irish. She'll just love you. Her dad came from Roscommon. Never told ya that, now did I? Ya thought ya knew why I let you inside my front door but ya didn't."

"But now I do."

"Now ya do."

He has to go do some more press – says to check him out on *Larry King Live* later though Larry isn't doing the interview – but he'll let me know when he reaches NY. The studio are sending him home by private jet. Hope it don't crash. They tend to.

His final word is, "what fucking movie with the Dire Straits soundtrack?"

I say, "Bye." And hang up.

I'M LOOKING FOR LOVE OR ISABELLA ARROGANT

"You meet me?" said in a voice of childish concern.

"You meet me?" like it's the last thing on earth.

"So. What's for dinner?" I ask, nonchalantly throwing my satchel onto her couch, turning up the volume on her stereo which is playing disco. I'm like a homo insofar as I like that type of music. Insofar. In so deep.

"Chicken a la bourgeoisie," says Isabella Arrogant, obviously an old rock chick when it comes to men coming home demanding food on the table while throwing their dirty underclothes into the washing machine. You can tell she's a gal used to being around bands and their balls.

I'm not all that demanding a sexual partner but I know for sure that I'm a very demanding personal partner.

Me, I've had nice girls a la bourgeoisie once or twice, but this idea with chicken is something new. Chicken is my favourite meat. Usually I like to do my chicken contra-bourgeoisie.

THE CROCOGRAIN WATCHSTRAP AND THE STORY OF A WATCH

"This is the story of the crocograin watchstrap and the story of the watch," said Longtree Gnoua to me and The Duchess as her Maserati Ghibli slides by the Dakota Building on our way to Ira Cohen's place on 105th Street.

"My Dad was stationed in Berlin and I was going through a kind of rough period. An early nineties techno period actually," he sounds all embarrassed like this is some best forgotten offence against civilized values.

"Don't worry about it," I reassure him. "We've all had those fumbling little techno moments. Anyone ever went to boarding school tried that techno. A recent survey showed that 80% of English men have tried techno at least once. There was even a dark techno remix of an Islamic Diggers track done one time. Another time I went to

see Two Lone Swordsmen. It's a mistake to think that those techno barbarians don't have aesthetic values. It's just that their values are... substantially... different from yours and mine."

Longtree is more annoyed at being interrupted in mid-reminiscence than he's embarrassed about his Berlin techno phase. Sullen at being upstaged, his narrative develops a smidgen more vigour. Lack of narrative vigour is his failing as a storyteller. Just like his occasional willingness to bite the pillow comes as a bit of a let-down to a hunter-gatherer backwoodsman. I expect no better from Carter, I happen to know that that's how he got into movies in the first place. He told me. When he was fifteen he gave pleasure to a certain prominent rock'n'roll magnate.

"Anyway, mother...fucker! Irish motherfucker!" says Longtree with fondness. The Duchess sniggers discreetly, insofar as you can snigger discreetly. "I fell in with a bad crowd in Berlin. These techno anarchists. One of them was this tall geeky kid called Anton. He was always in and out of mental hospitals. Told me he got into anarchism through techno. His grandfather was one of the approved East German painters under the old Communist regime. They gave the old guy this beautiful Bauhaus mansion in a privileged enclave. I guess the Commies grabbed it off the Nazis who grabbed it off the Jews who bought the land, paid the architect, paid the builders. The Commies turned the mansion's ballroom into an artist's studio for Anton's granddad. By the time I was hanging out with Anton the old painter was

long dead and Anton had the whole place to himself. It was kind of falling down around him a bit but it was cool. Took ten minutes for hot water to come out of the taps. Then it never got beyond lukewarm. Anton set up some decks and a small PA in the studio; that was where we used to do drugs. There were Picassos on the walls and photographs of Bertold Brecht being entertained in the back garden."

The duchess's driver has heard of Picasso. "A perfoomier? Right?"

Brecht seems to be an unknown quantity to him.

"A perfumier," The Duchess confirms without a hint of irony, "and a damn famous one too."

"One day," Longtree concludes, "I was crashing in one of Anton's bedrooms when I came upon this wooden box full of watches. About forty men's watches. Several of them were very classy, particularly this gold rectangular one with a crocograin strap. I asked Anton where all the watches came from and he explained that his grandfather had a thing for watches. Every time he attended one of those international Commie cultural seminars or festivals as an East German delegate he was given a gift by the local organizers. He always requested that the gift should be a watch. And these were the remains of his collection. I could take one if I wanted. I took this one."

He pulls back his shirt sleeve to reveal a very fine Communist Rolex. The gold shines magically. There is also something luminous about the battered old crocograin strap.

I'm kind of drugged out by the time Ira starts into some rap about Brion Gysin fucking a goat while Hamri flagellated him. There is something about this story I don't like and find nasty. I'm too zonked to react much but I think that I can make out, out of the corner of my eye, Ira looking at me to see what sort of an impression the story is making on me. It might sound a bit like Gysin but it doesn't sound all that much like Hamri. But one never knows, do one?

IRA COHEN SPEAKS ON PLAGIARISM, THE RAMONES, AND THE DECENCY OF CHRIS STEIN

Anyway I know of this pretty good Moroccan restaurant if you guys feel like going there sometime. The owner is Kamal and I guess he kind of recognizes what I do and says I am welcome to eat there anytime. Somehow he felt that it was appropriate for me to do some short readings down there. Other people that I have brought with me to read have appreciated the vibe. One young guy I met there called Roberto is putting a website together for me so who knows? So you guys should probably go

there if you've got the time. Kamal runs the place with his American wife and you should mention me to him if you go.

What I was going to say was that you have all these kind of connections with these people. I know you guys kind of admire The Ramones and I have this strange situation with them. Not too many people in New York know this but Joey was the surviving half of a pair of Siamese twins.

As you know, I never particularly liked Joey Ramone but I used to see him from time to time. He was aware of what I was doing and somehow interested in it. I got to know him over the years. He could appreciate some of the things I was saying because he could discern the meaning in them. It was over many years and many conversations that I explained to him my experiments in Mylar. How I had come up with this technique in photography of using Mylar — these reflective distorting sheets — to make images in some way different. I'd done Jimi Hendrix and William Burroughs. He thought a lot of this.

Now I never met him but I gather that, whatever you might have said about Joey when he was around, this Johnny Ramone is a very unpleasant character with very forceful views and had a lot of sway within The Ramones. People tell me these things. I can't know for sure. Joey got the idea that my Mylar approach might be a good technique to use on a Ramones' album cover so he brought the idea to a meeting of the Ramones. I don't know a whole lot about how rock bands organize their affairs but apparently The Ramones used to hold what were like board meetings where important decisions were made.

Joey explained at one of these meetings about this Mylar, how I'd done the cover for *Dr. Sardonicus* by Spirit, and the distorted images that could be achieved, Johnny Ramone said something to the effect of, "OK, this is a good idea. I like it. But why get this guy Ira Cohen to do it. Why can't we get one of our own guys to do it?"

To be fair to him, like I say, I was never a big fan of his, but Joey made the point that this would not be terribly ethical or just. His mother used to have an art gallery so Joey knew how these things worked. Johnny, who is said to be a pretty forceful individual, insisted. They'd do it themselves from within their own team, just copy my technique.

Joey had told me that he was going to propose using me for the cover so now he had to come back to me and explain what had happened. I wasn't too happy about this and told him so. There followed a lot of toing and froing about it. They wanted to use this photographer they knew, George DuBose. It turned out that he was familiar with my work and respected it so the next situation was that he didn't want to get involved unless I was happy. I met him and he was very good, we talked a lot and got along very well. He is a very nice straightforward fella. In the end the deal that was worked out was that George would take the photograph for the cover and in the credits it would say that the image was achieved by using a technique developed by me. I guess that's something. So that's where the cover for

Mondo Bizarro came from.

Chris Stein has always been very interested in my stuff so he came up here one evening and we were talking about things. He wanted to look at some of my photographs, some items that appealed to him so in the end he wanted to buy a couple of prints and we came to a deal. I didn't overcharge him and we settled on a price that pleased the two of us and I thought he was a good person to deal with. I guess he could see here that I'm not rich because when he was leaving he said to me that, you know, if I was ever short of money, needed some, to just get in touch with him as he'd be happy to buy some more stuff. I was impressed by this.

I saw her in the *New York Times* yesterday and she has somehow changed. She looks older now but powerful and strong. All the things that she and Chris have been through have made them interesting people. She's not the girl she was when she came up on the punk scene but now she is, perhaps, iconic. Preparing for the next stage.

PUNQUE ROQUER

I head for the fag supermarket and buy a tub of $20 organic cheese complete with chives, some $7 organic bread. On my way back, calming down (you always calm down when you spend money), I remember to pick up my white linen shirt from the dry cleaners right across the road from the hotel, next to the YMCA. Also picking up his laundry is Raymond Foye who published with Francesco Clemente those Hanuman books by Patti Smith and Taylor Mead and Richard Hell. We gets to talking while walking.

I found stuff on the internet where Foye was telling people about a free gig Patti Smith was going to do before the first date on her comeback tour. Then he had to apologize when the show never happened because Tom Verlaine, guitarist for the tour, was reluctant to do a free gig.

Later I find a coffee stain on my white linen number and since I don't touch coffee I know some fag has "borrowed" my poor shirt to look nice at some sand-in-the-Vaseline soiree out in Brooklyn Heights.

When I get into the lift I encounter this little French fag punk and I take it all it out on him. I dropkick him full contact style and while he is lying there on the floor I take out my sharpened eight inch knife and I put the little shit out of his Green Day misery. Or should I invite him in for dinner? Looks like he could do with a good meal.

I'm listening to Madonna's revisionist version of *American Pie*. The original by Don Maclean was this lachrymose sort of turd, intelligent in a collegiate seventies way beloved of trendy geography teacher/Clifford T. Ward types.

American Pie used to be an anti-Creedence Clearwater Revival/Chuck Berry vision of American freedom; still a good song, far better than that fucking starry starry

night shit or the one about *And I Love You So* that Perry Como had his last hit with before he became incontinent and ga ga. Fuck that shit.

The thing about what this cunt has done to *American Pie* is she's left out the line about Lennon or Lenin reading a book on Marx while a quartet practiced in the park. Little showbizzy white trash fag hag piece of shit.

I am preceded along the road of life by a yellow butterfly.

GAGOSIAN INTELLIGENCE UNIT/ The shock establishment

The Gagosian Gallery are the Shock Establishment on Manhattan. Maurice Steinhouse is the Shock Underground. I watch him working hard late at night in his gallery when I'm coming into the hotel or going out. Tonight I tap on his window; he waves, and lets me in. He is in exactly the state that a good art dealer should be in, a mixture of commercial delight and professional outrage.

He has a sensation on his hands in the form of this performance artist kind of boy called Nathan Solid who has just graduated from a minor art college, is currently in Berlin helping make a movie for a painter. Solid was the biggest sensation at the New York Art Fair, which shut three days before I arrived in town. Several times Maurice has enthused to me about this kid, and now he has the time to show me the famous video.

Nathan Solid made this high ticket limited edition video of himself. The video begins close up of the boy's face. He looks more or less like what he is; the scholarly son of an art professor from Florida and his lovely wife, a prominent Republican monster. He has a nice face so looking at him is not difficult. The camera is slowly pulling back as you notice that his face twitches occasionally, once surrendering itself up a reluctant smile.

Well, this goes on for five minutes, the camera keeps on pulling back ever so slowly and Solid grows more and more restless. I don't blame him. It emerges that he is naked. His shoulder and pectoral muscles are clenching and unclenching pretty rhythmically at this stage. Then the camera pulls back that bit more and you see that he is being taken from behind, and is bending over a small pine table. You never see his assailant's face but the two of them seem to come at the same time.

Maurice is a great salesman and I love listening to him on his phone, selling the video, of which there are now only thirteen copies left available, to rich folks who call him every day wanting to purchase it. Depending on who he's talking to, he describes what's going on either discreetly or salaciously. Always, though, he gives the impression that he thinks this is the horniest thing he has even seen, though I doubt if that's the case.

I'm wise to the ways of the art world but I don't want to seem too hick so I don't ask him how come you can get away with charging four figures for a VHS cassette that anybody can copy in the comfort of their own editing suite.

This evening Maurice is pretty annoyed. He tells me that the Gagosian Gallery have this whole unacknowledged intelligence unit made up of rich bitches, smart Jews, and smart fags whose job it is to keep an eye on the Shock Underground, with a view to buying off or soaking up anything which might make them a few bucks. Now the intelligence unit are hot on the trail of Nathan Solid who is due back from Berlin at the weekend, and with whom Maurice only has a gentleman's agreement.

The Gagosian people call him while I'm in the room. They're not even sure of the artist's name. Maurice, while talking with them, is busy taking the Solid page off of his website.

The jungle stinks. So what is new?

THE JANITOR OF LUNACY

Burroughs showed me a whole series of new holes to fall through. He was so neat, he would walk around in this big black cashmere overcoat and this old hat. So of course Patti gets an old black hat and coat, and we would walk around the Chelsea looking like that. Of course he was never too crazy about women, but I guess he liked me 'cause I looked like a boy. Patti Smith

Burroughs is in fine form. His Dreamachine — one of five that Brion Gysin gave him — is whirling around at seventy-eight RPM. The music in the room, as prescribed by Gysin, is Moroccan Trance. Hamri's Master Musicians of Joujouka right now, the Gnoua Brotherhood of Marrakesh boys earlier. Funky black cats in the desert sun.

He dismisses garish *Buffie*-style tales which suggest that Kurt Cobain had been staring at his Dreamachine for forty five hours solid before he killed himself.

"Those stories were put about by a guy in California who is selling Dreamachines by mail order. I use my Dreamachine every day. It's totally harmless. I find it very soothing, it just relaxes one."

I tell him that our mutual pal Hamri (about whom Burroughs once said "Hamri the smuggler king of the trains who was ruined at fifteen because he forgot the boy he was visiting had a wicked sister. Hamri the Painter. Hamri who is not at all content to be just a recording") had something of a health scare earlier this year but that he has now been given the all-clear. "I'm glad to hear it," Burroughs says warmly, staring at the Dreamachine, which acts as a window into the world of Moroccan magic. "Please send Hamri my regards. People have said many things about Hamri but nobody has ever accused him of being a fake. Hamri is the real thing."

Outside on 23rd Street the chemical snow is falling remorselessly onto the midnight deserted street. The central heating is on full blast, Burroughs is wearing a natty Old Guy suit, but the real heat is coming from his choice of music. Joujouka are singing Hamri's song about the historic trip to the village which he organised for Brian Jones, *Brahim Jones, Joujouka Very Stoned.*

We've been talking mainly about Huncke for two hours, how he was the last of the real deal hardcore guys living in the Chelsea. "They're all going out one after the other," Burroughs says, flattening his hands and spreading them out, much as a Priest might move his hands over the Holy Communion on an altar. "Paul Bowles, Samuel Beckett, Brion Gysin. The mould has been broken. Brion Gysin was the only man I ever respected. The only person of either sex. People used to say about him, 'Don't worry about Brion," because he was scheduled to enjoy… posthumous fame. He was not very happy about that and I don't blame him because he suffered from money problems most of his life. He used to say that what you needed for this whole area was black money."

The Old Man of the Mountain by Spencer Kansa

Although in person his slight loss of hearing meant having to repeat or re-explain something, Burroughs' precision mind would ignite periodically. One particularly memorable moment occurred during a discussion about how great it would have been if the film camera had been invented centuries earlier, allowing us to see history as it really was. To which Burroughs deadpanned in his drawling cowboy voice, "Yeah porno movies from ancient Greece."

Many of the themes that figure in Last Words were voiced over a succession of vodkas and coke as Burroughs rapped about drugs, guns, literature and all that good stuff.

Spencer Kansa: Your room in the El Muneria Hotel in Tangier where you wrote Naked Lunch is still pretty much the same.

William Burroughs: Sure. Well it was just a plain room. A bed, and a desk. It's weird. One of the off-handed hallucinations I had when I was real high on pot was that someone was right outside the door. I opened the door and there's nobody there. But I sensed it again and opened the door and there was a black guy about six and a half feet tall, and a short French guy, both with their hands in their pockets. They didn't say a word, they just came right in, looked

under the bed, looked in the wardrobe and then they went out onto the balcony. And the guy living next door came out and I said, 'What's this about?' And he said "Well, somebody is thinking of buying this building and he sent his bodyguards in to check it out." I don't think he did buy it but it gave me a turn when I opened that door. Ha ha ha. They never said a word to me or pushed me or anything, they just walked in to check things out.

SK: Your old villa on the Marshan in Tangier was beautiful.

WSB: Well that really was a hole in the wall. Jesus, yeah that was a terrible, horrible episode of my life living in that place. People banging on their doors, they hated me. I went out one day and they knew I hated women. They didn't care for me at all. Oh it was a nightmare living there.

SK: And hadn't Billy (Burroughs' son) seen them hanging out the washing and they took exception to that didn't they?

WSB: (Slamming down glass) No men are allowed on the roof during the daytime! That's an absolute tradition there. The roofs belong to the women. So anybody that goes up there during the daytime is asking

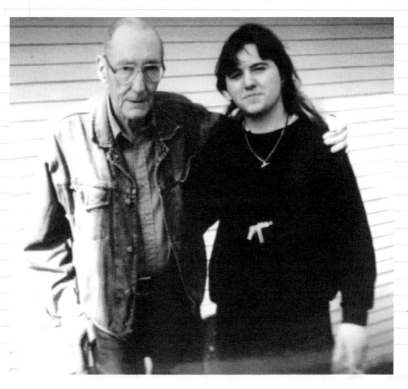

for trouble.

SK: You must have frequented the Cafe Haffa, that place on the edge of the mountain in Tangier where you get the pussy cats nudging around your legs and you can take kif and mint tea.

WSB: I know it yeah. Oh, yes it's great. It's got a wonderful ambience and people playing dominoes, lots of kif. But the trouble is I can't smoke their kif with their awful tobacco, it just tears my throat out. (Looks at photo of Herbert Huncke.) Whoa what a face! I like Huncke. Brion was not a Huncke fan, he'd say, "Who wants to see that evil face?"

SK: Huncke is reminiscent a little bit of Chet Baker isn't he?

WSB: Yes I knew Chet (Studying Huncke's face) Good god, that's something. Woo! Yeah Chet Baker used to stand up all night shooting up, blood running down his arm.

SK: I think Huncke likes me cos he used to have a boyfriend called Spencer.

WSB: Yes, Spencer I remember him, a black guy. He was very nice. He went on to work for Gore Vidal.

SK: Rap music is an extension of the cut up technique in music.

WSB: It is, of course. Yes in music. Yes it has great potential sure. Terrible thing about Kurt Cobain. He was here, he visited briefly. Why do people want to kill themselves? I listened to some of his stuff. I wouldn't say I was a big fan but it had something, it had something.

SK: What did you make of the whole Charles Manson saga? Because he studied Scientology.

WSB: Well, yeah, sure. Well I think he's a no good son of a bitch. That's my feeling of that. I think they can keep him in there forever. They better because let him out he'll do something again. I've always had no sympathy for him whatever. He said he didn't subscribe to the middle class morality. What's that got to do with it! Walking in and shooting a pregnant woman which is just disgusting. There's no excuse for it. Of course they'll always find women who want to marry them and all that, he had all these excuses, foster homes. Of course a guy like Polanski, he attracts that sort of violence.

SK: Manson was saying that society deserves the criminals they get and that he had been brought up in prison.

WSB: Oh, well sure. Well that's a good place for him. The thing is that when I was a kid the last thing a hold-up man wanted to do was to kill anybody. Now they go in and kill people for no reason

whatever. They walk into a convenience store and kill everybody in the store. If they ever started when I was there and they instructed me to get down on the floor I'd give them my play right then, old as I am.

SK: That's the thing that you say, if some guy goes into McDonald's and tries to shoot up the place, if you're carrying a gun you can put him out before he can even get one shot off.

WSB: Well, I always carry this one here (retrieves snub gun from denim jacket pocket.) It's a twenty-two long rifle, four shots, twelve screws; from close range they're dead. Yep four's enough. I always carry that, you never know when someone's gonna pull that kinda stuff. I wouldn't mind shooting at a head.

SK: They say that during the mid 70s Los Angeles was the hive of the black arts in America and that some ritual sacrifices still go on out in Death Valley.

WSB: I wouldn't be surprised. I wouldn't be surprised. Well but England is also a big centre for magick. There's lots of these brotherhoods and what not in England, some of them quite interesting, you know with real sorts of knowledge, interesting concepts, relating magick to physics, probability and all that.

SK: The Sitwells were interested in that weren't they?

WSB: Edith Sitwell she was a real proper bitch. Ha ha. Yes, well I guess she was. Whatever…she was talking about my books and Maurice Girodias, my publisher, "I do not like dirty little books. Mr Girodias whoever he may be and Mr Burroughs whoever he may be." Blah blah blah, the old bitch. Did you read that Majestic thing, written by Whitley Streiber?

SK: Oh, Communion? Yes. You stayed with him right?

WSB: A couple of weekends. But he's just finished another book which I'm reading; just the uncorrected proofs about all the trouble he's had with the government, how complicated the whole thing is, the different agencies and so on. They know all about it of course. Of course they know, and why they're trying to hush it up. They say that the actual government of the United States is one of the most complex in the world. We don't know who has authority. All of these different intelligence agencies, about seven or eight different intelligence agencies.

SK: Invisible government.

WSB: Yes. Invisible government. I'm just reading Whitley Streiber's book and this weird someone calls him up says, "This is Colonel Russell of the Air Force." And he gets there and there's some guy in civilian clothes. He's got the most nasty attitude, and then

Streiber calls up and of course they have no record of anyone of that name. Course not. People say they've taken over the government.

SK: The drug trade is so huge now. Dirty money and clean money are changing hands at very high levels. Something like a quarter of the money in circulation on the planet now is laundered money.

WSB: Yes exactly. Laundered usually through Malaysia and Singapore and the sums involved are not millions or billions they're trillions of dollars, a huge amount of money. So in order for them to launder their money, the launderer takes about thirty to forty percent. So there's huge sums of money going where? Who is using it and for what purpose? The government want to keep things like they are, and with that kind of money, trillions of dollars, they can, but the media is solidly behind them.

SK: The media demonises drugs.

WSB: Yes. yes. And also the same thing is happening with guns; nobody else to have guns – just ridiculous and nasty. I remember Dr Dent who was one of the pioneers of the Apomorphine treatment to drugs, which got me off heroin for a long time. He was this great old English gentleman doctor who only treated addicts and alcoholics, that was his whole practice. And he treated them with this Apomorphine treatment that he had set up. Apomorphine tends to normalise the metabolism so that you don't need the alcohol or the drug. But he talked to a lot of the people from the American narcotics department and entertained them at his club and listened to their stories. Dent said, "I think what they are doing is just plain bad." That was his word for evil. He didn't tell them that, but he told me, "It is just masked badness, they have no good intentions at all towards anybody." They said, "Oh well we don't want another addiction in our laps," about Apomorphine! As though anyone was ever addicted to Apomorphine! It's absurd! They really went to great lengths to discredit the Apomorphine treatment. So there was no synthetic device which might have been much more potent in normalising the metabolism like, for example, acupuncture does the same thing. It acts on the back brain to normalise the metabolism but that hasn't received any official recognition.

SK: They've gone the methadone route. They won't use the Apomorphine.

WSB: Well no. Methadone is a maintenance drug; Apomorphine's a cure. That's a very different thing. Yeah they wanna keep 'em on with it, so there's methadone clinics all over this country. Well that's a good step in the right direction. It's much better than having people

out on the streets, hustling to get up that money everyday, to show how criminal they are because they have to have it.

SK: A few high-up police officials are beginning to take an enlightened view. They've started saying, "We gotta look at legalising drugs, it'll stop the killings and burglaries."

WSB: For years they had legalised it! When I was first in London in the 60s, any doctor who was authorised could prescribe heroin for addicts. Pure heroin! I remember the Chinese Lady Frankau who was, ha ha, she sure was a writing croaker. Y'see the medical profession there was absolutely intimidated by these people who threatened to take their license. Whereas in London at least the doctors got together and said, "We will not have police officials telling us what we can and cannot prescribe for our patients." So it was perfectly legal then to prescribe for addicts. But then the American Brain Commission got over there and tried to put a stop to that, and pretty much they did. I don't know what the situation is now.

SK: Well you won't get busted for marijuana use any more. Although they've put the maximum sentence up.

WSB: They're bearing down so heavy on marijuana here, you can't believe it. People are getting life without parole for making a phone call! There's a terrific article in the Atlantic Monthly. Did you read it? You should. It's all about this guy who's in for no previous. He just made a phone call to someone who had this marijuana. I mean it's absurd! Sixty-two percent of the people in prison here – and we've got more than a million in prison – are in there for drugs; sixty-two percent without parole. Whereas the violent people, well they just let them go right out to commit more crime to show the need for more police. The answer to violent crime on the streets is very simple – it was posed by the Guardian Angels and boy did they get trouble from the police.

SK: They didn't like it: coming on their patch, "We can't have vigilantes."

WSB: Or for anyone else to come and do their job for 'em and do it better, patrolling where crime is actually happening, on the subways. I knew some of the Guardian Angels. That's what Mayor Koch said, "They're all para-militaries and we can't have this." Well for God's sake if they said alright we're gonna have people out there patrolling, it will be all-voluntary, then everybody would be willing. People would be glad to get out there and patrol. They should have, certainly, batons and tear gas. They don't have to have firearms, just batons, tear-gas, handcuffs and a little muscle. Local patrol groups

— that's it. I know everybody would be willing. I'd be willing to get
out there and patrol say three or four times a week. With batons,
tear-gas...I would be delighted hmpf hmpf. I have some great batons
believe me. They have a methadone programme in England don't they?

SK: Yeah they put everybody on it, although some doctors do still
prescribe heroin, but very few.

WSB: I went to this doctor who was a forensic doctor on Harley
Street. They gave me a huge prescription for morphine. I just needed
morphine for maintenance. I wasn't thinking about a cure. This doctor
at Harley Street was only maintenance; he was not into Apomorphine
or anything like that. I was staying at the Chelsea Arts Club which
was very nice.

SK: Yeah nice part of town. It was in Chelsea at his house in
Oakley Street when you first met Bowie in 74 for that big interview,
do you remember?

WSB: It was. I do remember it very well. He was living out near
the zoo. He was very nice. And then I saw him later in New York. Yes
he was in Elephant Man — very good. No make up; just the use of his
body. I thought that was a really brilliant idea. Not to try and make
up.

SK: Didn't Bowie ask you if you could speak to Jean Genet to ask

Genet's permission for Lindsey Kemp to put on a production of Our Lady Of Flowers?

WSB: I don't think so, cos I didn't know him direct. I met Genet in Chicago in 68 during the Democratic riots. He was one of the most intelligent people I've ever met. We had a great time in Chicago. It was incredible. It was funny, Genet was fleeing from the police and he ran into an apartment building and knocked on a door and someone said, "Who's that?" And he said, "C'est Jean Genet." And it turned out the person was writing a thesis on him! Heh heh. On Jean Genet! Isn't that something? He was an incredible person. There's a great biography of him by Edmund White. I thought that was a splendid piece of work, very accurate. Y'see Genet was such a touchy person. You were getting along fine and all of a sudden he would just turn over some little thing.

SK: There's a brilliant part in that book where Genet's in Paris and he's at some club and he sees this beautiful woman walk in, very elegant and exotic and she sits down and he walks up and goes over to her and says, "Mr Bowie I presume."

WSB: Ha ha ha ha ha. Well that's great. Isn't that fantastic? That's great. Genet said a great profound thing apropos his experiences in The Thief's Journal — that's a great book. He said very few people have the right to think. They haven't earned the right to think cos they have never been in a situation that would give them the right to think. And that's really quite a statement.

SK: And on from that they haven't got the courage to write.

WSB: Yeah, yes he said that about the writer Julian Green — not true. Julian Green wrote some great bits, particularly on the supernatural, and that's one of the most difficult of all genres, the ghost story, to make it real. He's still alive I have a feeling. I think that Genet should not have dismissed him like that cos he was a writer of great works.

SK: San Francisco is very disappointing now.

WSB: I don't really care for San Francisco. Well I just never liked it somehow. I've never lived there, never wanted to. I remember this one friend of mine said he had a disease called syphilia-phobia that was brought on by San Francisco — the fear of seeing too many queens at once hmpf hmpf. And oh the Castro! I remember this great line in a book this detective said to a colleague, "You couldn't find a queer on Castro Avenue." Ha ha.

SK: The house on Russell Street is still standing where Cassidy and Kerouac used to live. You were on the set of Heartbeat (film about

relationship between Jack Kerouac and Neal Cassidy starring Nick Nolte and Sissy Spacek), weren't you?

WSB: Yeah I was on the set. I had nothing to do with the film. I went there and well it was interesting to see how movies work. The fact that they work all day and if they get three minutes in the can that's good. So when I was doing the Gus Van Zandt film Drugstore Cowboy I got there at seven in the morning and I left at 10:30 at night for three minutes in the can. A lot of great old stories were thrown out. There was a story that I told how years ago junkies in jail would boil up the junk soaked in the lint from their breast pocket and shoot it.

SK: Did you like Bukowski's stuff?

WSB: I've never given enough attention to it to know. I would say that I would have to read it more carefully before I could say anything. But he was a great success in Europe, in Germany. Obviously he had merit and personality.

SK: There's this famous passage in one of his books where he says he saw you in a hotel room and someone asked you, 'Do you want to meet Charles Bukowski?' and you said, 'No.'

WSB: Well that's not true. I saw him in Santa Cruz and he was walking by but I did not say that I did not want to meet him. I've never said that I didn't want to meet anybody who's entirely reasonable. Yeah that's an absolute lie. He died at the age of seventy-three; a stroke I believe. I keep all the obituaries. Tennessee Williams. Did you know that Tennessee did not strangle to death at all? Cos I read the report of the coroner of the medical examiner for New York City and he said that the thing was so small it could not possibly have strangled him — the top of his bottle or whatever it was — and that he had died of an OD, a massive OD of barbiturates and alcohol, which he was always swallowing but he never got into any sort of regular use of opiates. It was always alcohol and barbiturates, which is so much deadlier. Yeah I interviewed him not long before his death in New York at the Elysium Hotel. He was a great playwright.

[Side bar 1: He Shoots He Scores.
William Burroughs' Zen Guide To Shooting Shanghai Style.]

The 'Shanghai Style' of shooting originated after the police chief in Shanghai began investigating why so many of his officers were being gunned down on the job. He soon learnt that his officers' hands were wavering because they were taking their time to aim at a specific part

of a suspects body, which was completely unnecessary procedure in hand gun to hand gun combat. The police chief maintained that in such situations the primary objective was to demobilize the assailant as fast as possible and that all a shootist had to do was bring the gun up slowly to eye level and squeeze off a few rounds.]

BILL CONDUIT COMES TO CALL

Bill Conduit came to visit me unannounced and uninvited. I get the feeling that he was sniffing me out, though I'm not sure why. Was he paranoid because I'm hanging around with The Duchess, or has The Duchess sent him around to see what he makes of me? The Dimitrios organization is permanently obsessed with the possibility that the intelligence services are trying to penetrate them.

He started asking me questions about where I bought my records. He was picking up specific items — such as *Brian Jones Presents the Pipes of Pan at Joujouka* — and wanting to know the story behind this album or that book. I was brought up to believe that a gentleman does not make specific reference to another man's possessions, so I wasn't inclined to go over the whole story again: how Hamri brought Jones to Joujouka, how they did the album, the first release of Rolling Stones Records, how Scientology and white magic types conspired with World Music gangsters to destroy Hamri, resulting in his eventual death.

HASSAN IN THE CITY

The old question used to be *Can a White Boy Play the Blues?* The answer is *Who really gives a fuck?* But can a seventeen year old white American boy from a family, who worked out until he was fifteen, discovered drugs and rock music, take within himself the spirit of Hassan I Sabbah, The Old Man of The Mountain, the man who said *Nothing is True, Everything is Permitted*.

The white boy's recollections concerned ball games, new NOFX albums back in the day, sex with his older brother's girlfriend. She had a reputation for dexterity and innovation. She looked like Madonna, only much younger. But he turned his back on that, said *The past is just the past. The future is a different country. They're going to have to do things differently there.*

The white boy walked down the steps into the men's toilet. In the background he could hear R Kelly singing; probably that black record shop. He walked up to another boy, about his own age and size, wearing a Green Day t-shirt. He grabbed the boy from behind, took the knife from his jeans pocket and shoved the knife into the boy's left kidney. Then, while the victim was howling like a beast in the slaughter house, he

removed the knife from the kidney and applied it to his throat. That was when the blood really started to flow. The assassin quit the scene, left before anybody noticed what had happened. R Kelly was still singing. The assassin was covered in blood, but he was heading towards the future.

Hassan Sabbah, Hassan Sabbah,
Hassan Sabbah, Hassan Sabbah.

WHITE TRASH HEAP OF SHIT/ Hair under there

The blacks in Big Town where I come from. Blacks here. I just know Longtree, and he is a pretty mellow jazz-listening collegiate individual by any civilized standard.

Once, when I accused him of being guilty of mellowness, he said to me, flying high high high after snorting too much, "Yass, Boss. I's a pretty mellow fellow. For a nigger."

"Be careful, buddy, there's hair under there."

The black aspirant worker going home — he passes the entrance to the Chelsea Hotel as I leave and we make our way alongside one another towards the 23rd Street Subway — is not the blue collar white hero of Sinatra's *What is America To Me?* The melting pot has melted down to meltdown.

I see the way this black family-man worker sniggers at the faggy blonde black boy who is walking towards us. The boy is about seventeen, dressed to kill, all cock and balls. His soft black leather shoulder bag must have set him back a dollar or two. A baguette protrudes from one corner. Why are there so many queer niggers in Manhattan? I know that the Chelsea district is Homo Central but my travels take me to the four corners of the island and you find tough aggressive queer niggers everywhere. And where can you get one of them? Do they come free with the cornflakes?

The homeward bound black family man pretends with a gee shucks shrug of his broad hard working shoulders that he's never seen such a thing, the implication being that the sissy boy is a disgrace to his race. The sissy boy looks happy enough. I turn to check my hunch and, sure enough, he ambles into the lobby of the Chelsea.

I arrive at Longtree's place an hour later. I tell him about seeing the blonde boy and ask him why there are so many homo niggers here. He gets all kind of flared nostrils and hurt red eyes about this, calmly tells me that he doesn't move in such circles, that I should write a letter to the *Village Voice* if I needed to inquire about that type of information. And have I ever seen this boy in the Chelsea before? I say he's somewhat familiar, that I reckon I've seen him at The Holocaust Café, a twenty-four

hour coffee shop around the corner from the hotel where I go for breakfast and the *New York Times* most mornings. Longtree reckons I'm talking about Al LeVino, "who is currently taking if up the ass from every queer movie director in New York; a name to watch out for." Longtree says that great things are expected of Al; he's just done a good bit part in *Law and Order*.

"Irish, you tell that fool you're working on a new Neil Jordan production, something that might have a role in it for Al LeVino as a teenage hoodlum, and that tramp will be your personal dog for a whole night for free. The meter turned off."

I don't know where Longtree gets this idea that I'm developing a taste for negritude.

You give the children the fornication wine.

You give them too much to blow their mind.

The velvet rope, the velvet cordon. You little white trash heap of shit. The Hamptons.

"Ever picture has its story and its own source of light." Paul Bowles talking to Frank about Gysin's technique.

CUT UP DUCK/ Bill Conduit

After our several backstage encounters, his unwelcome inspection of my rooms, after scoping one another from a distance at other folk's sometimes dubious Chelsea Hotel dinner parties, last Thursday I got a note from Bill Conduit left through my door. The note requested that I phone The Converse Kid at my convenience. This I did so he invited me around for "a little bought-in dinner and a little imported cocaine" three nights hence.

When I show up half an hour late I can smell something oriental and excellent in the oven before I knock but I can also hear what sounds like Billie Holiday backed by Soft Cell banging out some heavy primitive techno beats through the door. This seems a little bit dubious all round, so I hope, I pray, I hope that I'm not in for a night of fagorama. I had one of those in 1983 and that was plenty for a lifetime. This graphic designer I met when he did some book covers for a publishing firm I was running invited me round to his house for dinner the night of my birthday and I, like the innocent shmuck I sometimes can be, went. Just to be on the safe side, in case they got around to whipping out the Liberace albums and the lube, I brought Jacko, my homie from the queer bashing gang, along for the ride. Poor Jacko and me got stranded in the middle of six fags and two fag hags who, of course, hadn't managed to conjure up a decent dinner between the whole lot of them. They thought me and Jacko were a couple and offered us a room for the night with a double bed in it though I lived a twenty minute walk away. Jacko wasn't much in the mood for pillow chewing and kept darting amused but lets-get-the-fuck-out-of-here

glances in my direction all night. We were in total agreement in that regard, and fled shortly after all the brown rice and organic right-on tomatoes gave out.

So my relief is total when Bill opens the door and stands there in his black jeans, white t-shirt, and red leather Converse. I realise that the room is not rammed full of homos, that it's just going to me and him and there is nothing fishy going on. Nothing I've heard about Bill leads me to believe that he is anything other than a regular upstanding guy who knows how to keep his pecker sheathed and his feelings to himself.

"I can't boil an egg. What we got here," he says guiding me towards his biggish well stocked kitchen and for some reason pointing towards a two ring and small oven cooker, "is some kind of duck thing. A huge fucking pile of cut up duck with hot peppers and fruits essentially, plus a pasta salad in the cooler, some wetback bread my mother prepared and which I've been keeping in the freezer, and some organic salsa ice cream with mango to follow. That OK?"

This sounds just great by me. I hand him an Islamic Diggers CD mixtape and take the opportunity to ask him what the sounds are. It turns out it's just some dodgy Ibiza compilation that the beautiful nymphet on the couch, whom I now notice for the first time, has been playing for the last half hour. With that self-conscious air of fake spirituality that sexy bitches sometimes possess, Roberta Reier introduces herself to me. She is an NYU student of Modern American Literature. Well, there you go! It's a wild party after all. I have an immediate fantasy in which Roberta is entertaining five guys — and one of them is me — with her mouth, her two hands, her ass and her cunt.

Bill spends about twenty minutes in the kitchen — I don't know…stirring the bits of duck and the peppers around in their container maybe. Whatever the fuck, his absence, albeit five feet away in an open plan kitchen, gives me that unique opportunity to be in like Flynn.

Roberta says she was, "like, totally transformed by Ibiza." She was there one time for three days and obviously got the hole rid off her. She also seems to have lost whatever brain cells God gave her by consuming tabs of Acid three or four at a time. She tells me she is writing a book about her psyche and the spirit of Ibiza. Usually, it seems to me, when women start talking to you about their psyche they really mean something very different. I tell her that her book sounds like essential bedtime reading for the Ambrose household. She gives my quip the sort of unresponsive response that makes me think that she imagines I'm bonkers. You know the way stupid people are. They laugh at everything serious that you say, so when you make a joke they frown and look worried.

For her next Wildean joust the lovely Roberta asks me that most inane and hard-on-reducing of all questions, "You're a writer, right?" I confirm that I do a bit of writing when I find the time. She confides that last summer she worked as an intern on *Rolling Stone* and that Jann Wenner is "just, like, a real shit." This hot poop leaves me with the

distinct desire to join Bill in the kitchen to help him out with the duck stirring.

This I do. He is bent down inspecting the bird bits in the oven, delivering a salvo of one word sentences to no-one special.

"Wonderful. Marvellous. Great. Super," he grunts.

"So... what gives with the duck, Bill?" I ask inanely. I know neither of us is inane, but inanity is the meat and potatoes of polite conversation in big cities.

"Uh, the guy who delivered it said to give it twenty in a moderate oven when we knew we were ready to eat, so that's what I'm doing."

God bless Bill Conduit. You got to hand it to him. He got himself one of the fittest pieces of pussy in the whole of Manhattan (and that's saying something) held captive right there, as it were, in the Chelsea Hotel. She's as thick as two bricks but the rest of her is just handy dandy. Two lovely sweet tits, no hips, not too beautiful, thrift store black Converse, blonde hair dyed shocking pink and cut punk, a Ben Harper t-shirt and a pair of dazzling white Thomas Pink men's boxer shorts through which a tiny tuft of undyed blonde pubic hair is innocently emerging.

When the old men do the biting and the young men just look on...

Next thing to happen is the oddest development of the evening. Turns out this is going to be a boys night In after all. When the Ibiza crap comes to an end (which it does when the CD begins to fuck up and Bill Conduit intervenes, removes the CD, and replaces it with something vaguely more acceptable) so does Roberta. Presumably she was given a good seeing to before I got here. Whatever. She disappears into the bedroom where I can hear her cursing and moving stuff around before emerging triumphantly in an authentic black mink coat she says she inherited from her grandmother. To listen to some bitches, you'd think every piece of fur in the world was inherited, that the only dumb animal that has to die these days for you to get a mink coat is your grandmother.

Then she is gone, but not before she scribbles down her phone number and gives it to me while Bill is having a piss.

This suite, a pretty splendid set-up just to the left of the huge Hotel Chelsea neon sign on the fifth floor, is furnished with the latest minimalist trendy items. Flat white walls, black couches, glass tables and shelves.

Two hours later the duck has been in the stomach a while. We've been doing coke for half an hour when the conversation turns to Roberta.

"Roberta is a rich kid, a very, very, rich kid." Bill says, "I think her mom was a Mob girl, almost made it in movies. Then she got pregnant by Peter Lawford. *Somebody* married her off to this pliant guy who owned a major construction company. Lucky old mom – he contracted cancer seven years later. By that time Roberta had come into the world. Her older sister Mary is the Lawford kid, she also has a brother. Mom wisely never remarried, held onto a twenty percent stake in the construction firm when she sold the rest, moved to Manhattan where she discovered art and society. Roberta got her first apartment south of Houston when she was seventeen, moved

in here when she was twenty. I used to bump into her in the lift and, you know... think. She lives on the top floor. I'd see her hauling back these skinny guys from the punque roque scene who reminded me of myself when I was their age. Then one night six months ago she came in here all cross-eyed and sincere... her place has walls covered in works of expensive art, rooms full on classy antiques. The paintings and antiques are real enough but they look, in the context, like they're fakes. Her kitchen is decked out with Tupperware. I've not seen Tupperware since 1968, I think she paid through the nose for that shit.

"I do nothing alone, which is why I dread being alone, I guess."

I stay for two more hours. The conversation diverts into the world of crime — Bill was involved in a rather nasty attempt to assassinate the proprietor of three advertising weeklies in Jersey, in 94 — before moving on to the topic of women I've known and then on to women he's known.

WHY DOES MY SOUL FEEL SO BAD? LET'S TAKE SOME DRUGS AND DRIVE AROUND

I saw Moby live one time, supporting the industrial Ministry at the Brixton Academy. The venue was half-full/empty (a state of being which always seems more empty than full) and I must have been on the guest list or something because, despite their tiny little Burroughs connection, I hated Ministry.

Back then when I saw him opening for Ministry, they vilified Moby though he was hard trier. They dissed him because he was a Christian, he was a stone ugly son of a bitch, and he was guilty of genre hopping within our magical musical universe. I thought he was superb in Brixton even if he was a Christian.

Now he has hit the big time with the students, just like Fleetwood Mac or Air did back in the day, though his *Play* album of dead old niggers put to a disco beat is *not* a new idea – oldest trick in the book actually – but it has always been a very good one.

Right this second in the car speakers this old nigger is going on about how nobody knows his troubles with God, or his troubles somehow, or his troubles so hard. Who knows or cares what the fuck is ailing him really, so long as he keeps singing over the techno beat which is just about as forward looking as REM? Still – it works.

We are cruising along in the middle of the road but, for once in my life, I'm pretty comfortable in that territory. John, my seventeen year old, three hundred pound gun toting Mexican coke supplier is doing a smooth ninety in his surprisingly battered Citroën Picasso. I was able to get John's number again from Isabella Arrogant, who gave it to me in the first place.

This is powerful driving-through-the-city music – the one about going to the East Side/West Side is real New York to me – and you can't just dismiss music because it's too popular, because every deadwit in the world is listening to it and every corrupt payola radio DJ thinks it's just jim dandy.

The next track is a little bit more like real techno – this one is about coming with me to the ocean sky – similar to what you might hear in Ibiza in some dive with the word "shaft" buried in its title. The tune causes John to look at me wryly like he's about to take a shit or say something intelligent for the first time today. He takes a deep breath and shouts, "Fucking A, man! Fucking Patty! This shit is Fucking A!"

This could be his sales pitch for the coke I've already purchased or it could be his assessment of the Moby tune. These dance people are really low rent when it comes to literacy and suchlike. They pronounce Paddy as "Patty" in New York.

It must be getting on for five years ago now that I first began mixing the Alan Lomax prison chain gang recordings with twenty minute long Andy Weatherall remixes of commercial shit by Irish rock bands signed to Phonogram, which I used to pick up for nothing in the Record and Tape Exchange. Techno beats and those dead voices sure worked well. I don't know if Moby ever dropped in on the Dreamachines club Islamic Diggers were doing in Soho at that time but the best parts of *Play* are merely that idea, plus one and a half Balearic beats, plus something extra – a secret ingredient – that sells records.

In his dreams Moby is dying all the time. John leaves me off in front of the subway station which will send me home to Manhattan. As I leave the car he gives me a friendly grin, says, "See you soon, Patty. See you the weekend I guess."

EAST SAYEED WEST SAYEED – A KILLING LIFE

Crosstown bus from the East Sayeed to the West Sayeed.
This life is a killing life. Life in the fast lane. What they don't tell you is that you go home on the slow train.
I am fond of casting my hook in amongst the young fishes.

Herbert Huncke U S. Junky
by Frank Rynne

(1915-1996)
Resident, room 328, Chelsea Hotel 1994-96

I first met Huncke at his eightieth birthday party in Bruges , Belgium.
That was January 9, 1995. At the end of 1994 I had been recording the
Masters Musicians of Joujouka in Morocco. Meanwhile back in London Joe
Ambrose, while continuing work on our Burroughs documentary Destroy
All Rational Thought, had hooked up with and filmed Huncke. Introduced
by a friend of Herbert's, Spencer Kansa, Joe got on well with him and
an invitation to his birthday ensued. So, in a snowbound recreation
of a medieval city I got to meet a very miserable yet very charming
counterculture legend. Hard luck tales were part of Huncke's stock and
trade, but this time the poor man had been lured away from his warm
room at the Chelsea Hotel by false promises. Unfortunately he was in
Bruges at the insistence of a publisher who had the entire print run
of his book sitting unpaid for at the printers. All Herbert had asked
for, if he were to fly from New York, was that she provide the cocaine.
Of course she had neglected that one minor thing, the only thing that
Huncke could think about, narcotic supplies.

In the forties Huncke coined the phrase "Beat" which was picked up
by his friends Jack Kerouac, William Burroughs and Allen Ginsberg. He
was naturally Beat. Huncke and Burroughs met in 1944. Burroughs had
ampoules of morphine and a shotgun, or as some say, a machine gun to
sell. Huncke took him for F.B.I. but recalled : "I shot him up first".
He stated this not as a boast but as a matter of fact. Huncke spent
most of the 1950s in jail while his friends became famous through
literature. They all used him as a character in their works. In On
the Road he was Elmo Hassell, in Burroughs' Junky, Herman. Both books
give a similar picture of Huncke as arch-hustler and petty thief
who always attracted trouble or the "heat". When Huncke got out of
prison he was a semi-legendary figure. His friends were still writers
and jazz musicians. In 1965 Diana Di Prima's Poet's Press published
his first book, Huncke's Journal. At the Poet's Press offices Huncke,
while picking up a ticket to go to California in lieu of a royalty,
also stole a statue of an Indonesian sea goddess. Years later he

recalled that he needed a gift for the people he was going to stay with. Though he was once published by Playboy, Huncke never achieved the literary status his friends had. The title of his autobiography, Guilty of Everything, betrays the fact that he had that illusive tool that novelists crave but often are forced to borrow from those more interesting than themselves, a lust for life. There was perhaps his true art.

In the summer of 1994 Raymond Foye, the publisher of Hanuman Books, lent Huncke his room at the Chelsea Hotel. Huncke had been living in a house on the Lower East side with his friend Louis Cartwright since the sixties. The scene in the house had got too much for him; Louis was bringing in all kinds of street people and Herbert was afraid of the situation. Within a few months Louis was murdered. Huncke kept extending his tenancy. Foye reached breaking point on visiting the room and finding the walls and paintings which he owned had been freshly re-painted. Huncke with fresh paint on his hands denied all knowledge of how this happened, blaming a burglar and the poor security at the Chelsea. Next morning Foye booked him into room 328, gave him the keys, and told him his rent was paid for a month in advance.

At the Chelsea Huncke settled into a routine, morning visits to the methadone clinic, friends calling by and the occasional reading. His room was paid for by a group of friends, Raymond Foye, Allen Ginsberg and the Grateful Dead, amongst others. Haki, a friend of Herbert's recalls sitting with him in his room when there was a loud knock on the door.

"Is this Huncke's room?"

"Who wants to know?"

"I was told by a friend that if I needed to score in New York to see Herbert Huncke at the Chelsea Hotel."

Huncke said that he couldn't help but when the guy pleaded that he was sick he opened the door and let him in. The visitor seemed nice so Huncke made a few calls and sorted out about fifteen bags of heroin. It turned out that this was a coast to coast truck driver who someone somewhere in the world of illegal opiates had directed to Huncke's door. At the Chelsea Huncke was accessible. He did complain bitterly about the management because they wouldn't give him a room with its own bath. When Haki first met him in 1991 he had showed up unannounced at Huncke's flat, pounded the door and asked to do an interview. Huncke, having enquired about the nature of the interview, declared that he couldn't possibly do it without first getting to know Haki. He proceeded to interview Haki for three hours. Haki left at 5am stoned

and with his story.

Huncke spent most of his life on drugs. He started taking heroin when he was fourteen and, save for the time he was in prison, he was addicted to a wide variety of substances. He had worked with Burroughs growing marijuana in Texas in the forties and, just shy of eighty-one, tested positive at his methadone clinic, for heroin, cocaine, marijuana, methadone and valium. When asked by the doctor:

"Why do you do this ?"

He replied: "I've been doing it my whole life, why don't you leave me alone."

It was essential at this stage that Herbert got his methadone prescription and he was forced to attend the clinic everyday. Jerome Poynton brought him most days. He also enlisted the help of lawyers to force the clinic to allow Huncke to have his methadone delivered to the hotel which was eventually agreed to.

Haki recalls how protective Huncke was of his methadone:

"He was taking 100mg a day which would kill most people, but if you were sick he wouldn't share his bottle with you, maybe he'd give you the tiniest bit, if you persisted".

Huncke became great friends with another Chelsea resident, Linda Tripp. Tripp ran a casino in the Chelsea. Huncke both gambled there

and was also a dealer at celebrity card games. Tripp led a heavy lifestyle and according to some she was "mobbed up". She died shortly before Huncke in 1996.

Though his rent at the Chelsea was paid by friends, and he got his methadone free, Huncke still needed to buy his cocaine. As Haki puts it: "All he needed was cocaine, his rent was paid and he wasn't a big eater. People would visit and give him twenty or forty dollars, or he would sneak by the Allen Ginsberg office and get money. If you had taken away the cocaine he would have slowed down completely or just died. One time he was being tested by doctors to see how his lung capacity was and they told him he should be dead already. He didn't have enough capacity to keep a system going, but there he was, he had his methadone and his cocaine. It's scientifically proven methadone keeps you younger. Everybody, all those people, Burroughs, Peter Orlovsky, as long as they kept doing it, they kept going… as long as you don't stop."

Haki's opinion of methadone's potential for being an elixir of youth is strongly rebutted by others close to Huncke. Indeed, overweight ex-junkies with rotten teeth who are permanently half on the nod are the more common veterans of long term methadone maintenance.

Up until he turned eighty-one, Huncke was up and active. He started to get sick soon after his last birthday and spent time going back and forth to hospital. I last met him in London at the end of 1995 at another miserable affair organised by the Bruges mob, again failing to deliver the goods. Back in New York, Huncke was looked after by a group of friends: Raymond Foye, Jerome Poynton and Tim Moran. Jerome Poynton took his literary affairs under his wing and is now Huncke's literary executor.

Herbert Huncke died at the Beth Israel Hospital on August 8, 1996. For the six months before he died the door to Room 328 at the Chelsea was never locked. A tag team of friends made sure that Huncke was looked after. Within two years William Burroughs, Allen Ginsberg and Peter Orlovsky were also dead.

I think it was Ira Cohen the New York photographer who told me about Huncke's last days in hospital. Later I met Jerome Poynton by accident in Dublin while he was buying some Trocchi books from me. Jerome had organized the tribute to Huncke after his death and made a very nice memorial book.

I was thinking about Ira's description of Huncke's last days when I wrote the song below. In hospital Herbert had a morphine drip which

he could self administer when he wanted a hit. The irony of having
being jailed for having a fondness for the same opiate would not have
been lost on the oldest delinquent in town.

> HERBERT HUNCKE U.S. JUNKY
> The sun was white light in New York City.
> No plaster falling off the wall.
> One last shot of morphine in his hospital bed
> When there was no one left to call he went above us all.
> Let the story be told
> Herbert Huncke U.S. Junky
> From the flophouse
> to the crack house
> to the White house
> Herbert Huncke U.S. Junky
> Herbert Huncke U.S. Junky.

TERIYAKI BOY

I have previously noted an angel sitting on one of the many comfortable couches in the hotel lobby. He is this twenty year old Japanese boy wearing a kind of bespoke jumpsuit made out of the sort of material I would normally associate with wedding dresses. I suppose, put another way, his garment bears a resemblance to the outfits Elvis used to wear in Las Vegas. Angel's face is pancake made up so that he reminds me of virtually any member of the beautiful Arquette acting family. He sports two carefully constructed wings, giant versions of the type one might find on a Christmas tree angel. I can't see the strings or straps by which the wings are attached to his back – this is done terribly well. Normally Angel is talking enthusiastically with older women though sometimes he sits alone eating a McDonald's meal.

Today he talks to me for the first time and it dawns on me that he may not be a fag. Ryan Adams passes by and says hello to the two of us but I think Angel scares him so he doesn't stop to yap.

"Hoooh, those heavy metal boys!" Angel moans slowly, glancing at Adams' ass as he beats a retreat, though I don't think Angel is clinically queer – he just wishes that he was.

I walk south on 6th, bidding farewell to Angel who goes into a McDonald's. Now that I've seen him in the cold light of day, and not within the subdued confines of the hotel, I realise that he is not a kid but well into his thirties.

HAMRI REJECTS THE CHELSEA

One day in Tangier Hamri's wife Blanca told Frank about the time they went to the Chelsea Hotel and, later the same day, Frank told me about it.

They'd been living in California for some time in the early seventies and made the decision to return to Morocco so that Hamri could reclaim his thorny crown and become, like the beast in the Joujouka myth, a lion pulling a plough.

Blanca was from New York so they decided to stop off there en route to the Barbary Coast across the treacherous sea. She felt, what with his Beat Generation associations, that it might be nice for him to stay at the Chelsea which also had such associations but which, moreover, was very much a painter's hotel.

So they pulled up in front of the Chelsea with all their heading-home luggage and made their way inside. Hamri, a stickler for cleanliness and order, took one horrified look around the lobby, noted the various characters hanging out there, and said to Blanca, "Why you bring me to this filthy place? Full of junkies and hippies and dirty people. I not stay here! We must leave immediately and go to a correct hotel."

They did leave right away and bunked up in a pricey uptown dive where, in a few nights, they blew all the money they'd saved for setting up house back in Tangier.

MOSHING

I am in New York to write a book about the subterranean world of moshing and moshpits. Sometimes I wish I didn't have to do all this writing myself, that I could just copy it out of other people's books or newspaper articles published in obscure journals or online shit nobody else will ever discover. Some nights when I sit down to do my regulation 2000 words-a-night bottom line, I wish I could just take all these notes and paragraphs and memories and the seven and a half finished chapters I've done so far and pass it all on to Spencer Kansa who'd do as good a job as me. I could give him my advance, let him finish it for me, give him a co-author credit. But then I have my bit of fun in some pit and then I'm back in front of the screen again, staring at the words again. My screen is never blank.

A note written in my own scrawl on the back of a very battered ticket for Soulfly at the Hammerstein Ballroom goes like this: "'Giovanni has gone moshing a few times.' says Ricardo wryly, dragging the most battered copy of *Giovanni's Room* I've ever seen from out of his jeans pocket. 'Ever read this?' he asks shyly."

I have no idea what this refers to. I certainly didn't meet a James Baldwin-reading Ricardo at the Soulfly gig. Or anything even remotely like that.

ANGRY ANGEL

I am standing in the lobby near the front desk talking to Stanley Bard. He has just gotten off the phone after some tough negotiations with a mother from Pittsburgh who is sending her three daughters to New York for a long weekend.

He is the master of polite big city chit chat; we have yet another conversation about very little. Then the lift doors open and Angel storms out, flinging his room keys at the desk as he passes, looking neither to the left nor to the right, ignoring both me and Bard.

I look at Stanley and smile. He smiles back.

"Now you've got an angel living here," I quip.

"And, you know, he is a *very* very nice person," says Mr Bard.

DOOMSDAY DIABLOS

Longtree said to me yesterday that it was about time that I tried to come to terms with the fact that my adolescence might be coming to an end. He broke it to me gently. So, therefore, he would not come with me to check out the Doomsday Diablos, "or any other of these heavy metal fools you've obviously got some weird

seventies sexual trip about." He said he'd still be in the hotel when I got back – "if you get back" – because there was something on TV on one of my movie channels that he doesn't have back home.

Angel got into the lift on the third floor and wished me a merry Christmas. I returned the pleasantry. Nice one Angel — if you don't get going with that Christmas spirit in March you might miss out on something important later.

Remembering Marty Matz
by Laki Vazakas

The poet Martin Matz died last night in the hospice unit of New York's Cabrini Hospital. I believe Marty was sixty seven years old. I met Marty in the Chelsea Hotel in 1989 and we remained close till his dying day. This is some of what I remember Marty telling me about his life. Because we were usually pleasantly loaded when we talked, some of my memories could be off a bit.

Marty was not a prolific poet, but he was a poet's poet. Marty's poetry was a unique fusion of surrealism, lyricism and Beatitude. He was inspired by, and refined the traditions of, vagabond poesy. Look on the back cover of his book Time Waits: Selected Poems 1956-1986 (JMF Publishing, 1987; privately revised and expanded, 1994), and you will find encomiums from the likes of Gregory Corso, Jack Micheline, Harold Norse and Howard Hart. Beat eminence Herbert Huncke wrote a stirring introduction to Matz's book of opium poems, Pipe Dreams (privately published in 1989).

Marty was decidedly his own man, and stayed true to his own poetical calling. He wrote poems for himself and for his friends, and did not taste the admiration of a wider audience until late in his life. What quenched Marty's soul was late night pow-wows burnished with jazz, sharing tales of the brotherhood of fringe dwellers. His love of nocturnal creatures shines through in his masterful poem:

I KNOW WHERE RAINBOWS GO TO DIE (On The Death of Bob Kaufman)
Together we walked through a fabled city
Of hallucinating green
And talked away
A thousand smoking nights
As your aching heart

Beat its bones
In time to bird's brilliant sounds
Over the neon streets of murdered schemes

Matz was born in Brooklyn, spent his adolescence in Nebraska, and
served in an alpine unit (no mean feat for a flatlander) in Colorado during
the Korean conflict. After the services, Marty gravitated to San Francisco,
where he studied anthropology and met Jack Kerouac, Neal Cassady, Gregory
Corso and Bob Kaufman. Just as he was becoming part of the incipient North
Beach poetry scene in the late 1950s, Marty hit the road, heading south.

I am the perpetual wanderer
The insatiable traveler
The mystic nomad
Forever moving
Towards some strange horizon
Of twisted dimensions
And chaotic dreams
(From Under the Influence of Mozart, by Martin Matz)

His insatiable thirst for travel led Matz to Mexico and South
America, where he wandered from the late 1950s through the late 1970s.
He told me so many wondrous tales of his meandering in Peru, Chile,
the Yucatan. On one of his journeys he ran into the legendary director
John Huston. He told of how he and John and several others drank for
a solid week, talking through the nights. Marty insisted that Huston
never once slurred his words.
 Marty was an intrepid traveler, always seeking and finding the
least-trodden path. He told me of how he was once bitten by a snake
while crossing a river in Mexico. The flesh on his lower leg turned a
hideous purple-black, but he kept going. He always kept moving.
 Another time he was stricken with a flesh-eating parasite. Doctors
told him that his arm would have to be amputated. He sought out a
shaman, took a week of yage cures in a longhouse (in which the shaman
"threw light" into the darkest corners of night), and successfully
avoided any surgical procedure.
 Matz became fascinated by pre-Columbian art, and translated an
unknown Aztec codex, The Pyramid of Fire.
 Marty was also an accomplished smuggler, but those are tales to be
told at another time. Suffice to say that National Geographic did a
story which elucidated some of Marty's unique talents as a contraband

ceramist.

In the late seventies, Marty was pinched in Mexico with some grass and cocaine on him. Because Mexico had signed a treaty with the Nixon Administration which forbid transfers of drug prisoners, Matz's only recourse was to bribe his way into a somewhat inhabitable cell block in the notorious Lecumberi Prison.

Lecumberi was an old, dingy, frightfully overcrowded prison, built by Porferio Diaz in 1903. By his wits, Marty was able to survive four horrific years of the most abominable incarceration. In 1994, he told Huncke and me how he once was sitting in the Lecumberi yard when one man stabbed another in the throat, showering Marty with "a fountain of blood." He said: "I didn't know the human body could pump blood that fast." It was a tribute to Marty's formidable powers of resilience that he chuckled as he emphasized that, "I don't like to be showered in blood." Matz's warm and infectious sense of humor always remained intact.

When the Mexican government decided to close Lecumberi and transfer the prisoners to a new facility, Marty and another prisoner hid for days in a tunnel which they had spent months excavating. They hoped the prison officials would eventually stop searching for them. They were finally captured after hiding for a week, and much ado was made of their daring exploits in the hyperbolic Mexican papers. (For more information on Marty's experiences in Lecumberi, I suggest checking out his interview in Romy Ashby and Foxy Kidd's wonderful GoodieMagazine, issue number 6; http://www.goodie.org).

In 1978, Marty returned to the US as part of a prisoner exchange with Mexico. He settled in San Francisco and once again shared his poetry at readings. He renewed old friendships with the city's more famous poets.

In the late eighties, Marty married film maker Barbara Alexander. They spent the better part of the next eight years in northern Thailand, living on Barbara's inheritance.

Marty and Barbara also spent some of this period in the Chelsea Hotel, where they presided over a convivial literary salon. Their Chelsea suite was filled with the lost art of conversation, the walls covered with exquisite artifacts from Thailand, Nepal and Burma. Painter Vali Myers, storyteller Herbert Huncke and poet Ira Cohen were frequent guests. At one memorable birthday party for Matz's longtime friend and patron Bob Yarra, Harry Smith held court. Huncke and Matz gave two compelling readings at The Living Theatre at this time.

In 1991, I travelled with Marty and Barbara to Thailand and

Burma. Together, we made a twenty-six minute video travelogue called Burma: Traces of the Buddha, which documents a boat ride down the Irrawaddy River, a Shin Byu (coming of age) ceremony in Pagan, and the dedication of a new temple in New Pagan. Our time spent exploring together was indeed inspiring. After our visit to Burma, I settled with Barbara and Marty in Ban Muong Noi, a small hilltribe village north of Chiang Mai in Thailand. It was in this small, remote village that Marty wrote his book of opium poems, Pipe Dreams.

In the late 90s, after having settled in Healdsburg, California, Marty and Barbara separated. Marty again hit the road: Mexico; Vienna, Austria, Italy. He found a warm receptiveness for his poetry in Italy, where he joined a "Beat Bus" tour of poets, including Ira Cohen, Lawrence Ferlinghetti and Anne Waldman. For several readings, Marty was backed by avant-garde saxophonist Steve Lacy. Marty stayed for months with friends outside of Rome, where he basked in the glow of recognition of his poetical gifts.

In 2000, Marty found himself back full circle in his native Brooklyn. He recorded a CD of his poetry, A Sky of Fractured Feathers, with master musicians Chris Rael (sitar, guitar) and Deep Singh

(tabla, harmonium). He gave memorable readings, embellished by Chris and Deep's deft playing, at the Brooklyn Museum of Art and the Gershwin Hotel.

Marty was a thoughtful and comforting presence throughout, old and dear friend, Gregory Corso's valiant final months battling cancer. Gregory affectionately referred to Marty as "my Matzoh Ball." Matz's eulogy for Gregorio was among the most moving at the memorial services for Corso at the Orensanz Foundation and the St. Mark's Poetry Project.

Matz spent his final months at the Lower East Side apartment of his longtime friend Bob Yarra. Marty, like Huncke and Corso before him, received a new generation of admirers in a modest, tv-lit abode. He graciously acceded to interviews while watching his beloved San Francisco 49ers (Marty loved football and the sweet science of boxing). Old friends Roger and Irvyne Richards, owners of the much-missed Rare Book Room, came by to watch the Yankee playoff games. All the while, Marty continued to spin his magical tales of a fiercely uncompromised, hectically picaresque life.

Like his close friends Herbert Huncke and Gregory Corso, Marty Matz stayed true to himself, always travelling, always savouring extraordinary experiences, always sharing freely his unique impressions yet never straying from his chosen, off-the-Beaten poetical path:

Under a shadow of fractured eclipses
In the winter's unharvested shade
In some marinaded angle
Some secret perspective
Some hidden trapezoid
Some mechanized equator
Or occulted wrinkle
On the invisible longitude of madness
In money's frozen smile
In explosions of endless expansion
In the gulleys and canyons of time
(From In Search of Paititi, by Martin Matz)

Times Square Superstar
by Spencer Kansa

This interview took place on October 26, 1994, at the New Dawn Hotel in Bayswater following Huncke's spoken word performance at the Artist and Writers Gallery in Notting Hill.

Spencer Kansa: First of all I need to ask you about the new CD From Dream to Dream and how the re-release of The Evening Sun Turned Crimson and reading tour came about initially.

Herbert Huncke: Well first off to clarify a little bit, they stopped printing The Evening Sun Turned Crimson and since everything had come to an end so far as copyright and so on - I've always had copyright anyway - but since they stopped printing it, it becomes my property and when I met Suzanne (Hines at Neptune Records) who had talked to me many years ago and wanted me to go down to Kentucky and work with her - I guess in Nashville where she had hooked up with a company she worked for. I didn't go because I didn't think I was going to get enough money and I couldn't afford to pull up stakes and run the risk of losing the securities I had. So I refused to go, I just told her, "I'm sorry perhaps some other time." Until one day, not so very long ago, a few months ago or so my phone rang and this rather nice voice said to me, "You won't remember me of course blah blah blah but my name is Suzanne. I talked to you about coming to Kentucky a long time ago and doing a show. I didn't have very much money at the time but now I can afford you I think." Well I was pleased because y'know I'm always looking to make a little money, I have to, and I immediately became interested and we talked about doing...well she said a CD, she talked about a CD from the jump, and that piqued my curiosity but I didn't know how the hell they would use me on a CD, I can't sing, I can't carry a tune, I'm a long way from music. I tried to tell her all these things. "Oh don't worry," she said "you have a following in Europe you don't even know about."

Anyway y'know she flattered me a little bit and I went for the oakey-doke. I suddenly found myself saying, "Alright, jolly good," and I made a trip to Bruges that I had never heard of really - Brussels of course and Belgium - but Bruges was a new ball game and I was curious about it and I fell in love with the place. I'll be honest, it's so beautiful there, so peaceful and quiet. The people there are very gentle and it

does have a medieval, a truly medieval quality and although I've heard the same sales pitch about other places, this one really lived up to it, with narrow winding streets, cobbled stones, old ancient houses etcetera. So I liked it very much. I did a lot of reading with her and with David (Garfield — the CD's producer), and David was very beneficial with his inordinate background, making suggestions and so forth, and I was becoming more enthusiastic about it all the time.

Now oddly enough, I think I should mention this, Suzanne had very little knowledge of my work at all. She didn't know how I sounded or what I wrote about but David had chanced upon my work at some point and recommended it to her. She apparently decided to seek me out and also she had started her own business.

SK: Did you tape the readings in a recording studio?

HH: No we didn't do it in a recording studio, we did all this work over a few days and then we edited pieces together. Actually I wasn't in good shape physically, I'd been having trouble with my eyes, I still do, and I was afraid I'd be too slow, stumble too much. But somehow or other they jacked it up and it sounds like a pretty good recording.

SK: It sounds fantastic.

HH: Good, so that's how it came about.

SK: It's long overdue.

HH: Well, alright now, thank you.

SK: The depression era in America in the thirties that you were basically…you were travelling on the box cars and the freight trains?

HH: No I travelled mostly on the road with my thumb.

SK: It was basically thumb, basically hitch hiking.

HH: Yes.

SK: During that time obviously a few people became anti-heroes like Bonnie and Clyde, and Dillinger. They were also products of that time.

HH: Yes but that didn't necessarily make them the way they were. It's possibly something of an excuse.

SK: They had a heroic quality to a lot of people though during that time.

HH: Oh yes they certainly did. They certainly did, and they made great movie material. Hollywood was taking over very rapidly at that time.

SK: When you first hit New York in the late thirties, it must have been something to see for the first time.

HH: Well it was of course like any place you see for the first time.

SK: But especially to you because you felt it was the first place where you could hold your head up high and you had a sense of belonging at last.

HH: Yes I did, I see what you mean. Yes I suppose I did but even so I had always liked New York – period – whether I'd seen it or not, I liked the feel of it. It was exciting, man. There were things happening all around me. New things y'know? I don't know just what they were particularly but I met people who were free in their behaviour and they spoke openly about things and most people at that time were secretive. And I said, "Oh boy this is for me," and tried to become part of that scene...and did.

SK: You said you'd seen it; are there any movies that really capture New York during those times?

HH: Well most of the gangster movies...

SK: The George Raft and the Cagney movies would you say?

HH: I don't think the situation was quite that dramatic but they certainly captured the feel of the whole era.

SK: I can imagine there were loads of Damon Runyon type characters.

HH: Well Damon Runyon was a writer for one of the newspapers, if I remember correctly, who wrote a series of stories about people, Broadway types as he called them. That was the period of dance halls y'know, "ten cents a dance," heh heh, Broadway, the Palace Theatre: where every Broadway star wanted to be seen at least once and preferably be on the so-called 'Mighty Orpheum,' which was the company which handled bookings and so on. Also, it was the period of competitive movie houses, the Roxy, the Paramount, and the others that were done up very elaborately with lobbies where people stood in droves to get in and see certain Hollywood stars in their latest movie etcetera. Along with that came the new entertainment theory: "We'll give the public a package deal: a movie, a band on the stage, a show, dancers, a stand up comedian."

SK: Like a variety.

HH: Exactly. It was great to be part of that scene. Broadway really, y'know, zipped with all these activities. The legitimate theatre was more active then too and that was really exciting because New York was really the home of the centre of entertainment and excitement and so forth. That's what makes New York such a great city.

SK: When you first hit 42nd Street and Times Square and managed to make the scene there, were you running errands for pimps and hookers?

HH: No I wasn't running errands for anybody, I was out there hustling, hustling on my own and I didn't just set out...I didn't want to hustle; I had to learn the hard way.

SK: By experience.

HH: By experience that's right and did pretty successfully.

SK: Did you know that one of the hustlers around Times Square at that time was Malcolm X? His pimp name during those times when he was making runs from Harlem to 42nd Street was Detroit Red.

HH: Really? I didn't know that. There was so much happening at the time.

SK: The 103rd Street boys, the old time schmeckers like Louis the Bellhop, Eric the Fag, George the Greek and Pantapon Rose...how many of them did you know?

HH: I knew them all. I'd met them but I didn't sit around with them, they weren't exactly the type of people I liked particularly and Burroughs got to know them mostly because he hung round the needle park scene. And one reason they gathered in such a mass, in such a large group at 103rd and Broadway was because there was a great automat there and there were no restrictions about going in and putting a nickle in the slot and getting a cup of coffee and going over and sitting down and talking for hours if you wanted to. So that's all. And Bill knows much more about those people than I do by way of Sailor or Phil White.

SK: The West End Cafe is still there up at Columbia University, I know you didn't hang out there much...

HH: No it has changed in many respects.

SK: A lot of those old Beat hangouts like Jarrow's, Hector's, Chase's and Bickford's were cafeterias weren't they? Like coffee bars?

HH: Well I don't know if you'd call them coffee bars. The Automats, the cafeterias were eating places and you could go in for dinner and stand at the counter and point at the various things that you wanted. It hadn't reached the stage of coffee bars and things like that, though I guess the principle in a sense was the same but you're being just a little romantic.

SK: Well I wasn't there so I don't know about it, so I can only

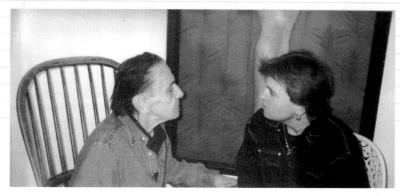

be...ha ha, romantic.

HH: Well of course you don't know, of course. I'm not criticising, I'm trying to explain it so in the future you've got a picture of it.

SK: That's what I want.

HH: That's what I'm trying to give you.

SK: Well you are. You didn't roll lushes like Burroughs did with Phil White.

HH: No that wasn't my cup of tea exactly, although I have tried it a couple of times and didn't like the results at all ha ha. I became a pickpocket, I boosted. To do what Phil did you must do it correctly or you're in trouble.

SK: So Burroughs shows up with these morphine syrettes and a sawn off shotgun for sale and you end up administering his first fix.

HH: Well Phil and I together yes. I shot him up first because Phil was busy rapping to him and Bill wanted his arm bathed in alcohol and a couple of other little things that weren't part of the routine so to speak. Never the less I knew why he wanted it y'know. He wanted somebody to hit him so I did it.

SK: You first met Kerouac in Washington Square Park when Burroughs asked you to come back to his flat because he'd found some new drug to shoot.

HH: Yes. He hadn't found it to shoot, he didn't know what the hell it was and figured he'd use me as a guinea pig.

SK: Oh that's what it was: "You take some first and I'll see what happens to you."

HH: Yes you try it, he was a little leery of trying it himself.

SK: Can you remember what it was?

HH: No I can't. I don't know what the hell that was. I didn't like it.

SK: It was some synthetic?

HH: I don't know whether it was synthetic or not but it was a pill of some kind; it dissolved. The person who had given it to him apparently had told him that it might give him a kick and having run into me unexpectedly in Washington Square Park, he and Kerouac...I didn't think that we were going to be long because Bill was still living in the village. He had a place on Waverly between Mcdougall and Sixth Avenue, The Avenue of the Americans.

SK: Kerouac wrote On The Road but the irony is that you'd actually lived that lifestyle a decade before — while this guy was still in school you were living it.

HH: Well he wrote his view of it, his way of putting it.

SK: His romance, his take on the thing.

HH: Yes. I don't know why. I guess he'd heard me talk like I'm talking now and having a retentive memory and feeling a little bit like that and also having met Cassidy, who was far more adventurous by nature and had had some first degree experience...

SK: Road experience.

HH: Yeah, smuggling pot or tea or grass whatever up the coast of California to San Francisco.

SK: Can you tell me about the opium dens in Chinatown which the gangsters used to frequent?

HH: Well yes, I only knew one or two that I had been to. I had seen them and they had been pointed out to me in Chinatown. I spent a lot of time hanging around Chinatown and I used to score down there from a Chinaman who knew all about them. Later I made a very good score when I bought a car and ended up living with Kerouac on the West Side which was not exactly gangster territory but it was, y'know, gamblers and people that hung around pool halls and places like that who were just on the verge of the underworld so they were in touch with that.

At any rate several of those, I guess you would call them middle class hotels, they were much nicer than anything like this, they had big spacious rooms and had been luxury furnished and catered to many people in show business, for example strippers and people like that, and some of them had rooms that had been converted into opium dens, which were conductive to a peaceful smoke, to lie on the hip, and I lived in one which had orange velvet drapes that fell clear to the floor and tall Georgian wood fronted windows. There were great soft cushions lying around and usually people who were interested in smoking and they would sit and lie around smoking opium, so it became known as a den and the place would be used by your gangsters as you describe them, I'd heard all about them.....

SK: You'd read about them in the book The White Hag hadn't you? It's strange you read The White Hag and the book that made the big impression on Burroughs was Jack Black's You Can't Win, which was very similar, a young boys travels and his foray into the underworld, and it was the same kind of book that made a deep impression on you. It satisfied a want in you to experience "the big bad beautiful world" and all the exciting things to explore and experience.

HH: Yes of course, very much so. "A big bad beautiful world" you say?

SK: Yes I'm quoting you, Herbert. I'm quoting you.

HH: No, you've never heard me quote "big bad beautiful world".

SK: I can show you it.

HH: Really?

SK: It's in Guilty Of Everything.

HH: I said it was a "big bad beautiful world"? Well I'm glad I did. It's a quote that I won't deny.

SK: I know you have a great love for black music.

HH: I have a great love for music but jazz was my first love in modern music.

SK: Would you agree that that black urban culture was the catalyst to what became known as the counterculture?

HH: Y'know counterculture, culture specified as a certain type of culture, is something that I never dealt with and I don't like the term particularly because it indicates separation and I think that is one of the major problems. Of course it was, because it is to be heard and it can be heard and we all sit around in corners and talk about it. So of course black music has influenced the lives of so many people. You might talk about some of the people who helped to produce it, y'know, how are you going to deny the existence of Miles Davis, Dizzy Gillespie, Charlie Parker particularly, Billie Holiday, Coltrane definitely? I really liked his stuff immensely. I knew Dexter Gordon quite well.

SK: Did you know Dizzy?

HH: No I didn't know many of them quite well. I'd met them but didn't consider myself to be lucky. I didn't search around for celebrities and anything like that. I always felt that people who said, "Oh I met dah dah dah, I sat around yeah man." It didn't cut much ice with me.

SK: There's one particular quote in Guilty Of Everything where you say that the difference between a 42nd Street faggot and a hustler is that a faggot is everyone's property.

HH: That was true in prison, not so much on 42nd Street. In the joint it certainly is true that if a man can't defend himself a little bit. Of course a lot of them don't want to; they are delighted to be in there, and they had a great time. But there are many of them that are picked up immediately by these guys who think they're not queer but who are obviously interested in men and prefer sex with men or wouldn't deny it and y'know suddenly they...especially, y'know, certain types, in order to prove their masculinity...they just use a kid until he's worn out. It's kind of sickening, that's what I feel about it.

SK: Most people have this perception that narcotics have always been illegal and drug use frowned upon.

HH: Some of them have, man, that's true. Drugs hadn't been put on the agenda as being really detrimental and they didn't know much about drugs and they still didn't know much about drugs after they became

illegal. As a matter of fact they don't know a hell of a lot about them now, not that I know so much but I know a few things and they deny all of that….

SK: One last one, would you like to squelch the rumour that you are Iggy Pop's long lost father?

HH: Oh come on, ha ha ha. I don't have to squelch it, ha ha, I just ain't, ha ha ha ha.

A SOUTHERN BELLE IN ROCK 'N' ROLL SHOES

Leee Black Childers is the Scarlett O'Hara of punk and glam rock, a Southern Belle in red rock'n'roll shoes sporting a black leather jacket Mick Farren would have died for. Plucked from late sixties Warhol-related theatre, he was Bowie's road manager, a rockist photographer, Iggy Pop's minder, Johnny Thunders' manager, and much else besides.

He remembers being woken up in his hotel room in Seattle one morning around 6am. The phone was ringing. It was David Bowie. "Hi, David," said Leee. It was his job to be woken in the middle of the night to deal with the whims of the man who fell to earth and sold the world.

"I don't know where I am. I'm in the woods somewhere. I found a strange phone booth. I went out with some people. I don't know who they were or where I am," said Bowie.

"I had Olivia de Haviland's suite," Leee recollects his sojourn in the Beverly Hills Hotel, "complete with a glass balcony with a palm tree growing up through the middle, the most exquisite place. After three weeks the management called me and they said, 'We hate to disturb you but you're in Olivia de Haviland's rooms and she is arriving. Can we possibly relocate you? Would you mind?' So I said that for Olivia de Haviland they could relocate me to Alaska, that it was fine by me. A few days later I was down in the Polo Lounge, talking on the phone to my mother back home in Kentucky. The Manager came over to my table and he said, 'Excuse me, Mr Childers. Can I disturb you? Miss de Haviland would like to have a word with you.' So I said, 'Mom, hold on.' Olivia de Haviland comes over and she says 'I understand that you vacated your room for me and I just wanted to thank you.' I said, 'Would you like to say hello to my mother?' She takes the phone out of my hand and says 'Hello, this is Olivia de Haviland.' My mother in Kentucky just goes 'Aaaaaaah!!'

"It used to be very dangerous in the Chelsea's hallways, very dangerous," he says, looking around my plush warm suite, "I hope its OK here now but, when I came up

here just now, all I had to do was step into the elevator. In the old days in the Chelsea Hotel you could get robbed in the hallways and there were certain floors more susceptible to this than others. When the elevator doors opened you had to brace yourself, have a look around before stepping out, and go straight to your room. It was all part of living in New York then. For a long time if you got on the elevator at the Chelsea Hotel you had to be careful about who might be there. There would be junkies, just ordinary robbers who'd come in here and get on the elevator, go to an arbitrary floor to wait for someone. Just now I just punched a button, I could have had a gun, a knife, a bomb, anything...very much cleaner now than it was then. The only reason I can think of for anything to do with Stanley Bard is that he always has gone with the times. Back in the sixties Janis Joplin, Patti Smith, Robert Mapplethorpe and people were living here for practically no money or no money at all, 'cause that's how things were then. Then it got really run down for a while. All of New York has gotten cleaned up, turned into Disneyland, and so has the Chelsea Hotel. I think Stanley just goes with the flow. He has always treated me with a lot of respect, even when I've owed him a lot of money. He never had a problem with that."

We look at a Max's Kansas City photo collage that he has prepared for me featuring Jagger, Bianca, Elvis, and Colonel Tom. I point out an anonymous rent boy from 53rd and 3rd and a blonde babe who could be Anita Pallenberg or Nico.

"It's a mannequin," Leee chortles. "Some people think it's Nico or Marianne Faithfull. Sometimes mannequins were more human than some of those Max's people. Marianne did the most wonderful thing for me about four weeks ago. She was performing in Central Park and this young guy I know called Tommy, who's starting a band, asked me to go with him to see Marianne Faithfull. I said, 'OK, I'll go, but we'll just sit there in the crowd. We're not going to do any of that backstage stuff.' When I got there I was looking over the barrier and I saw Lisa Robinson, so I said, 'Oh, no, this is too much of a temptation. I have to say hello.' So I went up to the security guard. I said to the guard 'You want to go tell Marianne I'm here?' He was very nice about it and went off to tell her. After a while he came back and says to me, 'After me.' So we went in, me and this young guy Tommy. Tommy says to me, 'Oh, my God, there's Lou Reed.' So I said, 'Hi, Lou. This is my friend Tommy.' And Lou goes, 'Uh, well, uh, what do you want?' I said, 'It's alright, Tommy, that's the way people can be when they know one another in this town.' We went down to the trailer where Marianne was. I said, 'Hi.' to her, and she hugged me and kissed me and stuff. I introduced her to Tommy, explained that he was getting this band together. She hugged him and kissed him. 'Oh, good luck, Tommy, it's a horrible life,' she said as she buried him in her substantial bosom. I thought, 'Good for her. She will go to Heaven, for sure.'

"I used to come here a lot back in the days of Janis Joplin and Patti Smith. That way Stanley Bard got to know me because we'd be sitting in the lobby talking. He'd come over and we'd talk and everything. I think that the first time I actually checked in was when I was working with this particular band. We were in London

and the lead singer got this horrible dose of food poisoning. He was just in a really bad way but we couldn't not get on that plane and come to New York. This was probably 1978. When we got to JFK I didn't know what to do because he was in a bad state. It wasn't drugs but from eating a bad kebab in London. I called the Chelsea. I got Stanley on the phone and I said, 'We don't have any money. We can't even function because we don't have a roof over our heads at this stage.' Stanley just said, 'Come. Come.' So we came here and stayed for a while. Then we began to occasionally stay here. With that band and with Johnny Thunders and the Heartbreakers. At one point this rockabilly band I was working with had stayed here quite a while and we owed a bill. Suddenly we got this string of gigs in Canada. So I said, 'We've got to go Stanley, we have to play this tour but I don't have any money to pay you what we owe. Do you want to keep my luggage or anything?' He said, 'What would I do with your luggage?' I said, 'Well, I don't know. It's security or something.' He said, 'If your bill gets anywhere near what Patti Smith owes me, then we'll talk.' I was never actually a resident. The longest I was here was when I was staying with Angie Bowie, who was here for about six months. I was with her for six weeks. This was way after the Mainman years. She had a nice little thing here, a suite. A living room, bedroom, kitchen, bathroom. I moved in with her but before I moved in the hotel caught on fire, the floor right underneath her. It was a pretty bad fire; bad enough that it made the front page of some of the newspapers. On one front page, there appeared this photograph of Angie and her little daughter Sasha in the lobby with blankets over their heads. It didn't even give their names, it just read, 'Refugees from the Chelsea Hotel fire.' Peter Brown who used to manage the Beatles (and had a cameo appearance in The Ballad Of John And Yoko) called me up and said 'Oh, my God! I just got the newspapers. Is that Angie on the top page?' I said, 'Yes it is.' He said, 'Oh, my God, tell her she can come and stay with me.' I said, 'It's OK, her rooms didn't burn.'

Introduction to Pipe Dreams by Marty Matz

by Herbert Huncke.

Martin Matz is, in my feeling one, of the most positive and eloquent poets it is my privilege to be in touch with. How fine and beautiful are the opium-drenched lines in his Pipe Dreams, exquisitely presented in manner: delicate, mysterious and wondrous. He succeeds

in developing an awareness of the strength and awesome beauty, the hidden power and intricate structure in the heart of a stone; the intangible mystique beheld in the flight of a hummingbird; the wine of a dragonfly or exotic butterfly kissing and drawing the sweet nectar from each flower. His demanding retentive memory in order — the essence complete and alive in that instant in time — fuses into revelation, of all which there is to see: the surface, the depth, a vibrancy we can instinctively recognize; the perfection of the moment. Thus he has lived, and knows the great power of what I refer to as Spirit - a word I believe, quite honestly, very often fails to consider the rush of life, or all that we find somewhat difficult to accept or handle.

There exist certain people of strange, mysterious bent who see the palest of colors of each day — who look beyond the heavy grey rolling clouds periodically illuminated by revealed areas of light, patterned with mists and wisps of gently fringed pearly smoke like bits of swirling cloud fragments. The eyes see what is not there, not necessarily due: agitation and undirected time — thought moving steadily through the inner being, alerting our senses to the charm and almost imperceptible awareness of the inspiring beauty, the outpouring of an energy pulsing within the scene unfolding before one unexpectedly. Mr Matz can successfully blend the strange and fascinating dream-level reality with the mundane daily experience most perfectly, weaving perfect magic.

All of this only a fleeting moment, now indelibly marked most vividly within the pictured memory of that moment. The poem becomes the memory we will instinctively know — and, unequivocally, always remember.

It seems to me I spend a great deal of time racking my brain while attempting something in the way of verbal or written description in order to speak of a friend — a poet, a prose writer, a painter, a musician; anyone who is alive, I suppose, is what it comes to — if I am to be understood. Regardless, I attempt this introduction with a sincere desire to speak of a man I admire not only as a man to be respected as a friend, but as an actually fine poet as well.

When I think of his poetry I think particularly of his words... or should I say his choice of words, words that he has rolled round in his thoughts, perhaps tasting their sounds in his head, his mouth. His lines are strong yet tinged with a touch of pathos. His world of color and ancient life, caught in a web of deep wisdom and deep knowledge and response to mystique, makes dreams unfold before him. There is a "force" at work within the whole of his poetry, very nearly in every

one of the poems I've read, but it is most definitely true of the poems in this volume. This can be sensed most clearly when Mr Matz reads his poems aloud — there is felt an exotic richness, as well as an almost world-weary sultriness and throbbing in the voice as he reads his Pipe Dreams.

And he draws support for the solidity of his statements from the earth, the soil — all of nature: trees, rocks, and gems; upheaval and restless winds; strange dream-producing flowers. His is an awareness of the endless mystery we are all so much a part of. Of such stuff are we allowed to fill out the shape of our lives, no matter our aim — or better, our hopes. Nor does it matter what dreams and memories compose the substance of our future. The moment is all. Marty Matz has lived the moment, and his poetry speaks of it wonderfully.

Summer 1989

WE ACCEPT YOU ONE OF US

As a bored teenager I aligned myself with New York punk, saw Patti Smith in concert when I was fifteen; couldn't believe Blondie, The Ramones, or Richard Hell.

The first time I saw Richard, in '96, me and Frank Digger were booking into a Madrid hotel. Frank said to me, "That guy in the sunglasses is Richard Hell."

I said, "It can't be." But it was.

We were all performing at Festimad, a poetics festival organised by this Spanish anarchist. Our fellow performers included Lydia Lunch, John Cale, Hamri, Tav Falco, and John Giorno. Hell and us – like bourgeoisie on a spree – weren't long getting to know one another. Over a paella lunch reception in a palace for artists, where Picasso and Dali used to hang out back in the day, I filmed Hell in conversation with Hamri. I also filmed a speech given to the assembled poetical types by a handsome young Zapatista longhair come all the way from Chiapas to garner our solidarity.

When his technique deserted Hamri, Hamri deserted his technique; Hamri's dark blue African black.

The music of Joujouka is like The Flight of the Bumble Bee being played at double speed on a flute on a crackly analogue radio.

That Sunday we went to look at the big Goya show at the Prado. They charged admission during the week but it was free on Sundays. Hell made the point that Goya's society portraits were in many ways more subversive than his crazed black war paintings. Later we talked to sexy young mohawked anarchists occupying a square alongside the Prado. There was also one very old lady with the punks, an obvious veteran of the pre-Franco anarchist days. She embraced us and thanked us for supporting their cause. We did support her cause, whatever it was, but I don't

134

know how she could tell.

A few years later Hell came to London and Islamic Diggers did a show with him. He showed his black and white movie and I showed my colour one. Islamic Diggers staged *Ongoing Guerrilla Conditions*, unseen footage of Burroughs in Tangier, London, and the Bowery, Brion Gysin in the Chelsea Hotel.

Richard came into town via the Eurotunnel. He was in Paris for the publication of the *Theresa Stern* book he wrote with Tom Verlaine when, in the seventies, the two of them ran away from rich kid boarding school and washed up in New York.

HE MUST BE QUEER OR SOMETHING

I don't know how M.J. stands it. He's been working behind that desk at the Chelsea since 74. I moved in here in 77 and M.J. was well established here by then. I don't know what kind of deal he has going with Bard. I guess they give him a free room or something. Bard was always OK in a funny way. He can be a little zany some days. I don't know how M.J. gets off on standing there seeing all these people's lives pass by, and all the shit you see going on here. Once you used to see a lot of punk musicians living here and people who were in trouble in their lives. Now you gotta be well heeled to pay the rents but there are still some very intriguing individuals present and correct. Musicians still hang out. I was with some kid the other night, I don't know his name, he comes from Australia. He told me his band has a deal with Universal and that they're a big deal in Australia and England. There are a lot of people who're involved in Hollywood. Designers, producers, script writers, actors. There are people from the advertising agencies. I don't like them.

M.J., sitting there in the friendly shadows, has seen all sorts of people come and go through this damn hotel. He must be some kind of queer or something, I don't know. But he was a real good pal to Huncke, Gregory, Vali and people of that ilk. Used to sit in on the famous Linda Tripp poker sessions. M.J. was a Major League footballer in the sixties, young, but he had some kind of an accident that caused him to have a problem with one of his knees. That put him out of contention in the game so he ended up in the Chelsea Hotel as one of the desk guys. "Ending up" in the Chelsea is a frequent life progression. I guess Bard gives him his room to live in for free. I've never been in his room but I would think it is kind of modest.

WHITE MAN THAT I FEAR

Johnny no answer
You know what I mean, man?
There there my dear.

It's the white man that I fear.

Silva Tone and Bobby Cisco, they were the best of friends.

Fred Zecca said to Del Saint that Naz had gone missing. Last time Naz was seen he was in the company of Mr Diamond Stainze, the warlord/dealer with the blonde blonde hair.

Del fixed old Fred Zecca with a worried look and emitted a low and mournful whistle. One of the several varieties of significant whistles he learned as a young man in the barrios of Williamsburg. In the background the new tracks that Del was working on were coming through the speakers.

Sugaree, Sugaree,

Why dontcha let me be?

Sugaree, Sugaree.

Nardo Ranks was surly at first and refused to speak. Later he calmed down, sent Cutty Ranks over to my table, invited me to join them. I politely declined, explained that I had spent a night at the Bardo Hotel with the ghosts of other bitches.

Nardo Ranks tried to tempt me. He introduced me to his top girl, Tomata Du Plenty, saying "This is Tomata the Screwing Nigger."

MARK CHAPMAN MISSED SOME LENNONS

I go to the ABC radio building to record a *Letter from Amerika* for Lyric FM in Ireland. St. Patrick's Day is coming up so I'm reporting on how the name of Shane McGowan still stands for something in New York and how some Irish fags plan to disturb the St. Patrick's Day Parade. Robert Christgau has briefly descended from Parnassus to give Shane the *Village Voice* thumbs up.

The nice fat woman working at the ABC studio which handles all these international recording situations longs to go to Ireland. Alas she can't afford to live in Manhattan so she lives "in a nice part of The Bronx." I feel like telling her to save her money as regards going to Ireland but there's no need to get too nasty this early in the day because she'll probable never get it together anyway. If she's lucky...

Soon I'm speaking to Olga far away in Limerick in Ireland and I do my bit.

I looked at the map before I left the hotel to come to the studio and noted that it's a short walk from ABC to the Dakota Building. This is a place I want to see because as an adolescent I was very much into Charles Manson, so I get the Sharon Tate connection.

Panna Grady, who wanted to marry Burroughs, who funded the Chelsea scene at one stage, who was close to Warhol, used to be the Queen of the Dakota Building. Ira Cohen's pal Charles Henri Ford still lives there.

My interest has nothing to do with that moronic fuck John Lennon though the spot where he got gunned down is certainly significant. On that day the world was saved from a lot of bad music, right-on bullshit, and a possible eventual Beatles reformation. Allowing the Stones to romp home at a gallop, with the comfortable lead which they deserve.

At the Dakota it all came to a dramatic halt, all in the middle of John's fucking Elton John duets and brown bread baking.

Sixties types who are Buddhist/environmentalist/reactionary scum are often ex-John Lennon heads. Like this old bitch I met in a nightclub once with a famous drug smuggler who turned to me and said, "You know, I believe in what John Lennon said. That life is something that happens to you while you're busy making other plans."

"Well, blow me while I take a shit!" I felt like saying to her but in fact I said, "You know, that is so *true*."

Because of course it is fucking true. And a rare example of Lennon writing anything prescient or even vaguely elegant.

I get to the Dakota and you can't help being struck by two things; how spooky/gothic it really is, re. *Rosemary's Baby*, and how sickeningly rich you'd have to be to live there. The rooms are so big, the proportions so huge, that you can tell this is the very essence of privileged living. The spot where Mark Chapman did his work is now all neurotic Aging Rich Folks security guards and cameras.

Mark missed out on a few people — he could have spared us that no-talent Julian Lennon, that fat little rich kid turd Sean Ono, and he might even have put old Yoko out of her misery while he was at it. She was interesting one time in Fluxus.

That fucking Tom Petty. I used to like him but now I can see that he was just the worst kind of eighties disease. Look how he dragged the likes of Johnny Cash and Dylan down to his own plastic level.

EATING WHERE YOU SHIT

"I felt almost serene for that moment," says The Duchess, as we gallop into our third bottle of wine in Abasement, under the Chelsea. I don't know what the deal is between the hotel and this gang, but it's a place where some of the permanent residents hang out. Certainly the guys behind Reception don't encourage you to go down there, stressing that it's expensive and that any number of different cuisines can be economically delivered to your door by surly oriental boys consumed with unfathomable thoughts.

Me and The Duchess are looking at a TV in the corner which is letting us in on the secrets of Omo and Alka Seltzer. Our table is set with a red check tablecloth, cutlery, and a bottle of cheap good wine. There are crumbs on the tablecloth, a sharp bread knife, and the dregs of bluish wine in two glasses. The meal was good so by

11 all I want is to sleep.

Somebody turns up the TV when the news comes on. At the table to our left four fags are comparing Debussy to Scott Joplin.

At the table to our right, a fortyish well dressed businessman with an Italian accent is talking with his much younger redhaired girlfriend. "Get me the Bryan Adams CD for my birthday. One where he does that duet with old one."

"The old one?" she asks in a pretty fatigued New Jersey drawl.

"Yes, what's his name? Old one who fuck the young girls?" he clarifies.

"Willie Nelson? Bryan Adams has done a duet with Willie Nelson?" she asks, as surprised by the news as I am.

"No, no. One like him. Like Willie Nelson. Old one who fuck young girls… Ah, yes! Phil Collins."

When I get her back to the hotel I grab her as I'd intended to do, her skin warm and her mouth salty. The cheap good wine has done bad things to my better judgment.

We get busy together. Her body has the unhealthy decadent charm of a thing about to wither, or half withered already.

PATSY KLEIN CRAZY

Following morning she wakes up alongside me in her bed. Her head gently lolls from side to side as she tries to convince herself that this was a morning in which I do not exist.

"Better," and she pauses as if in the throes of attempted recollection, "the red face than the black heart. Huh? An old Portuguese saying."

Later I am listening to Patsy Cline singing *Crazy*.

"Oh shit," shouts The Duchess, inspecting the CD box, "I always thought she was a Jew. I thought she was Patsy Klein! Like Allen Klein!"

Then, later, "Mariah Carey wrote that *Crazy* song, right?"

Last night she sat up in bed and howled in her sleep. She howled for help bathed in sweat and trembling like a leaf,

RADIO RUBIN/Righteous gentile

There is this rebel radio station I listen to when the World Service is dead and the country music station plays soft, and I can't find violence anywhere on the TV. Radio Rubin is run by these demented smart Jewish kids who play a lot of ragga, weird shit, post rock, and traditional New York or Texas punk. I know about the station because one of the smart Jewish kids – Nathan – lives just up the corridor. He and his pals do

the station from a space in a converted warehouse in Williamsburg. One night I go out with Nathan to see him do his show. He has a clapped out eighties Ford about the size of my London apartment in which we cruise regally towards Radio Rubin while tuned into the station on the car radio. Nathan's cousin Barry is at the controls. The first track we hear him play is *Righteous Gentile* by a punk band called Sad Vacation.

> *Daughter of Asher Benson,*
> *Good morning and I love you.*
> *I'll be yr righteous Gentile*
> *When we drive Israel into the sea,*
> *Give the Arabs back their country.*
> *Give Long Island to the liberal Jews,*
> *Their promised land by the sea.*
> *And the Tough Jews Florida can have*
> *If they battle it out with the Cubans*

FRANK SINATRA / LONELY TOWN

I want to be on horseback. I want to be where the piss poor protoplazm are roamin' free in the land. I want to experience the loneliness of the Japanese crowd so I dive in. The only crowd, not the only crowd but the lonely crowd for a break you town or a bring you down town. A quiet town for a riot town. Love you town and shove you town. Push you round town. The lonely town. Not the only town like this town but the lonely town. A love you town and a shove you down and push you round town.

REAR WINDOW SCENARIO

I am entertaining Longtree Gnoua with a wintry Irish dinner. He has brought the wine for now, the heroin and Polaroid camera for later.

There is a cut-off point for cooking which doesn't exist in art. With cooking you can go in one side of it and come out the other. You come to the end of cooking unless you're brain dead. After you arrive at an intelligent disinterest you still do five or six things well for yourself alone and maybe five times a year go to the bother of cooking something new or special for a guest.

I'm cooking nothing special for Longtree who is like family now.

While the lamb is cooking in the midget Chelsea Hotel oven, Longtree is going through my minidiscs and complaining that all I have is "hip hop and old shit." I say, "What else is there but hip hop and old shit?" Then later it's, "Don't you ever have an

abstract idea?" To which I respond, "No. I'm not renowned for my abstract thoughts." Eventually he shuts the fuck up and presses play on a compilation I've done of the Kinks. The stadium years.

On the TV they're interviewing the tennis-playing Williams sisters. Longtree says, "Man, those Williams sisters are kinda nice and friendly but that fucking Tiger Woods, man, is more of your Colin Powell-style nigger. Hey, what's wrong with me? My dick is always these days as limp as a Dali clock." Longtree likes to be in a world of plain living and high thinking. Ergo he likes to drop in on me at the Chelsea. The problem with his dick is heroin. The problem with plain living is that it's expensive. The problem with high thinking is that I'm not up to it.

I stand at my rear window doing my James Stewart bit. I pick up the rather classy opera glasses my father gave me as a Christmas present the year before he died and I peer out like a queer studying himself in the mirror. In the room directly across from mine, nothing separates us but the Chelsea's back yard, a teenage black kid is busy writing, sitting at his desk. He is working with a pencil on an A4-like pad. Every so often he stops, his brow furrows, and he angrily crosses out what he has already written. Immediately afterwards he persistently jabs the paper with the pencil, making a new impression.

The Kinks are going on about, "a guy on my block who lives for rock, plays records day and night."

I've put too much faith in sterile technology, that's my problem.

I need sex like a razor in prison.

Soon we start to sleep on strange pillows. My room has two huge double beds. Longtree is totally in dreamland on his bed but I've not entirely nodded off on mine. Every time we sleep we practice for death. And we all must get ready for bed.

I can hear music; Richard Hell is doing this song which speculates as to what the young thin punk '77 Richard Hell would make of the middle aged him if they ran into each other on the street. And what would the older Hell make of the nasty attitudinal little punk poet Huckleberry Finn recently arrived in town from Florida?

"I wouldn't shed a queer tear for you," says Longtree as he leaves by the dawn's early light. He is smiling wryly but I'm surprised by the discernible touch of bitterness and hurt in his tough blackman voice. I put it down to the heroin.

FAMOUS OLD GUYS

The little French guy must be a good fucker. I'm always bumping into him in the lift with his wife in the morning. Later at night you tend to encounter him alone. He says she likes to watch TV late night and do coke. So what else is new? The Duchess once said to me, apropos this little French guy, "If women didn't have a fatal weakness for TV and cocaine nobody'd ever get their hands on a decent looking man."

He has an earnest and good natured air about him; dramatically shrunken cheeks like he's had a minor operation around there. His wife is short just like him, both about five foot one. She ignores me while he is always making these covert nods and hellos like he'd like to be friends.

Pigeons, they'll perch on any summit. More beautiful birds are more modest and tend to hide themselves away in trees.

Lots of sexy looking tall middle aged women, some of them walking Irish Wolfhounds, roam the Chelsea corridors like deranged panthers on the loose. An old dear called Cynthia Durrand, on being told that I'm a Virgo, murmurs darkly that this explains everything. "Explains nothing, you fucking crazy rich bitch," I feel like saying but these days I'm much too nice and behave too well. Longtree is waiting in the foyer and soon we're happily thrift store shopping.

He gets a German edition of *Babel* by Patti Smith. Longtree has no German though he once lived in Berlin but the book is dual language. It has some cool pics in the back, a great one *mit Bob Dylan* and a still better one of her with her sepsi in Tangier. It looks like Paul Bowles' apartment. I think I recognize the bookshelf. Patti sure made it her business to go visit – and rub up against – all the Famous Old Guys.

Longtree, over five thrift stores, buys eight books, a new Paul Smith t-shirt, the second Stone Roses CD *Second Coming*, and a pair of Desert Storm combats that I'm kind of resentful about. I get five books and six vinyl albums of American folk recordings from the late fifties.

Using a coinbox in the Nova Cafe – a kind of internet cafe without computers – I phone Richard Hell. Longtree Gnoua is sitting at a table by the window browsing a Kathy Acker book he just captured. Hell picks up right away like he was poised by the phone when I called. He is full of talk, amused I'm writing a book on moshing, can't imagine that shit still happens. He is about to fly to California for three days but we will meet, on his return, at the Cafe Valparaiso, which looks out over St. Mark's Place.

I order my third coffee. The fag behind the counter is standoffish but I can live with that. I can even dig it. Late twenties types – into Duran Duran or Flock of Seagulls when they were eight or nine so now they're paying the price – flash their laptops and tiny mobile phones. The music is Beyond Real hip hop disco on the Nova Cafe ghetto blaster. *If yu could look into my life and see what I've seen.* Longtree Gnoua, who correctly claims that Harlem is the only decent spot on Manhattan, says, "Yeah right! The whole nine yards. Those guys are real fucking human brothers!"

Shaolin shadow boxing.

In the East Village With Allen Ginsberg

By Spencer Kansa

January 5, 1995. Ginsberg called me at the Chelsea and arranged a dinner meet for eight. I met him at his office on East 17th Street and it was kind of strange to find the most famous American poet of the last forty odd years working alone in a deserted office block. "I don't know where you get your energy from." I opined. "Neither do I." he mused. While he signed off on some paperwork, I scoured my surroundings and noticed a letter from Clinton on the cluttered notice board thanking Allen for his campaign support. There was a semi-naked image of Burroughs emerging from a tepee following the Indian sweat lodge ritual in which he attempted to exorcise his "evil spirit". Montages of Ginsberg on Rue Git Le Coeur in Paris outside the Beat Hotel and a photo montage of the Golden Gate Bridge in San Francisco were built up on tiles so that it created a trompe l'oeil effect. I also noted with incredulity an Arsenal football scarf hanging on the door which Ginsberg explained had been given to him by one of the Pogues and we joked how he'd have to be careful wearing that in some parts of London.

Over a dinner of beef with green beans, black mushrooms and brown rice Ginsberg told me about his recent trip to Dublin and visit with U2 where Bono recorded him and showed off the multi-sensory, visual-rama of ZOO TV exclaiming, "This is all Burroughs". I ventured how rap music was a musical extension of the cut-ups and he agreed adding how he hadn't seen anyone write that up yet. "I have," I assured him. We talked films and wondered why On The Road had still not been made into a movie. He told me about the movie theatres on 42nd Street that he Kerouac and Burroughs used to frequent back in the day, totally mesmerized by the films of Renoir and Cocteau. As we ate I brought Ginsberg up to speed with what had been going on in Huncke's life and passed on Herbert's best wishes and, amid the clatter of the restaurant, Ginsberg proof-read my Huncke interview.

Allen Ginsberg: There was never a Beat Generation.
Spencer Kansa: No it was a media term.

AG: It's a media stereotype, I guess, put on you and you either do something alchemical to turn the media stereotype into gold and shift the roles and make it valuable or you fight it and get ruined by the mainstream. What kind of hustling did Malcolm X do? Was he hustling his own body?

SK: No no he was pimping.

AG: Well pimping's not the same. Hustling means you're hustling yourself in America. There's a verb to hustle.

SK: Well there is that term but there's also the black meaning for hustling, just doing whatever you can to make money.

AG: Well yes hustling money but that's a verb not a noun.

SK: A lot of rappers like ICE-T talk of themselves as street hustlers, y'know not male prostitutes but out there getting money in nefarious ways, any way they can.

AG: [In reference to ICE-T's wealth] Well not now. Pantopon not Pontopon. Burroughs got busted for misspelling Pantopon in 1946 or '45, on a false script.

SK: That was what it was.

AG: Yeah he misspelled it and they picked him up.

SK: I like that Prague has become quite decadent. There's talk that it's become the new Tangier. The sex and the drugs and it's very cheap.

AG: I doubt decadent, that's another stereotype, the idea of milieu being decadent. No there are a lot of foreigners, a lot of Americans there, drugs are relatively cheap and the police are not so heavy on the Americans. But I don't think there's so many junkies there as all that. There's a very lively American community there that is very self-conscious about whether it's like Paris in the twenties or Paris in the fifties. But there's some conflict as to whether they're mixing in with the Czechs and all because the Czech language is difficult to master. [Reading on] Y'know Kerouac wasn't at school very long. He was only a year at Columbia. Kerouac did live that thing in On The Road with Cassidy.

SK: What I was trying to get over was Kerouac was well known for that but Huncke had already traveled across America.

AG: He didn't get much road experience, what did he say? Hitchhiking? - Not that much. Not like Cassidy. I think the key was Cassidy had his car. It wasn't that he was smuggling pot or that sort of thing but that he was in 1950 or in 49, he was involved in smoking and then giving it to people and turning them on. So it got to be that Johnny Appleseed did pot in San Francisco. But it wasn't

quite smuggling. Giving it away if anything. [Reading on] Living with Kerouac in the West 70s?

SK: Yeah I didn't know about that.

AG: No. He [Huncke] was living in a hotel with a young kid he was enamoured of. He was a really good burglar and they were making good money.

SK: Yeah I balked at that, I've never seen that written; living with Kerouac in the West 70s.

AG: No, Kerouac didn't live there. It was someone else: a young kid who died in jail I believe. He's talking about the seventies with these opium dens? It doesn't make much sense to me.

SK: Well I've given it to Huncke to go over to see if he's happy with what he said and he was.

AG: It may be he ended up living in the seventies with somebody else up there and they did it in those hotels around 72nd and 73rd; some of those big buildings y'know. Today some of them may be a little run down. But he did visit them during an earlier era in that same neighbourhood, not the late seventies. The White Hag? I dunno what that is.

SK: Yes, supposedly that had a big influence on him. [Scanning the page] See I even quote him one of his own lines and he thinks I'm putting words in his mouth ha ha.

AG: Ha ha yeah. Sound-track? Y'know you shouldn't stereotype. "Jazz was the sound-track to the Beat Generation". Bach was some of the music we were listening to at that time. See jazz is not the first rebel music; the blues was the first rebel music before that.

SK: Y'mean like Leadbelly and Robert Johnson?

AG: No, way back before any of that music, back to 1903 and Ma Rainey.

SK: But it was black music, that was the point I was trying to make, plus back then I think it's fair to say the blues didn't permeate American society in the same way that jazz did.

AG: Y'know a lot of the Beat writers were listening to Symphony Sid on the radio for jazz and advanced jazz. It's just as interesting as "sound-track". I don't think it's black urban music but the music of the ghetto, its black urban culture; class was as much of a catalyst as the music.

I show Ginsberg a bunch of photographs including a rare photograph of Brian Jones taken in a restaurant in Morocco given to me by my guide Ahmed in Tangier who'd encountered Jones during his famous visit to Joujouka.

SK: [Pointing to photograph] That's my guide there on the left.

It's a very rare picture of Brian Jones.

AG: Whose house is this?

SK: I think it's a restaurant in the Kasbah.

AG: Who are these people?

SK: That's the very famous art dealer in the sixties, what's his name....Robert Fra...

AG: Robert Fraser.

SK: Yeah. And these are two of Brian Jones' girlfriends. The nice one asked my guide Ahmed if he could procure any fourteen year old Jewish virgins for her.

AG: What - the girl? Jewish? Was he able to?

SK: He said well it went against his strict religious beliefs but he knew a man who could ha ha.

AG: How did you get this picture?

SK: Ahmed, my guide gave it to me. I actually have the original back home.

AG: What year would this be?

SK: I should imagine it's around 68... This was the time he was out there doing that album with Joujouka, y'know The Pipes Of Pan.

AG: He looks cute. I never met him... Was he making out with Robert Fraser?

SK: I dunno, maybe.

AG: Yeah coz I knew Fraser during that time.

SK: Is Gregory Corso still in New York?

AG: Yeah but Gregory's away from the scene now but his poetry is better than ever. He doesn't do the published stuff now but he writes a lot. Years ago he found that he could make more money by selling Corso manuscripts then by printing them in magazines. So many of his poems are scattered around but they'll come to surface sooner or later.

SK: I went to your old place on 206 East 7th Street of course, made my pilgrimage there.

AG: Oh yeah. Do you know who lives in that apartment now? Lee Renaldo and his girlfriend.

SK: Really? I wanted to ask you when is that collaboration you did with him coming out?

AG: Oh I just gave him a tape. We'll get together and figure out what to do with it. We did one thing together at Saint Marks Church for the Holy Soul Jelly Roll launch party. We had a bunch of musicians. Jim Carroll was there with Lenny Kaye. I'm off to do a Buddhist benefit on February 16th with Patti Smith in Ann Arbor. Ed Sanders and Steven Taylor, who was my old musician and a lead guitarist for the Fugs, were there. Then I read the complete Witchita vortex Sutra which takes about fifty minutes. We had a whole range of musicians accompanying, including Lee Renaldo and Shelley the (Sonics) drummer. Arto Lindsey and Marc Ribot and a whole bunch of musicians who were on my album. It was all organised by Hal Wilner and it was a really great evening with all these different musicians taking different sections of the poem continuing its sequences end to end and I think they'll make a CD out of it for the church cos we had it on a four-track CD and Wilner had a brainstorm. So we did do some work with Renaldo already on that and we'll probably do something else maybe working on the poem.

SK: What is it about the East Village? The place is still so cool even now.

AG: Oh, it's full of activity now. Have you been along Avenue A? It's great. There's a lot of good music. Have you been to Genets? People flock there every weekend. I sang there, Marianne Faithful sang there, Sinead O'Connor was there a couple of weekends ago. Hal Wilner conducts poetry readings there. The Pyramid Club used to be quite mad for rock bands and CBGB is still going, bigger than ever with the CBGB Gallery. Saint Marks Poetry project is thriving but it's a very small area actually, y'know the Mohawk, nose ring, belly button ring brigade.

In Ginsberg's apartment on 12th Street we enter to find a pan of chick

peas burning on the stove that he'd left it on a low flame. Allen opens a window to get rid of the smell. I notice the Gysin on the wall and Allen points out the Keith Haring painting given to him the year the painter died. There are photographic portraits of him by Corso and Peter Orlovsky and a Robert Frank one that adorns the back of Collected Poems. Hanging from a hook is his long, brown and cream striped djellaba from his Moroccan days. A huge bookshelf takes up one side of the room and it includes a ton of Blake, his own works in English and foreign translations from Czech to Yugoslavian. Burroughs, Huncke and Kerouac editions, including Kerouac in Chinese. Works by his father Louis Ginsberg, Creeley, Snyder, John Weiner ("a very important poet") Carl Solomon and Amiri Baraka along with of course a big pile of Dylan books.

SK: I love that bit in the Dylan documentary Don't Look Back where he asks those people in the hotel room "Man have you got anybody over here like Ginsberg?"

AG: Actually there was but the British still don't know about them. Basil Bunting was one of the greatest poets in the world and was quite alive at that time. He was the only one who knew of Tom Picard, do you know of him?

SK: I've heard the name yes. Do you keep in touch with Dylan?

AG: Yeah. When he comes to town we intersect. I usually go to his concerts. He was at the Roseland recently so I went a couple of nights and saw him backstage for about a half an hour and we had a long talk about translations of The Iliad. I went with Peter Haim, my secretary, who has studied classic Greek and Latin so we were interrogating Peter about what were the best translations of The Iliad and The Odyssey, some Latin work.

Press play/ rewind brion

Stop. Press Play. Rewind. Play. Stop. Rewind. Forward. Stop.
Play. Play. Rewind. Rewind.
"Hello?"
"Yes?"
"What kind of Jews do you like?"
"I like Tough Jews."
"What about Golf Jews?"
"Golf Jews? I like them too."

"Yes."
"Hello, yes?"
Stop. Press play. Stop. Play. Stop.
Stop.
Please stop. Rewind.

THE OLD ENNUI

"My life is a sewer," said Isabella Arrogant to the punk rock songwriter in 75.

"Uh, I think Isabella was just the girl delivering the pizza," he says. And he should know, having written the Jewish tune about his Catholic blowjob babe.

Isabella, be there anyworld
Be there anyroad
Be there anywhere.
Anyway. Any day. Any time.

I look out the window. A baboon-ass red Merc cruises past the Chelsea Hotel's entrance, grinding to a halt a few doors down. Inside the Merc the booming system blasts out totally pathetic German techno. Five tough looking black guys climb out and make for Abasement.

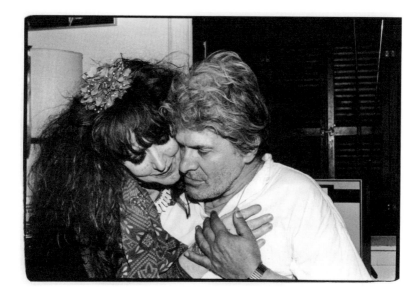

I leave my room for five minutes to pick up some cigarettes. On my way back I get cornered in the corridor by this Shri Lankan called Jeff who hauls me off to his room with the offer of drugs but who then proceeds to play me his employer's corporate promotional video because you can see Jeff in it for thirteen seconds or something. When all I want to do is drugs. Onscreen Jeff comes out one door with a file in his hand and he hands the file to some bitch whose tits are leaping up and down for the cameras. Like nobody's business. It would be fair to say that Jeff looks pretty good on camera, considerably younger and juicier than the real thing I see standing in front of me with a Coors can in his hand. I escape.

I learn a great many new facts each night in the Chelsea, but none of them is of any use to me.

"Elvis was just white trash wanted to be Mario Lanza," says the punk rock master songwriter, fighting vainly the old ennui, relaxed in an armchair, recently returned to Manhattan in triumph from the Mount Parnassus Summer Songwriting School where his fellow lecturers included Elvis Costello, Steve Forbert, and a Tennessee Blowjob Queen who wrote hit singles for the Dixie Chicks, Aerosmith, and Cher.

"Nostalgia," says the mentioned-in-dispatches punk rock songwriter to Longtree Gnoua who arrives with some great pizza and chilled beer, "is a form of fascism, hypnotizing us into a reactionary affection for an imaginary capitalist past."

We go to a tribute event for Gregory Corso. As we arrive Debbie Harry is onstage reading a Corso poem. Then Patti Smith comes to the mike and says that all those Beats – Burroughs, Ginsberg, Corso – used to like it when she sang old Hoagie Carmichael or Cole Porter songs to them – *Stardust* or *Buddy Can You Spare Me a Dime*. Then she sings *Stardust* with her huge emotion. She says it is hard to believe that they are gone, because they were so much around until recently. Somebody mentions Herbert Huncke, pointing out that he was the real thing.

The hall – in fact a nineteenth century liberal synagogue called the Angel Orensanz Centre – is full. Not so many pretty boys as you might expect but loads of good looking and horny women between forty and fifty. They're kind of like the hall itself, regal and covered in gilt. Corso was into the sexy rich women in their early thirties – I suppose he liked them to have a bit of hair. My guess is that all these besuited old gals still hot for the trot are the selfsame ladies now stranded out there in middle age. Some of them are making eyes at me which I like only what to do about them... ha! Besuited or besotted?

So I move to the right like a dog and I move between the seated players, freaks, and circus animals – this one is known to me while that one is Regina Weinreich who is editing the Kerouac haikus for Penguin – that boy there with the straight blonde hair is the singer in an Australian punk band who've only had hit singles in Europe and the next one alongside him is just a junkie without wealth or intelligence on his side. Why'd he bother showing up? Most of the kids look just like the kids I used to see at similar events in Dublin years ago only the Irish ones were more cracked and poorer too.

Taylor Mead is on the platform. I was given his book fifteen years ago by Eamon Carr and it changed my life in a minor way. I sit down on the floor to hear him speak.

Some old timer with very long black hair (it must be dyed) is onstage close to tears, mourning the passing of his old pal Corso. He says, in a firm old fashioned patrician voice which owes something to hard-boiled noir movies, "I was once a man in charge of what was once a bonded warehouse. I invented a board game called *Spit or Swallow*."

Marty Matz tells me afterwards that Gregory Corso had the hots for both Patti Smith and Debbie Harry: "Gregory used to brush his hair when Patti Smith came to call. He sure brushed his hair when Debbie Harry was calling!"

I go over smoothly and introduce myself to Ira Cohen who seems to have forgotten me, I guess it must be eight or nine years since we last met, and he says that I have somehow changed.

"Show me your teeth," he demands.

'The teeth have been done too, Ira," I say, opening my mouth and clenching the teeth in question to prove my point.

Then I notice that I'm interrupting Ira talking to Patti Smith. She turns to me to say hi and uses this break in conversation to make her getaway. I can see in her eyes that she is the nicest person in the world and that we will be friends forever. Us Catholics must stick together.

Ira invites me to dinner the following night, along with Marty Matz. I can phone for a Chinese takeaway when I get there.

They're going to try to bury Corso alongside Shelley. This seems like a noble and appropriate idea.

EL BAB DJ/ Standing on the verge of getting it on

The Lower East Side is truly nice, must have been a whole lot nicer twenty years ago, full of funky things to do and spaces but sometimes they try that little bit too hard. You have to try too hard to get in through the virtual hole in the wall which passes for an entrance into El Bab, a faux-squat venue where 150 students have gathered to check out six DJs and one of them is me. I'm the one with "credentials" but of course all the others have vastly superior technical skills to me. DJing is just like what heavy metal was like before the Chilli Peppers and Guns N' Roses wiped it out: a comic book land full of geeky mammy's boys who fancy themselves as aural cocksmen and gunslingers.

These people milling around me are Longtree's fellow film students. Many of them are his fellow privileged black kids while others are Japanese and the rest are the

worst kind of bedwetting sons and daughters of CEOs and IT millionaires. I'm on my best discreet behaviour, supposed to be his new friend, "an Irish writer who is pals with Neil Jordan." I've told Longtree that this is just the toughest possible form of exaggeration but he has it scripted in his mind. He is absolutely right, of course.

Being as they're all film students the whole thing has been perfectly planned although this is a small place and more or less packed solid. The main El Bab space is a basement room for bopping and hopping. It's right for about one hundred people and there are at least a hundred in there. Three DJs will be doing a two-hour set each. The chill out zone which, for the night, is wittily called Polka Dot, might take another hundred and, as befits a chill out zone, Polka Dot is not too crowded. There are three DJs pencilled in here too, including me.

It's just gone midnight and the first two DJs are manning their respective wheels of steel (or laptops). The main room is under the control of a fucking awful geek playing all this mournful dippy shit that the students just love. Polka Dot is hosting this funny little guy called Gee the Bored who, oddly enough, seems to be heavily reliant for his set of a 2CD which I co-produced. I think to remonstrate Longtree for landing me so low down the food chain that the other DJs are just guys who bought my own records but he has other problems to contend with and, anyway, this is kind of fun and plagiarism is certainly the cutest form of flattery. I think what really gets under my skin is the fact that I'd had it in mind to pad out my own humble set by playing this exact same 2CD which I went to the bother of buying in a Virgin Megastore this afternoon. Buying your own records or books in shops is a foul practice. I get what I deserve.

All eyes are on me, my "reputation" preceding me. I find that there is a backstage, surprisingly enough, so I decamp there with Longtree and Kandia Crazy Horse the online/Village Voice journalist I met at The Anita Pallenberg Story. They get on with talking to one another while I drag loads of stuff out of my orange DJ bag which I picked up in Geneva. There are three or four others in the room, all pretending not to notice me while at the same time trying to sniff out what obscure toons I'm going to be dropping tonight.

I'm going to be playing a bootleg cassette I picked up in Tangier called Mick Jugger Love Songs which has a nice-sounding version of Memo for Turner on it (great love song that one) and I'm going to be playing Music in the World of Islam, Vol. 2: Lutes which I borrowed from the Phil Fletcher wake (Phil won't need it anytime soon) and maybe some Janet Jackson forty-five RPM remixes at thirty-three RPM.

The organizer, a nice looking fellow called Max, the sort of buff dude that Allen Ginsberg used to like to molest, comes over and introduces himself. Hi. Hello. Nice to meet yu. I introduce him to Kandia. Her presence delights and relieves Longtree. Not alone have I managed to find a woman I like on the whole of Manhattan, but she is also a sister. Max gives me a little baggie and the running order. I'm on from two to four when the competition of the dancefloor will be a ragga DJ who escaped from

Montego Bay when he was fifteen, and who has just made his first movie short. This is fine by me. From four to six I'm being replaced by what looks like the only real DJ working El Bab tonight, a German fellow who made an album with some guys from Einstürzende Neubauten. I make a mental note to check him out and get an address because I like Berlin and Germans. Max has other things to do and also I have to get some sort of set together. The Sonic Youth-ish nerds who've been waiting anxiously to see how I'm going to chill them out look positively distraught when they catch sight of *Mick Jugger Love Songs* and mundane fare like Dr Dre's greatest hits.

One tall thin Japanese boy is wearing a puce W< jumper while his girlfriend boasts a top and skirt from Jun Jun. The boy – Muchi – tells me that he is planning to make a movie based on Anita Loos' follow-up novel to *Gentlemen Prefer Blondes*. Apparently he knows some old guy who bought the rights to it back in the Stone Age. I give Muchi a good sexual sizing up and reckon that this old Anita Loos fart has pretty good taste in manflesh. Muchi seems decent and straightforward, as does his girlfriend. He says that his movie would be about the fact that the appearance of evil is every bit as awful as the real thing. I think he might be a few steps ahead of Longtree in the theological or philosophical department.

A Portuguese boy called Anton looks almost sombre in a serious Christopher Nemeth suit and shirt with manly looking John Moor black brogues. A gal who wants to suck Longtree's cock is decked out in a tartan Super Lovers coat. She tells me, not him, that she wants to suck his cock. She says she knows he has a girlfriend and that she doesn't want to interfere. I tell her I know exactly what she means and that she is probably wise to keep out of it. Later I tell Longtree about her and he kind of nigger-blushes while, with typical male contradiction, giving me shit for not telling him at the time, when he could have done something about it. Longtree is in many ways an old fashioned guy but not so old fashioned that he is averse to having his cock methodically sucked by some mad rich bitch dressed from head to toe in high ticket gear. He can also reluctantly, disdainfully, confidently suck the occasional middle class cock himself.

The most beautiful of the girls is this gypsy-style female in thrift store denims except for her Vans trainers. Longtree tells me she's the only talented person in his class, that her dad owns twelve stores in Jersey selling second hand designer label women's clothes. Her family have just moved to Brooklyn Heights.

Beautiful or rich or talented, brilliant, shiny, or nasty, I don't give a shit what they make of the music. Right now I'm making up my set in my head where their opinions won't matter. Later I will forage into a labyrinth of uncomfortable noise where the kiddies will like what I do just like they always do. DJing is no big deal, nothing to get excited about, about as challenging as making an omelette, and I can do that also. Baby, wait and see.

Max comes back into the room to tell me that I'm on in fifteen minutes. In comes Molly, she walks up to Longtree to give him a perfunctory peck on the cheek. She is on the plump side, rather warm and motherly, chatty and likeable. We've met with

perfect timing because I must now leave the room and pretend to be a DJ.

The headphones don't work, like always. Two hours later I end with Sinatra doing *Bang Bang*, the old Sonny and Cher saw. Sinatra made something great out of it, a silk purse out of a sow's ear, on *She Shot Me Down* which was his last real album. This pretty little skinhead about eighteen comes up to me to find out who this is singing so I tell him Sinatra. He asks *Who?* and I say *Frank Sinatra* and he says *Who?* again and I say *He was an old singer. He died.* I got to get off because my replacement is glowering at me so I tell the kid I'll be around later to tell him everything he needs to know.

I'm approached by Leslie, this blonde in her late teens who talks like she just been to riding school or has a pretty big knob tickling her tonsils. She says she was totally blown away by my set, and I tell her I could blow her away all the more if she'd only give me a private consultation. This is just the coke talking. I find it easy enough to be like that around guys, after all they're my own kind, but I'm not usually so forward with females, which is probably why I score more often with nice girls. But she takes it in her stride (my comment), says sorry but her boyfriend is with her, points at him in the corner. He is just one juicier still piece of meat so I'm thinking I'd prefer to watch a double act of the two of them in action than to lay a hand on either of them. Then she says she's seen me round the Chelsea where she lives alone – she makes the point that her boyfriend lives in Harlem – that she runs a little art gallery from her rooms. She is having an opening the night before I'm due to leave so is there any chance I could do a set at the opening and how much would I charge?

I hum and haw about how I don't normally do these things for reduced fees – I'm playing El Bab because I'm committed to the venue and to new music – but since her art was no doubt as marvellous as herself I could fit in an hour for $2000. She breathes a sigh of relief when she hears this and I immediately know that I should have asked for five thou but we make a deal and a deal's a deal. She says come see her tomorrow night around 2am in room 323 and we can work out the details. That's showbiz.

ULICK O'CONNOR

Ulick O'Connor tells it like he sees it, talks of edgy writers like Paul Bowles and William Burroughs. His biography of Brendan Behan will always be invaluable and supremely elegant; the same can be said of his life of Oliver St. John Gogarty, the stately plump Buck Mulligan of Joyce's *Ulysses*. Since those two sixties successes, he has gone on to explore the worlds of theatre, poetry, criticism, sport, and politics. His diaries, *A Cavalier Irishman*, chronicled his subterranean involvement in stirring Irish political events, and his periods as a participant in the Chelsea Hotel circus.

I first met up with O'Connor in front of the Ritz to talk about his then recently

published diaries. We decamped to a local bar where he took coffee while I supped tea. Much of our talk was of mutual experiences at the Chelsea and at the American School in Tangier. We both knew Joe MacPhillips who runs the American School and who did a lot of work – theatrical and otherwise – with Paul Bowles. Ulick has a funny classical music story about MacPhillips in his diaries. He is interested in Brion Gysin so we chatted about him a while. I promised to get him a copy of the book on Burroughs and Gysin that Frank Rynne, Terry Wilson and I wrote. We had some salty chat about the boy-peccadilloes of Brendan Behan and Arthur C. Clarke.

Draculas Cousin
by
Frank Rynne

Frank Rynne: How did you come to stay in the Chelsea in the first place?

Ulick O'Connor: I used to go to the States every year to do a lecture tour. The money I'd make from that tour I'd use to stay at the Chelsea for about two months around Spring. I went down there first because someone suggested that I do my Brendan Behan one man show which was coming on at the Abbey Theatre a few months later. I'd already given a handful of performances of the show but it was going to be launched at the Abbey. The idea was to give a special preview at the Chelsea to raise money for the Berrigan brothers, Dan and Philip, who were in jail at the time. We went down to the Chelsea, myself and a guy called Milton, a Jewish guy who edited Argosy magazine. Milton was a great organizer. At that time I was staying at the Algonquin.

We talked with Stanley Bard when we got to the Chelsea, he showed us various rooms that might be suitable, and eventually we settled on a room which had been used by Dylan Thomas. That's where the show was going to happen. I think they charged a hundred bucks a ticket. We had most of the radical chic in New York at the show - it was packed - because, beforehand, there were receptions in various places up on Park Avenue. We had to install a PA and all the stage equipment in order to stage the show there. It worked out very well - I think naturally in that atmosphere. Malachy McCourt (the brother of Frank McCourt, author of Angela's Ashes and subsequently the presenter of an important New York radio show) said afterwards that he could actually smell roses when I was reciting Behan's poem to Oscar Wilde - written

in Irish - which I'd translated. This was amazing that he could smell anything because mostly if you opened the windows of the Chelsea, there was a yard underneath full mainly of decaying cats. So the smell of roses must have been working overtime. Later that night they had Irish whiskey provided by Jamesons at a party on the roof of the hotel which was attended by nuns and all sorts of things...priests. Malachy McCourt sang for us.

There was, at that time, a roof garden occupied by Shirley Clarke who'd made a very famous film. Around the Chelsea then there were a lot of people who'd previously in their lives done remarkable things though they didn't do too many more. Shirley had made a famous drug movie called The Connection.

FR: You must have had an interest in the hotel because Brendan Behan had lived there.

U O'C: He was trying to finish his book, Brendan Behan's New York, there. He'd been coming there over a number of years during his visits to America so everybody knew him. The atmosphere was, I suppose, perfect for him. The rooms were beautifully built, very big, spacious. They were well heated and that was important. They'd gotten a little shabby but when you got your room you decorated it yourself in your own way. Maybe not the curtains but you certainly put in all your own paintings and drawings on the great big marble mantelpieces. Very much Victorian but marvellous rooms to be in. Brendan Behan didn't always stay there. He really stayed there in the last nine months of his time in America. He was living there with a Dublin girl with whom he had a child. His wife Beatrice came over from Dublin and they had a big row. Beatrice went back without him and he later went back to Dublin on his own. There were a group of black ballet dancers - some of them very beautiful — living there, who did a show which more or less combined black dance with classical ballet. Brendan was chasing a few of them. Norman Mailer once said to me that Behan made it possible for the Beats to move Uptown because, in those days, television was "Uptown" and Behan was on television a lot. Behan may not have written like a Beat writer but he was certainly a natural Beat. He was really in a bad way at this time in New York, drinking and suffering from diabetes. When he came back from the Chelsea he was finished.

FR: What was the particular appeal of the hotel as far as you were concerned?

U O'C: There was a wonderful democracy in evidence. Nobody was laying it on because they were famous. Then there were a lot of aspirants and, like everywhere else in America, there were a lot of

people who just wanted to find someplace to live where they'd not be bothered. Americans are great that way; they have an ability to wear talent with a modest hat. One night I came in and there was this brown paper bag behind the desk. "What's that?" I asked the clerk. "That's the Oscar," he said. "What Oscar?" I asked. "Milos Foreman came in earlier after getting his Oscar and couldn't be bothered bringing it up to his room."

The lobby was where everything would happen. There were transvestites practicing their trade, bringing up people. There was no atmosphere of decadence about it but an atmosphere of people who were sensitive enough to lead their own lives while not imposing them on other people.

Harry Smith had the reputation of being a diabolist, and was said to have killed a few people in his room while experimenting with various rites. He used to have a beard and look quite sinister. I remember one day I came back and I met this guy in a sharp Brooks Brothers suit in the lobby. It turned out to be Harry! He was the first guy to actually paint onto film. He was doing Brecht's Mahoggany on film.

It was organised anarchy. You could get food sent up to your room from the restaurant next door. Everything was efficient. Stanley Bard turned it into an art hotel when he took it over from his father and was a sort of genius, him and his brother Milton. He had this capacity for dealing with artistic people because he had a reverence for them. He would make many, many deals — sometimes for paintings. He sometimes let people stay for a very long time without paying rent. He knew he would eventually be paid but he wasn't always. I don't know how he was able to run the place but he could carry things around in his head. He's still going. I know he is because I rang him two or three days ago to tell him somebody was coming over who wanted to see him.

There were people like Sid Vicious and Nancy Spungen who, to me, were like wallpaper, background which was interesting. I wasn't all that interested in them but it was interesting that they were there, throwing each other out the window or whatever. I never felt the slightest danger in the Chelsea. Maybe because I was reasonably strong and could run if something happened! There were lots of ladies in their forties and fifties, some of them were very genteel upper middle class Americans, living there, and nobody attacked them.

Going up and down in the elevator was when things used to happen. I met this little guy in a pork pie hat who was writing a novel, I think he had taken a sabbatical from life generally in the Midwest, which was boring. He was just standing there in the lift saying absolutely nothing for twelve flights down. Then, when we reached the lobby, he

turned around to me and he said, "Fuck Cardinal Cooke." Then he just
walked off. Another day I was going up and there was this really
beautiful girl in the lift with me. I was wondering how to start saying
hello to her. I got out unfortunately before she got out but just as
the doors closed she opened her raincoat. She was absolutely naked
underneath. So I rushed up to the top floor where she'd have to get off
to catch up with her. When I got there, there had been some sort of
mutation because there was just this black guy in the lift.

 Roderick Guika, who'd been to Eton, was generally known as Roddy
and was descended from Count Vlad, Vlad the Impaler, on whom Bram
Stoker based his Dracula character. Roddy was a Romanian prince, a
very owlish character who always reminded me of Billy Bunter. The most
extraordinary thing is that his mother was the daughter of Sir Nicholas
O'Connor who was the British Ambassador to Moscow. That was how Roddy's
mother met the Crown Prince of Romania. Those O'Connors were related to
me. As I said to Gregory Corso one day, this is the only place in the
world where you'll meet a Dracula and find out that he's your cousin.

DEAD BLACK GUYS

As arranged on the phone five days ago, we enter the bourgeois splendour of
the Cafe Valparaiso, a gilded dolls house defined by vast chandeliers and mirrors.
Richard Hell is already there. The PA emits some strange light classical music, the
likes of which I've never heard before and never want to hear again. Longtree says
to Hell that very dull people live their lives in very fine places. An old guy in a good
suit, with two umbrellas under his arm, shuffles past, glaring at us.

 Two hours later me and Hell are still holed up in Valparaiso. Now the NYPD
Tactical Response Unit have got us surrounded, the PA is playing *Duke Ellington at
Newport*, a black girl lies on the floor next to us breathing but close to the end. Five
million capitalist sirens wail in the distance.

 The mirrors and chandeliers of the Valparaiso concoct a mirrorball effect out
of the red and blue cop lights flashing outside. On the PA dead black guys are
clapping their hands, shouting "Yeah!" and working the snare drum like there is no
tomorrow. Hell is huddled under the Valparaiso's fake Shaker table and so am I. I
turn to him and say, "Richard, we're both writers and at last we've got something
to write about!" which causes him to stare at me intensely, curl his upper lip just like
he used to in photographs from back in the epoch of *Love Comes In Spurts*, and
burst into a smile which is almost a grin.

 The youngest of our captors, an unattractive fifteen year old Mexican girl with
large breasts and a mean pinched face, turns to me, points her neat Sig Sauer at

my crotch and rasps: "Shut the fuck up you Irish pig or I'll give you something to write about. You fuck!"

Through the Duke Ellington PA dead white guys who voted for Kennedy the first time and are thinking of voting for him again applaud enthusiastically, their enthusiasm such that the Duke, in his brandy and tobacco voice says: "Thank you ladies and gentlemen. I think we just have time for one more."

WAITING FOR A CONTACT TO CALL

"I don't know about Patti Smith," Ira Cohen is now saying. "I mean I phoned her the day after the event for Gregory to try to keep the vibe going because I felt like there was something special or magical there and I was talking with her and she was not trying to get off the phone or anything like that but she says to me 'Look Ira, I don't mean to be rude but is there something you want to talk about because there is... sort of... a domestic situation here right now and I can't stay on the phone talking unless there's something...' so we talked some more. She was friendly so who knows?"

"Maybe she was waiting for her contact to call," I quip.

"Huh?" says Ira.

"Nothing," says I.

Poem for Vali

by
Ira Cohen

Perhaps the Armenian carving elephants
on a human hair between heartbeats
can tell you better why you were born
at midday during a storm
or what the Moroccan is thinking
in the asylum
Perhaps he can tell you why the best
sailors can't swim or how to freeze
two perfect tears on a Chinese face
Perhaps the fox holding an egg
in her mouth can tell you better
how red conquered the rain

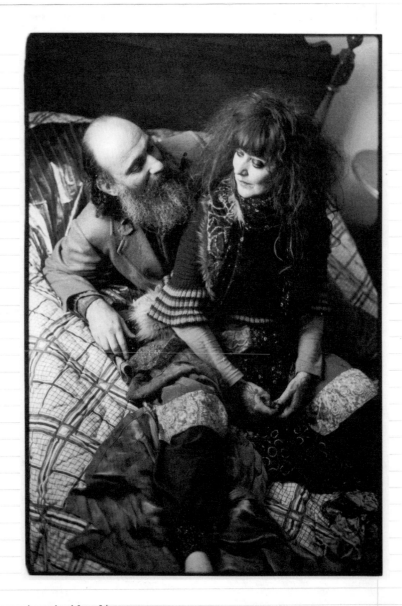

or how the blue line curves
around the nipple & I am sure
that the hound knows better
the meaning of the maidenhair fern
or the secrets of lavender under pillows
But only the harpooned whale

can tell you as he turns, rising
to the sun
how much he hates your blue green eyes,
how much a whale's heart weighs
when it is finally undone.

STANLEY BARD

In its relationship with the various art movements that flowed through New York, the hotel under Stanley's watchful eye was always a noteworthy recipient of those fringe, and sometimes mainstay, figures that were active then. The list is long and fearsome, something like the opening verses of Genesis. It begins with Brendan Behan who needed to finish two books for Geiss and was allowed in on the proviso that there was 'no destruction of property.'

He was followed by Dylan Thomas, whom Stanley remembers as being inebriated all the time (but then, 'they're all like that over there!'). The now legendary film maker Harry Smith, who had been living in the hotel while contriving his Folklore Anthologies hung out with Allen Ginsberg, who then brought around Dylan and (Leonard) Cohen. Along with Aaron Copeland the most important American composer of his generation, Virgin Thompson, lived in the most elegant of the rooms (a five-room apartment), until his death seven years ago.

John Cale

Around 1980 the playwright Arthur Miller, who'd first lived in the Chelsea in 1960 after the break-up of his marriage to Marilyn Monroe, was paying a return visit to soak up a little atmosphere when he ran into Stanley Bard, who'd taken over running the hotel from his father since the last time Miller'd lived there.

Bard immediately set about trying to get Miller to work there again. "Move back! Rent free!" Bard pleaded, displaying financial generosity beyond the call of duty for Miller was always a well-attended playwright. "I have a wonderful apartment for you!"

"Why don't you want to live here?" Stanley demanded when Miller demurred.

"Because I like surprises, but not where I'm living," said Miller. "Like when that girl got shot on the seventh floor..."

"What girl?" demanded a puzzled Bard.

"The prostitute who got one eye and a finger shot off."

"I never heard of such a thing," insisted Bard.

According to Miller, Stanley was really and truly outraged at the suggestion that

a prostitute had lost an eye and a finger within the walls of his hotel, "but at the same time smiling emptily as though at a remark he really could not understand. Why did people continue telling such stories!? Managing the Chelsea was like managing a forest where little fires kept breaking out."

Next thing Miller knew the phone rang, and Stanley was dealing with a lady whose behaviour was beyond the pale, even for the Chelsea. "Now just wait a minute, Ethel," Bard shouted down the phone, "no, wait now. I have something to say! You are not coming back. I don't care, we are not having that kind of business here and you know what I'm talking about..."

Eventually Miller went to look at the newly decorated pad that Bard had in mind for him. It was fine and tempting, new taps on the bath and everything. The two made their way back down to the lobby in the lift. When they stepped into the foyer Miller noted a large amount of shattered glass on the floor where the hotel's glass front doors had been when he arrived.

Bard summoned the desk clerk from behind his station to explain what had happened.

"I don't know what happened," the clerk said, pale and surprised.

"What do you mean you don't know what happened? The doors are gone!" hollered Bard.

"Well, some guy stopped on the sidewalk and took out a pistol and shot them."

"What do you mean, 'shot them'? He shot the doors?"

"He shot the doors and they crumpled."

"Why would he shoot the doors, for God's sake!" Bard asked sensibly enough, his voice containing the faintest note of accusation aimed at the clerk.

"How do I know? I seen him crossing on the sidewalk and he stops and takes out the gun and bang! And he walks away." (It would be impossible to see someone crossing the sidewalk from behind the hotel's front desk which is buried in the darkest recesses of the lobby.)

"This is what I mean, Stanley," explained a delighted Miller to the perplexed proprietor, "it's *too* interesting here, I'd never get any work done."

"Well you always stayed in your room, you never hung out in the lobby, and nothing's going to happen in your room. Will you think about it?"

While Miller stood thinking about it, a blind couple arrived upon the scene and, with their white walking sticks, felt around in the broken glass blocking the entrance, trying to get into the hotel. Bard nimbly stepped over the glass and took the blind woman by the hand. He led her gently around the glass with the man following on behind. He told them not to worry, that everything was under control.

No wonder Bob Dylan, the concrete surrealist and rock'n'roll existentialist, lived here for three years and, according to folklore, came back to write *Blood on the Tracks*.

The Chelsea Hotel was originally built in 1882 as the first co-op in New York. The

original intention was grand in scale and aspiration. The tallest building in New York until 1902, it came complete with soundproof walls, wrought-iron balconies, and purpose built painter's studios. Hence the vast amount of painter's light available on the top floor. At the time of construction Chelsea was the Up There theatre district of New York – the grand ideals behind the co-op reflected local wealth, style, and highbrow living. When the theatres gradually moved north towards Times Square, the beautiful people moved with them. The Chelsea district went into a temporary decline, causing the co-op to go bankrupt in 1903.

The building was remade and remodelled into a hotel which opened in 1905. This, in turn, went broke in 1940 and a consortium lead by David Bard took over. When David became the boss he brought his young son Stanley in to Manhattan with him to examine the family's new empire.

Stanley Bard, whom John Cale has called an "art maven," stands behind the Chelsea's reception desk to this day, welcoming new guests, greeting old residents, booking in rooms, and yapping kindly with the passing carnival.

"My father had little interest in the arts," Stanley explains, "but he had a great deal of interest in human beings. He loved to sit and talk with all the characters that lived here over the years. He used to say to me that running the Chelsea Hotel was a twenty four hour a day job. I used to laugh at him and promised myself that when my turn came, I'd do things differently. And here I am! Day in, day out, just like him. You always say you'll never be anything like your father but life has a funny way of playing tricks like that on you. I used to live here when I was a young man. I had a small apartment in the building but when I got married I realized that I couldn't combine being a family man with living at the Chelsea."

It was Stanley, with an academic background in art studies, who established the hotel's artist-friendly reputation. He befriended Brendan Behan, who stayed there at the height of his fame or infamy. One time when Behan was somewhat the worse for wear and had an important television appearance (if there is such a thing) to make, Bard shaved the Irish rebel before he faced the American cameras and public. Stanley took over running the hotel in 57.

I'd spoken to Mr Bard from Dublin after reading in the *Protestant Times* a dodgy piece which managed to make one of the most fascinating places in the world seem like the most boring. Despite the soporific nature of the article it reminded me all over again that the Hotel existed and, since I had to go to New York anyway, I decided to give it a shot. Frank Rynne reminded me that Miles, the counterculture activist and Allen Ginsberg biographer, had said to mention his name to Bard, who would then fix me up with someplace decent. Miles said Bard was an old sweetheart about whom he had nothing but good things to say.

Miles was right. Bard told me on the phone that he wouldn't give me a reduced rate but that when I got there he'd charge me their lowest rate and ensure that I had a good suite. He was as good as his word, I got good rooms in the heart of

Manhattan and was properly looked after. Most of the time I was staying at the Chelsea, certainly during the daytime, Bard was to be heard all over the hotel's lobby, frantically busy booking out rooms or trying to make a buck. Once he traded telephone accusations with one of his guests behind with the rent.

"The cleaning lady says she can't get in to clean the room the last three days," Bard hollered. "The only way I can communicate with you is here on the phone. You owe me five weeks."

Various disputes ensued concerning exactly how much it was than the tenant in question owed.

"I'm not trying to destroy you," Bard insisted, "I don't want to destroy you. I just want you to pay what you owe me." But that was more or less the end of it – for then – and I didn't hear Bard threaten to fire out the luckless guest.

When I showed up in the lobby one day at 12.30 to do a prearranged interview with him he was, as usual, on the phone.

"I know that Arthur would be very much disappointed if you did a documentary on him and didn't include the Chelsea Hotel. Arthur is a dear friend of mine and always stays here when he is in New York. You know he wrote 2001 A Space Odyssey in the Chelsea? Arthur would be surprised if you didn't use the Chelsea."

The hotel, naturally, charges film crews for the use of their rooms.

As we head to his office I mention that, when I return to my room, I have to speak on the phone with Francois de Menil, whose Texas oil family seem to have funded the entire Abstract Expressionist movement in America and whose Foundation builds museums of modern art like I take drugs. Talk of this calibre of art money causes his nose to tweak, and his attention to focus with unexpected sharpness on me.

"Francois de Menil?" he says all serious. "His mother and father used to come here all the time to buy work from my painters. The hotel is associated with writers and musicians as well as artists but my own particular thing is painting. The de Menils used to come here to see artists of mine like Jasper Johns, Claes Oldenburg, Yves Klein, Jean Tingueley. Julian Schnabel is a close personal friend of mine. Right here today I have an invitation to the opening of a new show of Julian's at the Gagosian Gallery this very evening. Unfortunately I can't go, I have to go home to my wife, but it gives me great pleasure to have people like that as my friends and to be able to help them in their lives. Here at the Chelsea we try to provide everybody with the exact atmosphere they need to relax or get on with their business."

The lobby and upstairs corridors are decked out with paintings from Bard's private collection. Hundreds of large modern canvases. Very few – other than a fine Larry Rivers – of them have any great merit. None of them are by the likes of Jasper Johns or Schnabel, and one imagines that there is a much more impressive Bard collection hanging on the walls of his home which, I think, is in New Jersey.

"Most of the art thing going on here today," Isabella Arrogant said to me one

time, "is a farce. Sure you got the Schnabel and Taffe connections still strong but for every half decent painter associated with the hotel today, you have some rich bitch daughter of a Bolivian drug smuggler who sees six months in the Chelsea as a sort of finishing school, or the fag son of a Tokyo architect who was at St. Martin's in London last year and is currently residing here dying his hair purple or painting his fingernails pink. There are a number of private galleries run out of here now because people will almost pay money to attend an art opening within the walls of the Chelsea Hotel, no matter how soft and powder puffy the actual art is. You get all this saccharine sweet crap being passed off as bohemian product because, in fact, Bard is just cashing in on the Hotel's reputation, charging huge rents to no-talent rich assholes."

To be fair to Bard, his desk is overflowing with an endless array of literary books, many of them seemingly by hotel residents. An anthology of new experimental American writing, about the size of a telephone directory, slips into my lap while we're talking. It sure looks interesting, but it also looks as if nobody's ever read it.

I feel like asking him about the day that the Sid and Nancy shit hit the fan, the day all that reckless giving of credit to, and the turning of blind eyes to the behaviour of, punks and junkies come home to roost but, sitting opposite him, staring into those intelligent but kind eyes, I don't have the heart to be so nasty. I feel that I'd be spoiling his day by mentioning such unpleasantness, so I can't and don't.

"In that very seat you're sitting in right now Brendan Behan used to come sit with me every morning and pass the time," says Stanley Bard. "My wife was pregnant at the time so I'd phone her every morning to see how she was and, as luck would have it that normally coincided with Brendan's visits to see me here. Well, lo and behold, he'd grab the phone out of my hand and start singing some Irish lyric to her down the line. My wife never understood a single word he said but he loved children. Beatrice became pregnant while they were staying here. They went back to Dublin then."

He looks out the window, sad to think about his long-dead friend, who was much the same age as himself. "As long as they respect the Chelsea Hotel and are not destructive to the fabric of the building," he goes on, "I'm happy to let people get on with their own lives. That's my breaking point; if they damage the building. It's tragic that a lot of these great personalities ended their lives prematurely because of their lifestyle. Unfortunately I can't control that but it is a sad commentary. Virgil Thomson was a marvellous witty person who was very straight in that he wasn't self destructive at all. He lived a nice bright life and he wanted to die here, in his own bed in the Chelsea Hotel. And that's what happened. His rooms are still untouched. An artist, who is in all the major museums now, kept the apartment intact completely. He bought all the furniture and effects from the Virgil Thomson estate. Arthur C. Clarke the great writer of *2001*. I'm just working with the BBC on doing a documentary about Arthur. He didn't drink, lived here very discreetly.

Unfortunately there are also many great poets and writers who were afflicted with this *terrible* drinking problem."

GERARD MALANGA/ PANTHER/ VIRGIL THOMSON

Iggy Pop, in the process of denying that he ever had sex with David Bowie in Berlin, once commented that the only man he ever considered having sex with was Gerard Malanga, the Velvet Underground go go dancer, described by *The New York Times* as being "Warhol's most important associate." When I met up with Malanga he'd obviously not heard this compliment before and, blushing, said, "I'm quite flattered. Thanks Iggy." We were discussing Pop's robust workout schedule which, as Malanga says, is part of his work as a professional entertainer. "Look at me," he says, laughing heartily and without guile, "I've let it all hang out."

He is a little chubby now but still recognizably the great focus of attention from the first flowering of Warhol's brilliance. Along with Nico and Ingrid Superstar, to name but two, he starred in what many consider to be the best of Paul Morrisey and Warhol's movies, the multi-layered *Chelsea Girls*, filmed on location in the Chelsea in 65. *Chelsea Girls* so very much involved the entire Warhol team that John Cale says the Factory was almost deserted, and the silk-screens uncharacteristically silent, while shooting was in progress.

Warhol told Malanga that, "The idea of the split/image in *Chelsea Girls* only came about because we had so much footage to edit, and I wasn't into editing at the time, and the film would have been too long to project in its original form time-wise. By projecting two reels simultaneously, we were able to cut down the running-projecting time in half, avoiding the tedious job of having to edit such a long film. After seeing the film projected in the split/screen format, I realized that people could take in more than one story or situation at a time."

This Factory shut-down when everyone went off to the hotel to make *Chelsea Girls* happened not just because of Warhol's absence, but because Malanga was Andy's silk-screen assistant, the man who rubber stamped the signatures onto the great electric chair series. Malanga co-founded *Interview* magazine with Andy.

"I don't really like the Chelsea Hotel," Malanga says, a feeling he shares with many Manhattan intellectuals or bohemians, a feeling unacknowledged by guide book writers and ignored by safe middlebrow fantasists who don't actually know what it's like to starve for a vision of extreme art. "It doesn't really attract me as a great place to be staying in New York anymore. I think it's kind of outlived its time, except that there are some legitimate people living there who will always live there. For a transient coming into New York for a week, I just think you might as

well stay at the Gramercy Park Hotel. It's the same price, in fact I think it might be cheaper, and they've fixed up the Gramercy really nice. I lived at the Chelsea for a while with a girlfriend, and with another friend of mine, René Ricard. It was like a place to crash at one time."

"I think I've photographed four people in the Chelsea..." he says, "but the fondest memories I have of the hotel concern Virgil Thompson, the classical composer and music critic, for whom I used to work as a sort of secretary. This would have been in 1970, the Spring of 1970. A friend of mine who had done some secretarial work for Virgil was leaving. At the time I was working for Andy Warhol. I would go to the Chelsea in the mornings and work with Virgil between 9.30 and noon. Then I would leave and go work with Andy at the Factory. Working for Virgil was a very interesting experience for several different reasons. For a man who was getting on for eighty at that time, he was just so full of intellectual life, a guy who wrote so well and who made such great music. It was an honour, as far as I was concerned, to work for this man. I'd go shopping for him, make his bed, type his letters. The Chelsea was originally built as a block of apartments and Virgil had the last apartment which was maintained in its original style with all the original features intact. It still had the original mahogany woodwork. They were originally basically two room suites, the big suites there, and that was what he had. A guy called Philip Taffe is the guy who now occupies it. He kept it exactly the way that Virgil had it, didn't tear anything out. It may well be the only apartment left with the original exposed dark mahogany wood. Really extraordinary. I shot a three minute colour 16mm movie of Virgil, just one roll. I brought the movie camera with me one morning so that I could have a record of him at the piano."

Albert Vanderberg/Albert the Panther's progression through the counterculture brought him to many strange places. Vanderberg, who had sufficient good taste to sense that he had nothing to contribute to sculpture once he's seen both Mick Jagger and Tina Turner perform live at the Royal Albert Hall, was sharing an early sixties factory loft on Cooper Square in lower Manhattan with painter-sculptor Edward Meneeley. The two mates rarely bothered to watch television but one evening PBS was showing a movie that Meneeley advised Albert to catch. It turned out to be a very beautiful film indeed, but the young artist was particularly touched by the soundtrack, the work of Virgil Thomson, somebody he'd never heard of. He asked around and found that a hell of a lot of people had heard of Thomson, that it was worth his while fishing out a lot more information about this substantial individual.

Albert The Panther: "Alfred Frankenstein, music critic for the *San Francisco Chronicle*, and I had been writing to each other about art-related matters, and when I mentioned Thomson to him it was as if two friends had met in a desert. Alfred had the then-unavailable Victor recordings of excerpts from the opera *Four Saints in Three Acts* which Virgil had done with Gertrude Stein, and he kindly sent

me a tape of it. I was also able to get a recording of Virgil's music for Lorentz's film, *The Plow That Broke The Plains*.

"Then someone told me that Virgil was living at the Chelsea Hotel. So I wrote to him, just to tell him how much I loved his music. He replied, on that elegant small writing paper he used, and invited me to join one of his Sunday salons. Having been so enchanted by tales of Parisian life in the twenties, the mere idea that someone could still be having such gatherings was intoxicating. To be invited to one and by such an eminent person was heady stuff for a twenty two year old.

"These gatherings were to be a treasured part of my life for many years. There is a montage of memories from them... Virgil at the grand piano while Betty Allen sang his songs; sitting at the feet of Edward Albee and gazing at him in shameless adoration while his lover glared at me; Leonard Bernstein putting his hand on my leg and getting a witty verbal slap from Virgil; sipping absinthe from a forbidden jug; being handed as a gift a first edition of Gertrude's *Three Lives*; a never-ending, totally fascinating parade of artists, writers and musicians from everywhere on the planet. Often the conversation was in French and I was lost. Even more often the guests were people I had never heard of and only later realized how silly I was not to have done my research better."

The friendship between the lean young vagabond and the portly elderly tunesmith grew, though Albert suspects that he was first allowed into these charmed circles because he was a good looking youth on a scene where pulchritude counted for something, which liked having pretty young men around.

Rolling Stones aesthete or not, Albert was guilty of that foulest of cultural sins, he admired the Beatles. When the walrus-moustached bores released their awful *Sergeant Pepper* album in 1967, an otherwise interesting enough year, Thomson was visiting London. He called on Albert who was temporarily living in a West Cromwell Road flat decked out in the psychedelic shack style appropriate to the era. There was a bedroom which was lined, floor to fourteen foot ceiling, with bookshelves all of which were painted a deep dark red. The bedroom had to be entered through a rectangular hole in the wall in the hallway.

Albert The Panther: "I warned Virgil that he had to step up to get through the hole, but he missed the step. Then he asked to hear the Beatles' masterwork. Fortunately I had a first class sound system, but he also wanted to follow the lyrics while listening. The only light in the red room was provided by deep orange lightbulbs. Anyone who remembers the original cover of that album will know how impossible it was to read the lyrics in such a setting. But arrangements were quickly made to provide Virgil with white light, and he listened to the entire album while following the lyrics and considered it 'worth listening to'. For someone who had struck terror in the heart of musicians during his time as a critic, it was indeed a laurel for the Beatles."

Or a rare lapse of judgment on Thomson's part. It just goes to show that elderly

men of a certain inclination should avoid trying to stay hip when they're confronted with unfamiliar youth terrain.

Albert The Panther: "In the seventies I moved into the Chelsea myself for some months. Next to my suite was Viva, one of Andy Warhol's superstars. We both loved Virgil and he was very kind to us at a time when we were almost destitute and often dependent on some kind person who left meals in the stairwell outside our rooms. It was bizarre to go from eating corn flakes with water to sitting at Virgil's huge dinner table laden with hummingbird-on-toast and, happily, more substantial offerings. I recall especially one such dinner when the guest of honour was my visiting friend, the British composer Sir Peter Maxwell Davies. I had been in such dire straits in the week preceding Max's visit and had been in such a state of excitement about Virgil's plans to entertain Max that I had to flee the dinner party for a time, return to my own suite and vomit before returning to the table. True Roman style.

"Strangely, I cannot remember for sure the last time I saw Virgil, but certainly one of the last times was at a dinner party I arranged in the late seventies at the Nirvana Restaurant overlooking Central Park West. I went down to the Chelsea to accompany Virgil to the party, and in the taxi on the way to the restaurant mentioned that they did not have a liquor license. 'Then we must buy some drink,' he said and we stopped at a shop and acquired a considerable supply of premium beers. Once, during the poorest time in my life at the Chelsea, I had gone to Virgil to pick up some leftover food he said he couldn't use. As I was leaving he asked, 'Don't you need any sugar?' The look on his face, like the famous poem about Santa, soon gave me to know I had nothing to dread, but I knew it wasn't the way it should be, so I gave him a hug and said, 'No. No sugar.'"

The Old Hotel (segment)
by
Jared Louche

Up in the old hotel, I walk the poorly lit hallways aimlessly, moved by the desire to experience again my dust-thick history in this beautiful, sad place; each frayed thread, every success and every single wasted moment. I wander from floor to floor soaking it all in, smelling stale cigarettes and food on the boil, lightly touching familiar doorframes. Listening to the faceless voices lifts me up out of my shoes, hearing doors opening and closing, the elevator

rising, rats eating and people nervous-pacing behind the walls and I'm transported. Music from scratchy albums played on battered stereos comes wafting out from under some of the doors and I find I'm laughing at myself, even though I really can't figure out my punch line.

I never lived in the old hotel per se, but so many people I knew did that it feels like my home, rich with longing, love and loss. Tonight the action's going down in the back room of the Doubling Cube, the illegal gambling room on the eleventh floor, run by Anna C., and there's no question but that it's all kinds of jump shaking back there. Noisy, like the inside of my head, full of talking and jagged laughter. Monk and 'Trane blow loose grooves through the night walls, filling out the corners past the dim light. 5:30am. I step out of the close, smoky riot of the Cube and into the black-and-white tiled hallway. Eyes shut, standing still and listening, letting the flitting ghosts come leaking out of the air and into my brainpan. 5:30am, and up in the old hotel I look over my shoulder into my history there, watching it all over and over again, reaching out a finger to unravel the thread and draw it out, the light stutter-shuddering awake in my projection-booth head.

Down to the left I can hear Dimitri talking feverishly and almost too fast for his own words; recollections of Barbara, his renegade princess in dappled sunlight, crazy Detroit stories and snippets about grooving with his band. Sweating profusely in Paul's narrow and comically compact second floor room (Dylan's in 66) packed with opera programs and Met memorabilia, Z whines about dropping too much money in all directions as Paul hits him up for yet another ten-spot to support the night's gas. "You gotta burn to shine, Z". Janine Vega muses something about losing her short-term memory and I realise I can't remember what she just said, and I think that's kind of funny. From a party a couple of floors above, Bowie sings Word On A Wing, though I can only catch occasional wisps of it, sounds looping away down the wide stairwell. Through the walls comes one of my favorite quotes from old friend Ray, cab driver and career drinker of steely dedication who only managed to zigzag it back to his thumbprint-sized room half of the week. I'd foolishly accused him of passing out in the gutter over near my apartment one night after a long bout of boozing together, and he retorted; "I don't pass out, my funny friend. Some nights I just go to bed suddenly and early". Taxi horns are bleating outside on the street as the world of traffic scurries on by. The phone hanging at the dark end of the hall by the bathroom on the sixth floor rings forever, a constant irritation. No one ever seems to answer it,

or care that it rings on without relief. I found an unopened pack of smokes stuffed into an almost new pair of Chucks beneath that phone one morning though, so I allow it this one transgression.

Back in the slo-thick of the Cube, Corso wants to know where his money and drugs are. "If that god-damned skinny kid doesn't get back here soon, he whines "I'm gonna crawl right out of my skin, man." Scratch, scratch. Louie drifts in off the street, draped in a loose coat, a paper bagged bottle snugged love-tender under his arm. He bums drinks from soft touches, casting off comments and greeting old friends out of the side of his ragged mouth, eyes candle-twinkling, swinging his palm up through the room, always on the make for a spare smoke or a fin. Louie, Louis Cartwright, was the old thief's lover, Huncke's lover, that is. They bickered and loved and hustled and scored together for over twenty-five years, intertwined un-unknottably. Huncke was the genesis seed of the whole Beat generation scene, unwittingly helping to create that world by just being himself as he tried to make it on the streets of Times Square in the late forties. Burroughs and Co all desperately wanted to be Huncke, mirror that solid cool he evinced without ever trying. He jived through all their novels as well as writing a few himself, my favorite being Guilty Of Everything, but he's another story for another time. Louie, that sugar-charming, fast talking, beat-down, small-time, hypnotic storytelling hustler would turn up one Saturday afternoon stabbed to death on 2nd Avenue over a spread of second-hand books he was selling. He never made it up off the pavement. When Louie died, Huncke closed in on himself for a while and didn't have the warmth to entertain, his door tight-lipped and slightly shadowed. I can see Louie again tonight though, in my private Chelsea peepshow, see him overflowing with crooked smiles and hand gestures, laughing his glorious tattered laugh, riffing off richly embellished stories, endless stories gattled rapid-fire, stories that made my jaw hang and my eyes water.

I think the first time I ever dropped into the old hotel I was freeloading at a party thrown by the filmmaker Robert Frank, auteur of, amongst other gems, the classic Stones tour doc Cocksucker Blues. Music thrummed through the heavy door when I banged on it. Impossible to tell if anyone could hear me. Suddenly, Johnny Thunders, the grey skinned, guitar-saint, appeared in the door to greet me in, all shark's eyes and dusky glitter. It blew my mind that such a tiny room should not only have so many people jammed into it, but a door that opened inwards. Looking sharp as a flick-knife and dressed in the most elegantly tailored burgundy silk suit I'd ever seen, Thunders

carelessly held a mostly-full pint of melting Rum Raisin ice cream in
his free hand. It slopped sleepily down the sleeve of his beautiful
jacket; raisins dripped off that spiny elbow and heavily onto his
matching burgundy suede shoes. "Noo, don't drip on my red suede
shoes. You can do anything, but don't drip on my red suede shoes". He
swayed back into the roaring room with a wide, welcoming sweep and
folded onto a nearby sofa into the waiting arms of three feather-
fluttering, Swedish groupies. He ran an ice cream-smeared hand through
his jagged black hair and swerved back into drowsy conversation with
the sycophants. That was the first five minutes of a night that lasted
years. Welcome to the hotel, son. Where've you been?

One of the strangest things I ever saw at the hotel happened as I
came out of the penthouse apartment one night many years later. I'd
been visiting an old friend who was just back from erecting a massive,
commissioned steel sculpture in Oslo's pristine main square. I'd always
found her work fascinating yet frustratingly obscure, a poke in the eye
with an unknown object. We sat up for hours that night drinking red
wine and talking highbrow shit about "Art", and laughing at ourselves.
Her apartment was painted in a lush bordello red, ceilings and floors
too, the whole place festooned with a wild collection of rugs and
pillows and books and photographs and mirrors and bone sculptures and
tapestries and paintings all woven together, layer upon interlacing
layer. None of the furnishings and fixings argued, everything worked
in concert and the combination of her towering talent and intriguing
apartment made her home a desired destination for a wide range of
characters. Unlike her home though, not all her guests moved in concert
and around 5am a tense clutch of her friends from the cocained club
scene fell by. Strangely clean cut, jabber-jawing in fifth gear and
looking at me wall-eyed, they tasted all wrong and I figured it was
time to cut out before things changed for the worse. I felt a yawn
describing itself across my level of interest, hostess-kissed good
night and made lazy haste for the hallway.

Moments later, falling through the hotel, the elevator heaved
to an unsteady stop on the fourth floor and a couple sauntered in,
rolled up in a swirl of perfume and stale smoke. Must've come from a
private party, all hyped up on some sleazy soundtrack. I could smell
it clinging to them. He was a straight, pure citizen in a three-piece
suit, dark navy blue pinstripe, swank tie, tack and cufflinks, gold-
buckle kicks and a sharp Italian overcoat draped over his slight
shoulders. Briefcase. Monogrammed handkerchief in his breast pocket,
the whole nine. Not quite four-and-a-half feet tall. Perfect in

miniature. Next to him stood one of the most stunning transvestites I've ever seen. Sheathed in a spectacular, mid-calf length, maroon, silk dress, with a string of pearls that shone like hope and lust against her jet-black skin, she was utterly regal and aloof. She wore sparkling red accelerated nighttime pumps, and had the best legs I've ever seen on a guy. She must've stood over six-and-a-half feet tall. Perfect in full-size. At the ground floor I graciously let them split the elevator first just so I could cop a look at her ass on the way out, and it wasn't until they were halfway through the dim, early morning lobby that I noticed they were holding hands…and that the world's shortest businessman was wearing just one disposable surgical glove. Long after they'd walked out through the glass front doors, I stood rooted and trying to puzzle out why the glove was on the hand holding the briefcase.

The Chelsea was always jumping with music when I hung out there, a bizarre and beautiful mix that sound-tracked each visit in some way, every hallway sketched with the layered-in decorations of sound, each room clothed in its own sonic colors. Bobby Ross used to sling lazy slide guitar at me as I draped myself across his bed, his riffs both wild and loose, leavened with distant longing, each note drawing on a laconic cigarette and squinting at the dusty sun. There was always some intentionally obscure seventies punk rock skronk hammering out of Trip's dark, back-building room. That room looked out into the blunt airshaft, a plugged nostril of pigeon shit and wires, and his choice of records seemed to fit it perfectly: James Chance blurting Contort Yourself and Suicide howling Ghost Rider, violent truth hurled through the close and unholy nights. He intentionally kept his door open and spent a lot of time staring out it, down the hallway from the dim to the wrought-iron stairwell railings. He said that, although it wasn't the Nile, or even 23rd Street, it was all he had and that was fine, and besides "you gotta watch. You never know who's gonna come sloping down the hallway when". He was both Art and Arch, intentionally, and his music was riot loud. I hung out for hours listening to the near constant and richly descriptive chatter that flowed from Ricky Orphan when he lived in Leonard Cohen's erstwhile and oddly shaped room. I loved to watch him jaw and draw his twisted cartoon scenes of aliens getting it on in the off-world capital of Pornopolis, while the heavy, sexy funk of Parliament coiled around us, slowly squeezing our muscles. His room was all sultry hips and warm grooves. I've got a sketch of one of his Saturnalian lunar hookers hung by my bed and I can almost smell the reefer and hear the mix of slow-balling funk and

cartoon talk blossom when I run my fingers over the dry paper.

Above all though, I loved Barbara and Dimitri's apartments. Over the years I knew them they lived in a patchwork collection of them, dotted across the hotel's curious geography. They were forever moving back in and then sneaking out a few months later when too far behind on the rent, leaving jumbled boxes of books and records abandoned in the mad escape. Sometimes they'd dog-fight with Bart, the manager, about how much they owed, finally coming to some crazy deal that didn't much benefit him, but fit them fine for another month. Somehow they always snared a room overlooking 23rd street and I dug nothing so much as hanging out the window in the close sweat of summer, or oblivious in drifting snow-dust, soaking in the shifting patterns of the world outside. I spent my life just watching the rippling action on 23rd Street become little animated strips that ran together into tangled blurs, stories coalescing then breaking apart to chaos again, short film clips knotting and unknotting below me as jerky figures slipped in and out of the hotel beneath that battered and sooty awning. Their apartments always seemed to me to contain the very distilled essence of the hotel. It felt like the axis of all things fascinating and stimulating, a constant hustle of creativity and activity, people coming and going at all hours, a river of stop-offs, drop-offs, pick-ups, hook-ups and hang-outs, trades made, deals sealed, ideals argued, tales ranted and music incanted. There, in that heaving river of life, I was a constant stream with those two, all three of us flowing together, madly in love with each other. Barbara and Dimitri liked to have the TV. going while they listened to music, Lenny Bruce cracked jokes in black-and-white while Billie Holliday cried out long and heartbreak-low in black-and-blue. One sound blurred into another, erasing everything else, real gone in those long-gone days. We melted years together as that crazy sonic mix hummed in the background, voices singing, mumbling, laughing, sighing, crying, joking and swooping, until Barbara exited one summer. We melted timelessly, melted until one day when suddenly we cooled and too-quickly hardened, melted until she was gone and the hotel swung those heavy glass doors shut behind us, dusty and silent, the wick pinched out, the radio unplugged.

Steam comes hissing out of the old cracked radiators now and Tina's sleeping face drifts slowly up to me like a warm updraft of air through my dream state in the hallway. Pam's voice cuts through occasionally, telling me what time it is and that, in her opinion,

two weeks without sleep is plenty. Out on the street, Hot Dog raves and screams and bitches all about the latest nothing to no one. "I just got out of Rikers, the god-damn cops KIDnapped my motherfuckin' ass, kept me in the Hole for three MONTHS, is's a GOD-damn kidnapping, aaah-ha-ha-haaa..." The pictures fluttering around me start to flicker and fade as the shape of my gazing dream state takes wing, leaving the weight of years pinioning me to the floor where, moments before, I was drifting. That's the drag about oblivion; you have to come back down some time.

Then, buried somewhere in the lower regions of this sonic barrage, comes the sound of that ancient elevator scraping and laboring once more up to the eighth floor and the gate clatter-slams open. I catch Huncke's footsteps as they shuffle down the dim and echoing corridor to his tiny room by the stairwell, his frail yet elegant voice keeping itself company. Now the old thief too joins the rush of noises and film clips that swirl around me as I drink in my memories of a life up there in the old hotel.

HELLO IN THERE, SPARKLE HAYTER

I am listening right now to Sparkle Hayter's copy of *The Best of John Prine*. Sparkle is allegedly in Paris — she has an apartment on Rue du Saint-Gothard — for the winter and I see from the biog. on the back of the French edition of one of her Chelsea Hotel-set hard-boiled detective novels that she was a reporter in the Gulf War. I wonder about the effect that awful war must have had on her when I think about her private belongings which are, right now, scattered all over the corridor outside my rooms with an inept note attached saying, "All this material to be removed by the garbage man."

Jerome, who looks like he was Sly Stone's personal assistant or Phil Lynnot's brother, but who tells me that he is cruising sixty, is pounding on Sparkle's door very seriously indeed, like a pneumatic drill. Jerome dresses Johnny Cash-black with a sharp Kangol cap on his head. When I was a squatter the sort of vehemence he's displaying was inevitably the prelude to something awful happening — your electricity being disconnected or somebody wanting to serve eviction papers. I presume that Sparkle is behind with her rent but I've never seen debt collection *a la* Chelsea going much beyond Mr Bard getting on the phone to the miscreant involved. It emerges, however, that I've got the wrong end of the stick. Jerome's unexpected nastiness is pro rather than anti Sparkle. I turn down John Prine so I can hear what's going on.

"Hello? " Jerome shouts. "Is there anybody in there?"

Silence. Jerome pounds again.

"Who is in there? There have been several complaints. Mr Bard has sent me up to find out what's happening."

Last night, in the middle of the night, I arrived home from a punk rock show with a companion to find three hotel residents and two members of staff going through the mountains of books, magazines, and CDs which were scattered everywhere. There were also many items of shabby furniture which, in fairness, were probably best left for the garbage man. Foreign language hardback editions of Sparkle's novels, multiple copies of UK paperback editions, hundreds of detective novels by other writers, slightly better books by the likes of Camille Paglia. I retired to my room with my pal until the crowd went away. Then we went out and foraged ourselves for a while. I eventually went to bed around 6am and was kept awake for an hour by the loud banging and clattering emanating from Sparkle's place.

Jerome is nothing if not insistent. Eventually a male voice acknowledges him.

"I'm a friend of Sparkle's," the voice, rich but faggy, says. "We're decorating her apartment for her. It's going to be a surprise for her when she comes back."

Bigger surprise than he can possibly imagine, I reckon.

SUMMER CANNIBAL

The same time that Patti Smith moved into the Chelsea, Brian Jones died in his swimming pool in England. Patti got more upset over his death than might have been entirely appropriate. She began work on a black rock 'n' roll mass based around numerology and spells which was "like in medieval language, but with rock 'n' roll rhythms."

The ability of Americans to write in things like "medieval language" has always amazed me, but let's let that one pass.

Patti Smith: "Of course they were rock 'n' roll orientated because they were about Brian, and I would write them in the rhythm of the Stones' music. I wasn't trying to be 'innovative' — I was just doing what I thought was right, and being true to Brian. William Burroughs was there [in the Chelsea] and Gregory Corso, and Jefferson Airplane and Janis Joplin and Matthew Reich — who was also an early influence on me — and it was really a good time. It was time for us to strike out on our own... Robert as an artist and I had been writing some of my poetry."

Victor Bockris, *Patti Smith*: "While keeping their room at the Chelsea, Patti and Robert now also rented a loft together just down the block on 206 West 23rd Street. (Ironically, given Mapplethorpe's later subject matter, 206 West 23rd would in the nineties be the site of an S&M theme restaurant called La Nouvelle Justine where patrons eat out of dog bowls and are served by drag queens dressed as

dominatrixes.) Robert spent most of his time working in the loft on his art projects and this left Patti free to network."

THE DUCHESS DEPARTS

The Duchess leaves tomorrow for Pakistan where she has lots of business to do. From there, she tells me, she flies directly to Turkey where she must spend a few days going through things with Dimitrios. I'll be long gone by the time she gets back here. The clock is ticking. Tonight she throws me one last dinner.

She is not in great humour for talking, having other things on her mind. Also I'm about to disappear. When you leave Big City you're forgotten within six hours.

Her shrewd blue-grey eyes study me like she's the painter and I'm the model whose line she is attempting to capture. I make a casual remark about Bill Conduit, to the effect that I had a very interesting time with him over the duck dinner. She just nods, like a near sighted horse confronted with oats in the middle distance.

THANKSGIVING 1991: HARRY SMITH
by Herbert Huncke

Many people telephoned — wished me an enjoyable day. I was pleased people were thinking of and about me — it is good being thought of, regardless how, although the nearer the thought of love — the closer an awareness of happiness is bound to exist.

I have never been a close friend of Harry Smith. Our paths have crossed many times and I know the majority of my friends spoke well of him concerning his mind or, perhaps I should say, his ability to be creative with his interests: film, film animation and experimental projects (which I know nothing about). He was also a knowledgeable and learned philosopher and mathematician. I really knew little of him. Today everyone who phoned — or almost everyone — mentioned he died either late in the day, yesterday, or perchance, early in the morning.

He was respected, admired and liked by many, many people — all over the world. It embarrasses me. I can't list his accomplishments — one, two, three — on down the line, so to speak.

As I said, we met on and off — here and there — since early so-

called Lower East Side hippy days. We had mutual friends and many
similar habits, thusly he became popular among various groups of
people. Allen Ginsberg knew and liked Harry. Allen helped in many
ways, as have Raymond Foye and Panna Grady — people at the Chelsea
Hotel — Stanley Bard, Linda Twigg, Paola Igliori, Vali Meyers,
and others throughout New York, the entire country and, in all
probability, the world.

To speak honestly — I didn't respond comfortably to his personality.
His appearance made me feel sceptical of his trustworthiness.

How dare I make any comment that should indicate how petty I am?

About 10 or 10.30am my phone rang. My caller was Allen Ginsberg,
who immediately offered me a belated but heartfelt greeting pertaining
to the Thanksgiving wish for enjoyment for the seasonal period — so to
speak — as well as to tell me of Harry Smith's death.

We chatted mostly comparing our information about Harry as we knew
him individually. I did ask Allen about Harry's age — mentioned I had
been told, by several people, he was in his early eighties but that
quite a few other people thought him younger; somewhere in his late
sixties. Allen said at some point he had seen Harry's birth certificate
and was almost sure sixty-eight was closer to factual. Although that
was closer to what I felt was correct, I was a bit surprised — since
in my opinion, at least, Harry looked nearer to eighty, if not older.
Allen agreed with me, qualifying his reason for thinking so by telling
me Harry had abused his system by consuming vast amounts of strange
and little-understood drugs and — although he wasn't specific — I got
the impression Harry had been a somewhat heavy drinker. Apparently,
Harry had been internally bleeding from some disorder and coughing
up blood for nearly a year or maybe longer. The sum total of the
information implying Harry had been in deplorable physical condition a
long time. To judge by the decayed and rotten condition of his teeth,
one can easily accept such diagnosis. Why Harry adamantly refused to
permit anything to be done towards correcting whatever problem existed
concerning his mouth is presumably anybody's guess.

Allen, in passing, did speak of the possibility of Harry having
been a member of some group, influenced perhaps by the teaching or
belief of Aleister Crowley.

Before closing our conversation, we both agreed Harry was strange
and exceedingly fascinating.

I sincerely feel annoyed as well as a bit sad I don't know more
about him. Even though I have always been aware of him as a rare and
unusual man, I was never enthusiastic about becoming closely involved

with him. I suppose it wouldn't be particularly difficult to analyze just why I stayed more or less clear of him. Perhaps I feared his seeing me too clearly, seeing my vulnerability and the weakness in what I believe my personality consists of — so to speak.

I am trying to end all these words — I'll try to give my impression of his appearance since inside I feel his appearance had much to do with why I didn't try to get closer to him as a human being.

If my memory stands me in good stead, I met Harry the first time in Allen and Peter's apartment on 2nd Avenue about January of the year 1960. In an attempt to indicate, the reason why I refer to the apartment as Allen and Peter's is because in fact they did rent the apartment in name and also because I think it bore a sort of reputation as a focal point for the very early days of the Lower East Side, a creative gathering point, for writers, poets, visual artists, musicians, and, in a sense, new-type thinkers of all kinds, trying to break free of the rigidity of the so-called social behaviour and thinking of so-called normality. I merely offer a generalization of the lifestyle beginning, at least, to seem freer of taboos that no longer seemed necessarily right or applicable in every instance, allowing for the greater display of individuality. All of which deserved a fuller accounting that I offer here. It, putting it mildly, vibrated (all this, in my opinion) with much activity and heavy conversation, not to pass up the constant coming and going of people of every description.

And so it came about, I think, one evening I, who was spending much of my time at the apartment, met Harry Smith.

He was noticeably small of stature, with sharply defined, small facial features. A small sharp nose, which came almost to a point. His eyes, I think, were grey or green and tinkled sometimes and became piercing on other occasions, behind small, plain, perhaps metal-framed glasses that fit in the center of his nose, held in place with thin metal bands which extended to his rather faun-shaped little ears, projecting a trifle obviously from both sides of his small face that ended below his mouth, thin and somewhat colorless, with his sharp, pointed, chin. I seem to recall his hair as being a little curly or wavy, with a somewhat high forehead, light brown in color, and neither sparse or very abundant. The neck was thin, centred between fragile-appearing shoulders with thin arms, ending with small hands. He wasn't what would be referred to as tiny, yet he was short and small, giving off an attitude I thought of as resembling a little fox, although not as appealing as a fox might appear.

In all probability I am entirely out of line, offering any comments concerning the man. Still, speaking honestly, I never really was comfortable with him nor felt inclined to develop his acquaintance or friendship. On the other hand — continuing this list of clichés — I did not wish him despair or pain, and certainly not death.

So be it

SURFIN' IN HARLEM

The junkie lead singer type individual in the blazer who greeted me so friendly on arrival now ignores me because I'm leaving tomorrow morning. Jerry, the nice patrician old guy who has been here as long as Stanley Bard, who is Bard's right hand, mans the whore computer — one of those early lime green screen jobs — and summons up from the digital void still more funds they can extract from my account. Long distance phonecalls to my best friend across the Big Sea who never one goddamn time returned my calls in all the time I've been here. My friend forgot about me but the whore computer noted my loneliness and charged me for it.

All morning I went shopping for others: guitar strings of some special kind for my brother, a Manhattan Portage superbag for myself. (The oriental fag behind the till in the LES Manhattan Portage store had obviously not met a real man for some time. He started tweeting like a sparrow when I inquired about the price of my bag. Eventually I got the information out of him, so now I have the biggest Portage bag there is.) I took a sack of Sparkle Hayter's possessions to a second hand book shop on St. Mark's Place where I got $30 in credit for them. With the credit I purchased ten Maigret novels. In the book shop they had a nice photo of Huncke attending a literary function but, of course, none of his books. The longhair behind the counter got a little nervous when I told him I'd known Huncke. The cult of the Beat Generation is all presentation over content. They were serious writers, Bowles and Burroughs and Huncke, but the knuckleheads who're "into" them have never ever read anything that they wrote.

I have seen Longtree Gnoua in many different moods, guises, and conditions of being. All the way from buck naked through to Nu Metal Nigger through to dressed for a funeral. I'd seen him sitting opposite me for silent ambient hours hating me for what I was doing to his head, the way I was changing him.

This is our last time together, our last party, so he has cleared the decks for me, like I have for him. We meet at Calvin's at lunchtime but don't linger there too long. Molly and he had a big argument last night so we can retire to his place. It finishes where it started.

Later I ask him what was that stern and somewhat vicious look with which he fixed me Day One on Lennox Avenue as he walked away from the crackhead's record stall. "It said either come talk with me in the next twenty minutes or I will disappear and

you will never see me again."

Three bitches, like a post-hip hop Diana Ross and the Supremes, stand on the street corner, hands on hips, purple lip gloss shining, as if to say: Stop. In the name of love.

I didn't say that. Adrian Henri said that.

The pillow gets chewed to shreds. He'll never explain that to Molly; he'll just have to go buy a new one and spend hours searching for tiny feathers, hoovering them away from under the bed. That's what comes from investing good money in feather pillows. Nature cannot be tamed.

"I don't want to be around when you leaves," he whines, though I don't know why he's pretending to talk like Bessie Smith (I guess they both suffered at the hands of the white man) since he's much better educated than me, much better spoken than me, intellectually quicker than me, and not in the least bit sentimental. He is the cool indifference of New York made flesh.

I've decided never to speak with him again. When I get back to London I'll block his emails and if he writes to me at my convenience address I'll tear up the letters unread. This is a junk decision I have arrived at. Junk emotions and junk ideas are good, but junk decisions are always bad for other people. He falls asleep in the early evening. I get dressed and sneak away.

Carter the bicoastal bisexual movie star never got back to New York. That's what happens when you win an Oscar — you lose control of your life. He phoned me last night to say goodbye. He is scheduled to star in a remake of *Desperately Seeking Susan*. The action has been relocated to Seattle. He is playing Richard Hell, Rosanna Arquette is playing herself, and they got Elizabeth Taylor playing Madonna. Or maybe it's the other way round. Philip Glass is writing the incidental music, while Iggy Pop is working on the theme song, a Latino love song about eBay, with Andrew Lloyd Weber. In three months time Carter will be in London working on an all-star thriller. The Hubert Selby Jr. project is going to come together but not in the near future. He was talking to Rod Steiger about it at a party last night and Steiger is up for it.

CHELSEA PARTY BLUE

Three young guys are sitting on the floor in a small room. Jeans and sensible thick sweaters but not bad looking fellows for all that. The TV in the corner is one of those seventies gone-blue/green jobs. The controls are set to give a narrow distorted image. The sound is turned down. This is real Dublin-in-the-seventies bedsitter party stuff only the attendees are mostly millionaires or the children of millionaires. The three boys in sweaters turn slowly in my direction like automatons at 3.35am. The least intelligent looking one of them removes a pair of expensive D&G sunglasses and says to me, "You're standing there like it's another channel, daddy."

It must be time for me to go.

EROSION

I pick up my suitcase at six in the morning, take the lift to the ground floor, and say goodbye to no-one.

I'm going where I've never been before. I'm going where the chilly winds don't blow. Going where I've never been before. Don't leave me alone out in the cold.

An old black guy dressed like an undertaker — or John Lee Hooker — picks me up in the Chelsea lobby. An old fashioned Tel Aviv Cars limo awaits my pleasure on the sidewalk. A night porter I'm unfamiliar with says goodbye to me Sir. As the old black guy drives the limo through empty streets and highways towards JFK, he puts on a tape of a dead Christian preacher preaching and a bad Christian choir singing. I despise these Christians. They deserve the shovel and the six feet of dirt.

The plane takes off.

I ain't sleepy.

The good bad drugs are all gone now and they cannot be replaced.

I've changed my mind about Longtree. I'll phone him when I get to London.

Time passes slowly. My erosion continues.

THE END

/// WRITTEN IN RAMADAN — AN EPILOGUE

That beautiful moment in time when I first visited New York, Manhattan was fat at the gullet; high culture was mixing it with Clintondollars. Everything cost outrageous money and everybody said that it was cheap. Debbie Harry was still on the streets and the poor were still stranded out of town. It was a guilty capitalist rat trap full of truly great culture and Latino hungry hearts that deserve some day a chance to run the entire nation.

When Brando spoke out against landmines at Michael Jackson's Madison Square Garden flop comeback gig, celebrating his forty years in showbiz or his twenty-five years keeping company with blonde boys, or whatever the fuck it was, the New Yorkers booed Brando for his advocacy. Within days they paid a fabulous price for their indifference to poor people's suffering.

I am sitting in front of my laptop in Asilah — near Tangier — looking out over the seafront. It's Ramadan. This is yet another sad vacation for me. No doubt some day I'll snap out of it and become just another bourgeoisie on a spree.

Brown sugar informed this writing, and there is a dark shadow peering over my left shoulder. I came to Tangier, this time, immediately after my second visit to New York and to the Chelsea Hotel. I've been to the city and the hotel twice in connection with book writing work (my book on moshpit culture and a book on Iggy Pop). Chelsea Hotel Manhattan is based on notes taken during the first 2001 visit and on similar notes made during my second trip in 2002. Between the two visits Manhattan got to bop 'til it dropped to Osama Hip Hop. They're thoughtful people there, and I found them much improved by their little adventure.

I'd intended writing huge swathes of my moshpit book on the hoof in the city but when I plugged in my laptop in my room, I got my first ever touch of writer's block. Perhaps I'm the first writer ever to encounter writer's block on arrival at the Chelsea. But the notes I took on the same laptop, on pages torn from spiral notebooks, on the back of techno and punk flyers, were an obvious tableau inspired by Manhattan, the people I talked with, and the narcotic prism through which I saw everything. All these notes, some of them visual rather than verbal reminders of my adventures — sometimes I'd roughly sketch the interior proportions of a coffee shop, a club, or a dive — seemed exciting, colourful, and book-like.

I bought six spiral notebooks for a dollar for my work on moshpits but they ended up full of phone numbers, email addresses, brief notes on covert interviews, and many clear paragraphs which appear here exactly like I wrote them down in the Chelsea. Virtually all of the immediate action stuff here derives from those spiral notebooks; things seen or heard on TV or radio; verses sometimes gotten down wrong from songs on the radio that I'll never hear again. Other times I got the lyrics wrong, then got them right the next time I caught the tune, and a mixture of the real and the misunderstood has been included.

Some "diaries" took the form of pages torn from paperbacks before I binned them. The paperback pages tended to note overheard conversations and comments as I roamed the streets, the trains, the back alleys.

I know that Dogs Run Free is not the correct name of the Joni Mitchell album. Richard Hell

and I never got besieged in the Cafe Valparaiso, though we did go see the Goya show in the Prado. I knew Herbert Huncke but I never once met him in America. I spoke with William Burroughs about Hamri and Dreamachines on the phone but we never met face to face. He had, of course, deserted both the Chelsea and life itself by the time I hit New York. There are occasional deliberate repetitions and contradictions because life in big cities is full of repetition and contradiction. The first person has been liberally abused; various first person narratives happened to other people. Sometimes they happened to me. Sometimes they're a complete concoction. Go figure.

By the middle of 2002 I'd worked up about 20,000 words from my notes. I was living in Morocco, surrounded by Islamic people. I occasionally consulted a Penguin English language edition of The Koran. The war against the Taliban government was in full swing, the whole of Morocco protested in the streets outside my apartment one day. Morocco provided me with a scalding atmosphere within which to consider my New York adventures.

I've finally hammered all these disparate strands into one lump over six days in Asilah, some fifty kilometres south of Tangier. It's a town with its own magical relevance to the subject matter of this book. Many onetime Chelsea Hotel residents have also passed through Asilah. It was in Asilah that Hamri had his Thousand and One Nights restaurant in the sixties. Errant Rolling Stone Brian Jones went to visit him there, and from there they arranged to go to Joujouka where Jones did the Pipes of Pan at Joujouka album. Paul Bowles used to escape to Asilah when the political/moral climate got too hot for him in Tangier. Burroughs and Gysin were frequent visitors. It is a great town to write in. Every day for the last six days I've travelled the streets and rooms of New York in my mind, while actually traversing one of the smallest and most beautiful medinas in the Islamic world. The babel of one community has helped give shape to the babel at the community which constitutes the Chelsea Hotel and Manhattan.

Joe Ambrose
Asilah, Morocco
www.joeambrose.net

PS. Since I wrote this book Stanley Bard has been deposed from his position running the Chelsea Hotel. It seems that the Hotel's "Golden Age," which he curated and reigned over, is now over. His achievement never consisted of bricks and mortar. The work he faciltated changed the course of popular culture and art irrevocably.

PPS. The publishers have pointed out that the use of the word "nigger" in my text might be open to a racist interpretation. I use the word, in all its brutality, precisely because I am a committed anti-racist. I work with words the way a painter might work with oils. I slap them down on paper for effect. I am neutral about all words, defend my right to use any word that comes to mind or to hand, but loathe racism and have fought against it since childhood.

READING LIST

The Mask of Dimitrios by Eric Ambler

But Gentlemen Marry Brunettes by Anita Loos

Epitaph for a Spy by Eric Ambler

Homecomings by C.P. Snow

Sands of Torremolinos by Juan Goytisolo

Aground by Charles Williams

The Koran

The Sheltering Sky by Paul Bowles

Yesterday's Spy by Len Deighton

The Party's Over by Juan Goytisolo

Dirty Story by Eric Ambler

Horse Under Water by Len Deighton

Maigret At The Crossroads by Georges Simenon

Death of an Ex-Minister by Nawal El Saadawi

SOUNDTRACK

Man and His Music / Boogie Down Productions

Joujouka Black Eyes / The Master Musicians of Joujouka

End of Time / 2Pac

Money Talks / Tav Falco and Panther Burns

The Beat Suite / DJ Spinna

Second Coming / Stone Roses

Albion Dance Band

Ghost Dog soundtrack

Controlled by Hatred / Suicidal Tendencies

Voodoo Glow Skulls

Music in the World of Islam, Vol. 2: Lutes

Love and Things / **Point of No Return** / Frank Sinatra

Voice of Jamaica / Buju Banton

Love of the Common People / Joe Gibbs

Growing Up In Public / Lou Reed

Jah Screw Presents Dancehall Glamity

Love and Theft / Bob Dylan

We're Outta Here / Ramones

How High? soundtrack

A SELECTIVE GLOSSARY

Betty Allen, a black mezzo-soprano, made her New York City Opera debut in 1954 as Queenie in *Showboat*. In 1964 she made her formal opera debut at the Teatro Colon in Buenos Aires, Argentina. She sang at the New York City Opera from 1973 to 1975. She is well known for her performance in Virgil Thomson's *Four Saints in Three Acts*, in which she appeared in 1952, and the ANTA Theatre's 1973 Mini-Met production of the same work and all major productions of it until 1982.

Ray Bremser. Charles Plymell wrote that Bremser was, "one of the original, if not one of the most authentic Beats, a hipster from the same vein as Herbert Huncke (probably closest to him philosophically than others), from the jazz subterranean world down the block to where Kerouac was blowin'. He lived a spartan lifestyle (not without excesses) associated with the early Beat movement. A bed on the floor in a room a couple times bigger than a cell, a few tattered books and a sink to piss in was home to him. He was not a clean liver by any means. His pad was probably more like Howard Hughes's, except in Ray's case filled with labyrinthine mounds of beer bottles, cans and ash trays. His economics were similar to Huncke's, too. Always on the hustle, scuffling enough for beer, cigarettes, drugs, and a room. He had one windfall from a class-action suit against the state, which brought several thousand to his kitchen table piled high with butts and beer cans and thousands of dollars. He lived in a pad in Utica with no street numbers. I talked to a couple of black guys at the door to find him. He gave me a thousand to go for cigarettes, saying to keep the change and not to say he ever owed me anything."

Shirley Clarke was an independent filmmaker who made experimental movies which challenged convention. Her film *The Connection* was a gritty exploration of drug addiction banned in New York on grounds of obscenity. Her other films include the Oscar-winning *Robert Frost: A Lover's Quarrel* and *The Cool World*.

Andy Clausen is the author of nine books of poetry, including *40ᵗʰ Century Man: Selected Verse 1996-1966* (Autonomedia) and *Without Doubt* (Zeitgeist Press) which carries an introduction by Allen Ginsberg. Clausen is a construction worker and teaches poetry in public schools and prisons in New York.

Steve Dalachinsky is a renowned New York downtown poet active in the free jazz scene. He has been featured in anthologies like *The Outlaw Bible of American Poetry* (Thunder Mouth Press), *Self Help* (Autonomedia) and *Off The Cuff* (Soft Skull Press). His 1999 Knitting Factory CD, *Incomplete Direction*, contains readings of his work juxtaposed with the work of musicians like Matthew Shipp, Thurston Moore, and Vernon Reid.

Dilaudid. Hydromorphone is a drug used to relieve moderate to severe pain. Hydromorphone is known by the trade name "Dilaudid", though an extended-release version called Palladone was available for a short time before being pulled from the market in 2005 due to a high overdose potential when taken with alcohol.

Lady Frankau. In 1957 Lady Frankau, a London physician world-renowned for her work with alcoholics and drug addicts, began treating a few Canadian and American addicts who turned up in London as refugees from persecution back home. Some other London doctors began to take on such patients. The number of addicts who could afford to transfer their activities to London was small but by 1964 the UK's official addict population, more than half of it cantered in London, was 753 and by 1967 the figure had jumped to 1,729.

Panna Grady had as much money as Peggy Guggenheim. She was very much taken with William Burroughs and, allegedly, had designs on marrying him. In New York she so readily gave away her fortune to the Beats that she was nicknamed "Pan of Gravy". Andy Warhol wrote in *POP* about film work he did with Edie Sedgwick in 1965: "One of the last movies we made with Edie was called *Lupe*. We did Edie up as the title role and filmed it at Panna Grady's apartment in the great old Dakota on Central Park West and 72ⁿᵈ. Panna was a hostess of the sixties who put uptown intellectuals together with Lower East Side types — she seemed to adore the drug-related writers in particular."

Hamri had turbulent associations with, amongst others, Paul Bowles, Brion Gysin, William Burroughs, Mick Jagger, and Timothy Leary. Leary said he was the "Napoleon of painting." His great achievements were his vast body of paintings and his work with the Master Musicians of Joujouka. Burroughs said of his art that "The djnoun spirits of Morocco whisper and ripple and frolic through Hamri's paintings — scattering light over fruit trees, sunflowers, walls and fields, pelting the streets of Tangier with winter rain." An epoch in Moroccan cultural life came to an end with his death in 2000, and the once-infamous Tangier Beat Scene shuddered to a reluctant halt.

Paola Igliori was born in Rome and moved to New York in the mid eighties. Her first book *Entrails, Heads, and Tails* contained photographic essays and conversations with artists such as Louise Bourgeois, Cy Twombly, Francesco Clemente and Julian Schnabel. In 1990 she became the publisher of INANDOUT PRESS, which did beautifully designed books like Paul Bowles' last collaboration with Mrabet, *Chocolate Dreams and Dollars*, and *American Magus Harry Smith: A Modern Alchemist*.

Lech Kowalski was given a Super 8 camera which he used to shoot his first film, *The Danger Halls*, when he was 14. In 1971 he moved to New York and enrolled in the SVA. His films include punk junk classics like, *D.O.A.* , *Hey Is Dee Dee Home*, and *Born to Lose*

Neon Leon. At the time of New York's punk explosion, there were ads in New York Rocker for shows at CBGB's and Max's Kansas City where Neon Leon was listed, usually supporting better and more famous acts. He got started around 1973 when, as a young musician in South Jersey, he opened up for the New York Dolls. "Backstage," he recollected, 'I was like, you know, 'I wanna make it, blah, blah blah, what should I do?' And they said, 'Well, you gotta get outta here.' I said, 'Yeah, but where should I go?' And they said 'You should come to New York.' And I said, 'But I don't know anybody in New York.' And they said, 'Well, you know us.' And I said, 'Yeah, can I have a number or something?' They said, 'Yeah, of course, of course, no problem. Take this number, come in to New York and call me.' Me and Johnny

[Thunders], we got along, so, I couldn't believe it, you know, I thought they were just being nice. But then we played around for another year and we got a lot better doing South Philly and things like that, so finally, I said 'Wow, it's time. Lets go.' We went up there, Honi O'Rourke and I went first and we hung out first cuz the Holiday Inn wouldn't take us; we looked weird. So I said 'The Chelsea Hotel, they had Jimi Hendrix and all these people.' So we parked our car in front of the hotel and there was a sign saying 'No Standing.' But being from South Jersey, we didn't know that meant 'No Parking.' 'No Parking' means 'No Parking,' and we thought 'Oh, you can't stand there.' So we parked the car there, of course the next day we thought it was stolen. The police stole it. So then we were kinda like homeless, you know, because we didn't pay our rent, and the money was the car and the car was towed. But actually, it was a blessing in disguise, so I called this number (of Johnny Thunders) what the hell, right? I called, and he says 'Hey, come on, over,' and he remembered who I was. They had a loft right next to the Chelsea Hotel, and in that loft also was this new group called Kiss rehearsing, who were like the rejects…"

Sharon Mitchell was a seventies porn star, one of the most inexhaustible of adult movie actresses. Before becoming a porn star, she was an actress and dancer who toured with the Martha Graham company. As an act of emancipation, she decided to be a hardcore superstar, appearing in over 2,000 films. She became a junkie but kicked the habit in the nineties. A lesbian, she was known by her lean androgynous figure and for her enthusiastic cunnilingual skills. In 1996, Mitchell was attacked and raped; it almost killed her. When she recovered, she quit the sex industry.

Vali Myers. The subject of Ira Cohen's *Poem for Vali* was born in Sydney and grew up in the New South Wales bush. As a young child, unable to read or write, she immersed herself in drawing and dancing. Myers (1930–2000) later travelled the world as a professional dancer, hanging out in Paris after 1949 with Tennessee Williams, Dali, Cocteau, and Genet. Specialising in fine pen and ink drawings, she lived her life in Melbourne, the Chelsea, and an idyllic fourteenth century cottage hidden in a valley near Il Porto, Italy. The movie *Vali* was co-produced by George Plimpton, who wrote of her in the *Paris Review*: "She is the symbol and plaything of the restless, confused, vice-enthralled, demi-monde that was the personalization of something torn and loose and deep-down primitive in all of us." She also appeared in Cohen's *The Invasion of Thunderbolt Pagoda* and in *Patti and Vali*, a half hour documentary in which Patti Smith is having her kneecap tattooed by Myers.

Barbara Nessim is an artist, and illustrator. She studied at the Pratt Institute from 1956 to 1960 and has been teaching computer art since 1980. Her works have been exhibited at the Kunst Museum and the Louvre. The Museum of Modern Art in Sweden, the Smithsonian in Washington DC and the Hungarian National Gallery in Budapest all hold work of hers in their permanent collections.

Pantopon is a remedy for pain, bellyache, spasms, and anxiety. It contains all the opium alkaloids in a standardized form free of inert material. Pantopon is still sold in a few countries, making it Roche's longest-selling product.

SVA is New York's School of Visual Arts. Its Main Building is at 209 East 23rd Street, between 2nd and 3rd Avenues, proximate to the Chelsea Hotel. People associated with the School include Klaus Janson (*Batman*), Sam Viviano, Art Director at MAD magazine, and Gary Panter. Keith Haring attended SVA, as did Ralph Bakshi (*Fritz the Cat*), actor Jared Leto, and Gerard Way, singer with My Chemical Romance.

Tuinal (often called Tuinol) is the brand name of a drug composed of two barbiturates — secobarbital and amobarbital — in equal proportions. Although both secobarbital and amobarbital are classified as short-acting barbiturates, combining the two drugs results in a longer duration of action, thus making the combination medically useful in situations requiring both a long and intense period of sedation. Tuinal is much sought after by junkies, who call it things like "blue tips", "beans" and "jeebs".

Janine Pommy Vega is an American poet who grew up in Union City, New Jersey. At the age of fifteen, inspired by *On the Road*, she travelled into Manhattan determined to become a part of the Beat scene. Her first book, *Poems*

to Fernando, was published by City Lights in 1968 as part of their City Lights Pocket Poets Series. She is featured on the cover of *Women of the Beat Generation*.

Bob Yarra. Ed Sanders wrote, concerning moves to bury Gregory Corso alongside Shelley in Rome: 'I spoke with attorney Robert Yarra, who lives in Fresno, California, and is a long time friend of Beat literature, and Gregory in particular. Mr Yarra's specialty is immigration law, and it was he who was responsible for setting in motion the requests and permissions required to get Gregory into the Roman cemetery. 'George Scrivani and I had thought about that. George asked Gregory if it was something he'd want and he seemed very positive about that. He wanted Rome or Venice.' Robert Yarra has friends with connections, as they say, in Rome, so he called a woman named Hannalorie, a friend of his, and asked if it would be possible to bury Gregory at the Protestant Cemetery. 'She then spoke to the director,' Yarra told me, 'and he said no, it was very difficult. And then I said can you still try again, and so she did, and she was finally able to persuade them to bury him there.' When did this occur? I asked. Yarra replied, 'This about six months ago, and Gregory knew of the results.' Hannalorie is a long time friend of Robert Yarra, and lives in Rome. She met Gregory about two years ago, and they got along very well. She's a very forceful lady, and usually gets what she wants."

..

BIOS

Joe Ambrose works as a writer, filmmaker, and DJ. As a member of experimental hip hop group Islamic Diggers, he has performed live with Lydia Lunch, Anita Pallenberg, Richard Hell, and Howard Marks. He is the author of seven previous books including two novels — *Too Much Too Soon* and *Serious Time* — praised by The Guardian as being "unputdownable". His non-fiction includes *Gimme Danger: The Iggy Pop Story*, *Moshpit Culture*, and, with Frank Rynne, *Hashishin*. He co-produced with Rynne the 2CD *10% File Under Burroughs* featuring tracks from William Burroughs, Brion Gysin, John Cale, Marianne Faithfull, and the Master Musicians of Joujouka. He is Literary Editor of outsideleft.com. A longtime activist on behalf of the Master Musicians of Joujouka, he co-directed the movies *Destroy All Rational Thought* and *Joujouka*.

Thelma Blitz survived the sixties at the Chelsea to have her own open air novelty handicrafts business, Thelma Blitz Knitz, in Soho, New York. A Barnard graduate, she has written copy for major New York advertising agencies, magazine pieces for Redbook and Village Voice, liner notes and translations from the French of Jacques Brel and Yves Montand for DRG Records, PR for the now legendary ESP-Disk, and is videographer for Fug Tuli Kupferberg's public access TV show *Revolting News*.

Ira Cohen born 1935, travelled to Tangier (1961-65) where he published Gnaoua, a magazine dedicated to exorcism which featured Paul Bowles and William Burroughs. He returned to New York to film *Invasion of Thunderbolt Pagoda* and *Paradise Now*. In 1970 he moved to the Himalayas where he founded the Starstreams Poetry Series, publishing the work of Bowles, Gregory Corso and Charles Henri Ford, among others. A traveller to Kathmandu, India, Japan and Ethiopia, he now lives in New York.

Gene Gregorits is a writer/icon with a decade of hard experience behind him. His work has appeared in such magazines as *Filmmaker*, *Brutarian* and *Raindance Film UK*. His book *Midnight Mavericks* is one of the most important film books to have come out in the last ten years. He has worked with Lech Kowalski, Islamic Diggers, and Lydia Lunch. A cool customer and the real thing.

Herbert Huncke was the role model studied and copied by better known writers like Kerouac, Burroughs, and Ginsberg. He gave them the word "Beat" to describe their movement. He turned Burroughs on to heroin. He appears as a character in *Junky*, *On the Road* and *Howl*. But it is for his own remarkable body of writing that he deserves to be known. A small time thief, a lifelong drug user, a natural born storyteller, he was an authentic outsider

uncomfortable with any of the labels which straight society and the counterculture attempted to hang on him. Kerouac once wrote: "Hunky, whom you'll see on Times Square, somnolent and alert, sad, sweet, dark, holy. Just out of jail. Martyred. Tortured by sidewalks, starved for sex and companionship, open to anything, ready to introduce a new world with a shrug."

Spencer Kansa. Writer, musician, photographer and collagist Kansa has written for many publications including *Hustler UK, Mojo, Headpress, Vox, nme.com* and *Hip Hop Connection.* His photographs of William Burroughs adorn the cover and booklet of *10% File Under Burroughs* and also feature in David Buckley's David Bowie biography *Strange Fascination.* An excerpt from Kansa's screenplay *Kim Carsons* appears in *Hashishin* by Joe Ambrose and Frank Rynne. He is currently working on a biography of artist and occultist Marjorie Cameron. www.spencerkansa.com

Jared Louche. Poet, performer, singer, rock star, writer, educator, DJ, painter, photographer and sculptor from NYC currently living in North London. Louche toured all over the world with his band Chemlab and as a poet and storyteller. He has recorded over a dozen albums and unleashed a book entitled *A Handbook on How to Wreck Other Peoples Lives.* His second book *Unplugged Memories* is expected soon. He soundtracked a collection of stories and songs called *The Death Of Radio Mars* with Mark Spybey (CAN and other sonic experimentalists). www.hydrogenbar.com

Barry Miles ran with John Dunbar, during the sixties, the hugely influential Indica Gallery and bookshop in London. A close friend to Paul McCartney, Burroughs, Gysin and Ginsberg, he has been actively involved with the Beat Generation since the early Sixties when he became one of the founding members, and leading lights, of the counterculture. He edited *International Times*, a seminal underground magazine.

Gary Panter, the King of Punk Art, is an illustrator, painter, and designer. Robert Williams dubbed him "The King of the Preposterous". His art has graced album covers for Frank Zappa (*Studio Tan*) and the Red Hot Chilli Peppers. Panter is a major post-underground, new wave comic artist — his work helped define a genre in publications as varied as *Raw, Time* and *Rolling Stone*. He won two Emmy awards for his set designs for *Pee Wee's Playhouse*. www.garypanter.com

Frank Rynne is a singer, producer, filmmaker, writer and historian. He co-organised the 1992 *Here to Go Show* celebrating William Burroughs and Brion Gysin, and with fellow organisers Joe Ambrose and Terry Wilson co-wrote *Man from Nowhere*. He co-produced the two CD *10%: File Under Burroughs* (1996). In 1994 he was brought to Joujouka by Hamri where he began spending months at a time producing The Master Musicians of Joujouka. These recordings resulted in the CDs *Joujouka Black Eyes* (1995), *Sufi* (1996) and *Boujeloud* (2006). As part of Islamic Diggers, Rynne performed and organised at London's ICA and other cultural centres events featuring Richard Hell, Lydia Lunch, Howard Marks, and helped oragnise the first public showing of Anita Pallenberg and Keith Richards' home movies, *No Expectations*, at London's Horse Hospital. His film credits include *Destroy all Rational Thought, Joujouka,* and the restoration of Antony Balch/William Burrough's *Three Minute Movie*.

Laki Vazakas is a video maker and educator. His works include *Huncke and Louis* (1998) *Cherry Valley Arts Festival* and *Burma: Traces of the Buddha*. He has been a staunch ally to powerful counterculture mavericks like Marty Matz, Herbert Huncke and Ira Cohen.

George Wallace is a New York-based poet and performer who travels widely in the US and in Europe to read his work and lead writing workshops. Editor of *Poetrybay, Polarity* and *Poetryvlog*, he is author of fourteen chapbooks of poetry in the US, UK and Italy, and has appeared on stage or CD with David Amram, Claire Daly, Levon Helm, Glen Moore, Lee Renaldo and more. Many of his conversations and exchanges have been published, including Baez, Bly, Cassady, Creeley, Donovan, Ginsberg, Max, Plymell, Stafford, Vega and Yevtushenkov

BIBLIOGRAPHY

Ambrose, Joe, *Moshpit Culture*
 Omnibus Press; London, 2001
Ambrose, Joe, *Serious Time*
 Pulp Books; London, 1998
Ambrose, Joe, *Too Much Too Soon*
 Pulp Books; London, 2000
Ambrose, Joe, *Gimme Danger: The Story of Iggy Pop*
 Omnibus Press; London, 2004
Ambrose Joe, Wilson, Terry, & Rynne, Frank, *Man from Nowhere: Storming the Citadels of Enlightenment with William Burroughs and Brion Gysin*
 Subliminal Books; Dublin, 1992
Ambrose, Joe & Rynne, Frank, *Hashishin*
 Sidecartel; Los Angeles, 2007
Antonia, Nina, *Too Much Too Soon*
 Omnibus Press; London, 1998
Antonia, Nina, *Johnny Thunders: In Cold Blood*
 Jungle Books; London, 1984
Ashfeldt, Lane (ed.), *Down the Angel*
 Pulp Net; London, 2006
Bockris, Victor, *Patti Smith*
 Fourth Estate; London, 1998
Bockris, Victor, *Beat Punks*
 Da Capo Press; New York, 2000
Bockris, Victor, *Muhammad Ali: In Fighter's Heaven*
 Hutchinson; London, 1998
Booth, Stanley, *Rhythm Oil*
 Pantheon Books; New York, 1991
Booth, Stanley, *Dance with the Devil: The Rolling Stones and Their Times*
 Random House; New York, 1984
Breger, Udo, *Identity Express*
 Caos Press; Milan, 1970
Burroughs, William, *Last Words*
 Grove Press; New York, 2002
Cale, John & Bockris, Victor, *What's Welsh for Zen*
 Bloomsbury; London, 1999
Clancy, Liam, *Memoirs of an Irish Troubadour*
 Virgin Books; London, 2002
Cohen, Harvey, *The Amphetamine Manifesto*
 The Olympia Press; New York, 1972
Cohen, Ira, *On Feet of Gold*
 Synergetic Press; Oracle, Arizona, 1986
Cohen, Ira, Malanga, Gerard & MacLise, Angus, *Ratio:3 — Media Shamans*
 Temple Press; Brighton, 1991
Geiger, John, *Nothing is True Everything is Permitted: The Life of Brion Gysin*
 Disinformation; New York, 2005
Greenspan, David (ed.), *Nunzio: A Gregory Corso Memorial 1930-2001*
 Butcher Stop Press; New York, 2001
Hamri, *Tales of Joujouka*
 Capra Press; Santa Barbara, 1975

Harry, Debbie, Stein, Chris & Bockris, Victor, *Making Tracks; The Rise of Blondie*
 Elm Tree Books; London, 1982
Hell, Richard, *Artifact*
 Hanuman Books; New York, 1990
Hell, Richard, *The Voidoid*
 Codex; Hove, 1996
Huncke, Herbert, *The Herbert Huncke Reader*
 Bloomsbury; London, 1998
Huncke, Herbert, *Huncke's Journal*
 The Poet's Press; New York, 1965
Huncke, Herbert, *The Evening Sun Turned Crimson*
 Cherry Valley Editions; New York, 1980
Huncke, Herbert, *Guilty of Everything*
 Hanuman Books; New York, 1987
McNeil, Legs & McCain, Gillian, *Please Kill Me: The Uncensored Oral History of Punk*
 Penguin Books; New York, 1996
Miles, Barry, *William Burroughs, El Hombre Invisible*
 Hyperion; New York, 1993
Miles, Barry, *The Beat Hotel*
 Grove Press; New York, 2000
Miles, Barry, *Allen Ginsberg: A Biography*
 Simon & Schuster; New York, 1989
Miles, Barry, *In the Sixties*
 Jonathan Cape, London 2002
Mrabet, Mohammed, and Bowles, Paul, *Chocolate Creams and Dollars*
 Inandout Press; New York, 1992
O'Connor, Ulick, *A Cavalier Irishman; The Ulick O'Connor Diaries 1970–1981*
 John Murray; London, 2001
O'Connor, Ulick, *Brendan Behan*
 Hamish Hamilton; London, 1970)
O'Connor, Ulick, *Travels with Ulick*
 Mercier Press; Cork, 1967
Ramone, Dee Dee, *Chelsea Horror Hotel*
 Thunder's Mouth Press; New York, 2001
Ramone, Dee Dee, *Lobotomy; Surviving the Ramones*
 Thunder's Mouth Press; New York, 2000
Rechy, John, *City of Night*
 MacGibbon & Kee; London, 1964
Rechy, John, *Rushes*
 Grove Press; New York, 1979
Sargeant, Jack, *Naked Lens: Beat Cinema*
 Creation Books; London, 1997
Thompson, Dave, *Beyond the Velvet Underground*
 Omnibus Press; London, 1989
Turner, Florence, *At the Chelsea*
 Hamish Hamilton; London, 1986
Wilson, Terry, & Gysin, Brion, *Here to Go; Planet R101*
 Creation Books; London, 2001
Wilson, Terry, *"D" Train*
 Grapheme Publications; London, 1985
Wilson, Terry, *Dreams of Green Base*
 Inkblot; Berkeley, 1985

ACKNOWLEDGEMENTS

Parts of *Chelsea Hotel Manhattan* have appeared in *The Idler*, thehandstand.org, outsideleft.com, and *Texts Bones*. Thanks to the editors of those organs. Hayley Ann at Codex was originally going to publish the book but due to sad circumstances, it never happened. I'm grateful to her for her enthusiasm and support. I'm grateful to all my fellow travellers, those who contributed their own texts to this volume, but special thanks go out to my soul brothers Gene Gregorits and Spencer Kansa who, between them, wrote substantial chunks of a book which has only my name on the spine. Frank Rynne took turns paddling the canoe which eventually allowed me to wash up in Manhattan, and played a hands on part in securing the essays by Herbert Huncke to be found in these pages. David Kerekes may well be the last publisher of his kind on England, one who publishes books that he likes.

Jerome Poynton, Herbert Huncke's literary executor, granted me permission to use the two essays by Huncke to be found here. Barry Miles gave me permission to use an extract, Claude and Mary, from his *In the Sixties* book. The quote from William Burroughs concerning the disappearance of writers like Beckett and Bowles comes from the movie *Destroy All Rational Thought*. Longtree Gnoua, who is known to his pals as Longtree, has asked me not to include his real name but I'm grateful to him for all sorts of stuff, not least for a good excuse to keep going back to Harlem. Chuck Prophet provided the perfect counterpoint to Huncke on the *I Mostly Travelled on the Road* track which Frank Rynne and I produced, and which derived from Spencer's interview with Huncke included here. Billy Name sent me a really nice contribution for this book but it got unforgivably lost between the time when I first thought up this project and its eventual publication. Sorry ,Billy.

Photographs of Ira Cohen (p 89), Herbert Huncke (p 113), and Marty Matz (p 121) copyright Laki Vazakas. Spencer Kansa with William Burroughs (p 96) and Herbert Huncke (p 126) copyright Spencer Kansa. Vali Myers with Gregory Corso (p 148) and Ira Cohen (p 159) copyright Ira Cohen. Images on pp 27, 101 and 116 copyright Here to Go Show.

I'm proud of my connections with Shane Cullen, Tav Falco and the enduring Panther Burns, Andrew Sclanders, Penny Arcade, Bill Murphy, Mattia Zaparello, Bill Laswell, Gunther Schultz, Jack Rabid, Peter Playdon, Richard Hell, Chris Campion, Nick "Sly" Smith, Tony White, Richard Morgan, James Hollands, the Doomsday Diablos, James Williamson at Creation Books, Sylvain Sylvain, the Andy Warhol Foundation, John Giorno, Fred and Guy Marc at Sub Rosa Records, Mike Luongo, Danny Fields, Roger K. Burton at the Horse Hospital, Jocelyn Bradell, Soulfly, Seb Tennant, Andrew Beck, Candida Crazy Horse, Liam Clancy, Barry Neuman, Victor Bockris, Paul Hawkins, The Chamber of Pop Culture/The Horse Hospital, Ian Gilchrist, Lars Movin, John Bentham, Elaine Palmer at pulp.net, Regina Weinreich, Chris Charlesworth, Lucy Bradell, Dan Stuart, Helen Donlon, Daniel Figgis, Howard Marks, the OTO, Sepultura, Slipknot, Deirdre Behan, Eamon Carr, the Master Musicians of Joujouka, James Lister, Stanley Bard, Anita Pallenberg, Henderson Downing, John Foley, Brendan Maher at *Start* magazine and South Tipperary Arts Centre, Alex Brandau, Nourredine Batchi, Paul Bowles, William Burroughs, Declan O'Reilly, Tim Wheeler, Paul Lamont at outsideleft.com, Bob Gruen, Nina Antonia, Mick Rock, Anne Foley, Roberta Bayley, Stuart McLean, Michael Murphy, Olga Buckley, Tiago Almeida, Leee Black Childers, Kirk Lake, Gerard Malanga, *livingwithlegends* (the definitive Chelsea Hotel blog), Gordon Campbell for his generous and thoughtful involvement with the Here To Go Show, Marek Pytel from Reality Film, and the superb shocks almighty Lydia Lunch.

Will Swofford has taken on the Herculean tasks of managing Ira Cohen's archive and bringing the work of Angus MacLise to a wider public. Hannah at Headpress got stuck with the job of turning my foggy notion into an actual book. Terry Wilson opened many doors and gave me the keys to many kingdoms, introducing me to Ira Cohen, marking my cards on Hamri, giving me William Burroughs' home phone number. Tavis Henry wrote the opening sentences of this book and parried with me by e-mail while I was staying in the Chelsea. He told me I'd never catch him but he caught himself in the end.